MANAGING THE ARTS?
THE BRITISH EXPERIENCE

JOHN PICK

R·

RHINEGOLD PUBLISHING LIMITED
241 SHAFTESBURY AVENUE LONDON WC2H 8EH
TELEPHONE 01-240 5749 TELEX 264675 GILDED G

TO
MY PARENTS
For the flowers and the books.

First published 1986 in Great Britain by Rhinegold Publishing, 241
Shaftesbury Avenue, London WC2H 8EH (Tel: 01–240 5740)

Pick, John, *1938–*
Managing the arts?: the British
experience.
I Arts—Great Britain—Management
I. Title
700'.68 NX770.G7
ISBN 0 946890 11 0

Typeset by Oxford Publishing Services, Oxford.
Printed in Great Britain by Perfectaprint, Byfleet, Surrey.

MANAGING THE ARTS?
THE BRITISH EXPERIENCE

JOHN PICK
Professor of Arts Management, City University.
Gresham Professor of Rhetoric.

c. 1986

Other books by John Pick

Arts Administration
The State and the Arts (Editor)
The West End; Mismanagement and Snobbery
The Theatre Industry
The Modern Newspeak
The Privileged Arts
Off Gorky Street; Arts Administration in the USSR
Weasel Words

In preparation

The Culture of Comedy

CONTENTS

PREFACE

This book has three main aims. First, to explain that the history of the arts in Britain is not the same thing as the history of state subsidy. Second, to demonstrate the system which involves the Arts Council in a once-admired role as the purveyor of subsidy to the arts has broken down, and that much in its present operation is divisive, narrowly political and over-bureaucratised. Third, to indicate approaches which might be made to a policy for the arts but which are not simply a matter of reshuffling the pieces in the present game.

It is written from a profound belief that British culture does *not* readily divide into the demanding and valuable arts (subsidised, and cherished by the highly educated) and the popular and less demanding (commercial and an entertainment for the less privileged). It is written also in the belief that if we take a wider look at all the arts we practise and enjoy – the gardening and reading and dressing up and listening to recorded music, the pleasure in cooking, in talking, in taking photographs and enjoying musicals and films, and *all* the rest of the arts that make our lives rich and enjoyable – we do not thereby forego the right to make qualitative judgements between them. We do not have to pretend that all the arts are the same kind of experience, or that they are 'just as good' as each other merely because we have lifted our eyes from that highly politicised corner of the arts which is the province of the bureaucrats of subsidy.

For at the core of the argument there is a paradox. In Britain the world of the subsidised Arts has, in general, gradually shrunk. In broad terms each performance and each exhibition costs the state an increasing amount, and fewer people attend it. The subsidised Arts world is a decreasing part of the wider world of creative leisure pursuits and popular entertainments. As it shrinks however it has seemed to gather unto itself all the approbation, all the critical merit, all the assumed excellence and distinction that we can bestow. We often speak as if the arts are the same thing as the subsidised

1

Arts, and as if excellence can be found nowhere within commercial or media productions. It is the subsidised Arts that are supposed to be the most medicinal, the most moral, the most glorious, the most educational and the most profitable to the state. All these benefits are however supposed to flow from a slowly shrivelling system which is patently failing.

We have become so trapped in our bureaucratic arts language that to many people a successful arts policy is one which gets a little more tax-payers' money each year for 'the' arts economy, and fiddles about with the representation on the Arts Council so that it accords with current pre-judices. This book argues that the whole System has failed, and that even if government subvention to 'the' arts were to be quadrupled, the present problems would remain. For, contrary to the usual arts theology, I argue that we must look at the whole range of arts markets before we can begin to think about policies which affect the quality of our lives, and not concen-trate so exclusively and blindly upon the maintenance of a few subsidised arts organisations, as if they *are* 'the arts'. Accordingly we spend time in looking at aspects of the commercial arts markets, at the provision by local authorities and at the arts in the media. We look at gardens, amateur music making, bookshops and the look of the towns and cities in which we live as well as the National Theatre, the Hayward Gallery and the Royal Opera House. Our scope is therefore much wider than the Arts Council's new 'strategy', outlined in their *Glory of the Garden* publication in 1984. That publication not only confused devolution and decentralisation (whether wilfully or not one cannot say) but assumed that 'a thorough and fun-damental review' of its purposes involved only minor redistributions of its finances between favoured art forms, and then announced that tinkering with elements of the comparatively small subsidised segment of the arts market was a master plan for national cultural development.

We do not of course deny that governments should give financial aid to some activities within the arts world; we only question whether our present System, which makes unpopularity and commercial failure preconditions of state aid, is right. Nor do we deny that keen judgements of value have to be made; we merely suggest that our present Arts Council system, which marries artistic approval with commercial failure, and which carries out critical assessments of the state supported arts in secret, is not necessarily good for artists, audience or criticism.

My argument will of course be thought idiosyncratic and personal (I was

2

a decade ago surprised to find that *personal* was a term of mild abuse in modern arts politics, but recognising the pressures towards conformity, particularly towards conformity in political arts jargon, I am surprised no longer). It may also seem that I have concentrated overmuch upon failures of the British system, and not upon its successes. (That is true enough, but in an earlier book, *The State and the Arts* can be found a counterbalancing description of Arts Council systems, in earlier decades, producing successes). Some matters which would be important in a full historical account of the British experience are, in this argument, omitted. A certain truncation was necessary if it were not to become tiresomely long and boringly detailed.

Some aspects of the argument I have discussed at greater length in papers given at the Third International Conference on Cultural Economics and Planning (Akron, 1984), at the Leisure Studies Association International Conference (Sussex 1984), in the series of lectures on 'Who Owns Britain?' given in London University in 1986, and at the World Conference on Arts, Politics and Business in Vancouver, 1986. Certain historical aspects have formed a part of the series of public lectures I have given during my tenure of the Gresham Chair of Rhetoric in the City of London. I am grateful for these invitations to speak. For illumination in various conversations I am grateful to Professor John Allen, Professor Anthony Field, John Elsom, Norman Buchan M.P., Sir Roy Shaw, Dr Alan Tomkins, Dr David Cwi, Harry Chartrand, Professor Denis Donegan, Dr Robert Protherough, Dr Michael Hammet, Eric Moody, Keith Diggle, Lord Gowrie, Peter Stark and Caroline Gardiner. None of the foregoing, nor any of my students who find their insights embedded in the text as if they are wholly mine, is of course in any way implicated in the book's general argument or in its conclusions which, like any errors of fact, are my personal responsibility.

John Pick
London
1986

CHAPTER 1

THE ARTS

'Applied science has enormously increased the world's population. The extra people live mainly in large units that tend more and more to resemble each other. They have to be reached by their governments and by all the agencies that wish to impart news, opinions and announcements of goods and services for sale. The town crier, the notice in the church porch, and the back-street printer have been replaced by the means – radio, popular press and advertising – that technology has made possible. The next gifts of applied science to very large numbers of people was more leisure, more energy to enjoy it, and a much greater spending power. And as a result home-made amusements, live performances, and inexpensive hobbies are now supplanted by a large and well organised entertainment industry that reaches deeply into our homes and pockets. Much that used to be supplied locally is now centrally provided by newspapers, publicity, radio, film, records, magazines and the mass production of things used and enjoyed in the home.

The reformers of the nineteenth century nobly hoped that the workers, once freed from the prison of illiteracy and long hours, would give themselves a liberal education and feed on the same intellectual delights as the reformers themselves. Their disappointed hopes may have been pitched too high: today our expectations of popular culture seem altogether too low.'

Denys Thompson, Discrimination and Popular Culture

'What we really mean by the arts in Britain,' said the Earl of Gowrie in 1985, 'is one of our most successful and dynamic industries. They earn millions of pounds for the country at home and abroad and employ hundreds of thousands of people. Mostly they do it without subsidy.' Speaking, as the reigning Minister for the Arts in Britain,[1] in a House of Lords debate, he went on to list some of Britain's most successful living

Managing the Arts?

artists as evidence that 'the industry' was 'alive and kicking'; Bennett,
Stoppard, Ayckbourn, Frayn, Peter Brook, Glen Walford, Sir Peter Hall,
William Golding, Grahame Greene, Anthony Powell, Kingsley Amis,
Ted Hughes, Geoffrey Hill, Dick Francis, P.D. James, Sir Michael
Tippett, Peter Readman, Bob Geldof, Simon Rattle, Andrew Lloyd
Webber, David Hockney, Lucian Freud, Francis Bacon, John Davies,
Thérèse Oulton, Adrian Wiszniewski among a long and impressive list of
Britain's artists who were so eminently 'marketable' in the modern world,
and who yield such tangible macro economic results.

In opposition, former Arts Ministers painted an entirely different
picture. Lord Jenkins said the arts world was in 'seething discontent',
exemplified by 'resignations from the Arts Council committees and what
appears to be, at least in part, some degree of open revolt':

> 'From the largest to the smallest the voices of protest are being
> heard, from people and from organisations who feel that they are
> being betrayed: that the Arts Council, which they have regarded as
> their champion and as a body which, for all its faults, has tried hard
> to represent their case to the government, has in effect changed
> sides and now represents the hard face of a monetarist cabinet. Dr
> Jekyll has become Mr Hyde: or, as Sir Peter Hall has said, 'The
> council has become an instrument of government'.'

Lord Donaldson found 'from many directions gloom verging on despair.'
Lord Hutchinson added of the Arts Council, 'I must tell the Minister that
in the view of many of its clients and of many working at 105 Piccadilly,
as has already been said, the Arts Council seems to have lost its way.
Daily, it has become more like a Government department with a staff of
civil servants. It seems to face towards the Government.'

The opposition speakers were not in fact contradicting the Minister
directly. They were using a different, though equally modish, definition
of 'the arts'. Whereas Gowrie was taking the term 'the arts' to refer to
saleable goods, to be judged by their economic successes, his opponents
took 'the arts' to refer to a political or managerial bureaucracy. So, when
Gowrie later in the debate begged their Lordships 'not to confuse the
financial problems of the arts and of artists with the problems of the
organisations which serve them', the plea hardly needed to be made. Few
people were much interested in the financial problems of *artists*. It was the

6

contribution 'the arts' made to closing the export gap, and the slightly lurid, backstairs politics of it all which fascinated the Chamber. In that debate, no less than in others, 'the arts' were wilfully confused with the administrative and financial systems that supposedly serve them.

The Arts Council of Great Britain confuses the two things totally:

> 'The arts have been one of our greatest success stories – perhaps the greatest. We are asking the nation to invest in this well proved 'product', to provide the cash to ensure that past glories do not become insubstantial memories, and that present achievements can be built upon for even greater returns in the future.'
>
> *The Arts: A Great British Success Story 1985*

The Arts Council's present chairman, Sir William Rees Mogg, confuses the two with more grace, but no less irrevocably. 'Art,' he announced in a recent public lecture,[2] 'is simply one of the things crowded out by state over-expenditure, along with education, research, productive investment and other desirable goods.' Useless apparently to protest that education and research are not *goods,* any more than is productive investment. Useless to point out as well that you extinguish the arts *market* by misapplied economic controls, not art itself. For Sir William, 'the political economy of the arts is dependent upon the political economy of the nation', and, for him, the political economy of the arts is the same thing as the arts. The axiom is delivered *ex cathedra*; who are we to doubt it? When the gross national product is up, then government subvention for the arts is up, and there will be a proportionate increase in fine poetry, good music, stirring dramas and other desirable goods. What use are our feeble protestations that the creation of art, and our pleasure in it, have never borne any relationship to a national economy that can be quantified and pronounced upon in such terms, when we are faced with such a blatant piece of monetarist flummery?

The confusion of the two different realms however is made as readily by the soft left in Britain as by the hard right, and 'monetarism' cannot singly be blamed for our ills. There is in all political camps not just confusion over what 'the arts' actually are, but a desire to make the management and the politics of the arts much more important than are the arts themselves. The media is prone to it as well. The backstage politics of

a music group splitting up are much more newsworthy that was the music they produced. The battles to 'save' a theatre attract more publicity than the dramas it presented. The wrangles over any dramatic increase in, or sudden ending of, financial support for a gallery will create an interest far in excess of any reaction there has ever been to its exhibitions.

For behind the bland generalities and the apparent confusions of much contemporary debate about the arts, seem to lie two unspoken assumptions – expediences of language which are found convenient for politicians of all parties, which are also adopted by 'serious' journalism and by the educated section of the public that occasionally strikes attitudes in such matters:

1. The assumption that it is possible, in phrases such as 'the arts' or 'the arts world', simultaneously to embrace all the different categories of art, and all the various contemporary descriptive and judgemental uses of the word without qualification into one simple and easily understood usage.
2. The assumption that it is moreover possible sensibly to discuss the 'success' or 'importance' or 'effect' of the arts, as if there were one simple method of assessment which people agreed to and understood.

Both beliefs are demonstrably unsound. Further analysis of debate over arts policies will only confirm the suspicion that a brief look at the 1985 Lords Debate has raised, that people smear over the many differences in the ways we use the term 'the arts' in most public debates, and skip from one kind of usage to another as it suits their case. We shall in a moment have a closer look at the range of meanings the word has. And if our definition of 'the arts' is blurred, and we have too many definitions dancing upon the head of a pin, then it follows that the second belief must be highly dubious. We shall indeed throughout the book have cause to point out in different ways that almost invariably, when public figures urge upon us the view that 'the arts' in Britain achieve this social or that economic or those spiritual results, they are not telling us anything about the world that we know, but about their private vanities and their political dreams. 'The arts' has become a token phrase in the public pieties of politicians and of officialdom. It crops up in discussions on the quality of life (The arts' role in the inner cities), in discussions of our mental and physical health (The arts as therapy), in economic debate (The arts revive

our cities' economies), in education (The arts have a central role to play in schools), in strategic defence (The arts embody the nation's essential values), in religion (The arts teach us to have reverence before life) and in politics (The arts are the basis of democracy). We hear a great deal of this all-purpose elixir, 'the arts', but we must never assume that the speaker is referring to the application of a particular skill, or the delight taken in a particular artefact. The word will more probably be referring to an economic or political movement, a psychological tenet or an educational idea – or all of these things at once. Here, for example, later in that same House of Lords debate, is Lord Gibson:

> 'Are the arts to be given a special, and specially protected place? Do we acknowledge that they deserve such a place? First, I would put forward that argument because of what the arts do for the spirit. I recall Austria at the end of the war when the economy was on its knees. What was its first priority? – to rebuild its opera, a symbol of national attachment to real values. Which country since then – Austria or Britain? – has had the better economic progress? I would argue for a special place for the arts because of what they can do to help social problems, inner city problems, problems of unemployment.
>
> The third reason why the arts should be given a protected place is that they are both directly, and, even more, indirectly hugely successful earners for the country in relation to the size of the investment that is made for them. Therefore, in my judgement, the case for the arts is impregnable. But what worries me is the disunity that is displayed in making the case to the public and the Government.

It does not seem to occur to their Lordships that 'the arts' in which people in our inner cities might participate, 'the arts' which are promoted as symbols of national attachment to real values, and 'the arts' which are good for overseas trade are three quite different things. The disunity that he laments is therefore, so long as we make no further attempt to define the word, inevitable. Just as we cannot have one 'Arts Lobby' which speaks for the myriad kinds of activities that cluster under the name, so we cannot have a unified corps which makes 'the case' to government. *There is no single case.*

Polemicists will, it is true, *use* the convenient fact that the word conveys – like 'community' or 'wellbeing' – a warm air of approval without anything being precisely referred to. They will use it so that it fits with the fashionable political concerns of their governments. 'The arts' in Britain have thus been fitted to the welfare economics of the Wilson administration, the pragmatic government of Edward Heath, and now the monetarist economics of the dry right in Mrs Thatcher's cabinet. 'The arts' – often the same music, the same books, the same pictures, and certainly the same operas – have been concurrently promoted in the U.S.S.R. as enhancing world communism, in pre-war Germany as an endorsement of the Third Reich and in America because they enhance the capitalistic market. At a lowish point in Israel's smouldering war with the Arabic states, apologists for the art of a night club magician called Uri Geller claimed he could use his artistic prowess to destroy Egyptian tanks. Indeed it is hard to think of a claim, physical or metaphysical, which has *not* been made for them.

1.1 The meanings of the term

There are four primary meanings of the term which will sometimes help us to distinguish between the different things we mean by 'the arts', and understand better the use of the word 'art'. These meanings are:

a. **Great cunning.** We use this still, as in *the art of the orator*, or *the art of the beautician*, and sometimes approvingly of a cunning artist who seems artless to the uninitiated, as in *the art of Rex Harrison*, *the art of John Betjeman* or *the art of Grandma Moses*. It is an early sense of the word.

b. **A skill.** This was the primary meaning of the word until the middle of the nineteenth century. 'Art' meant any human skill, and 'the arts' referred to gardening, needlework, conversation, letter writing, dressmaking, playing tennis or archery as readily as to making music, writing poems or acting a play. The poet Byron referred to the Isles of Greece 'where grew the arts of war and peace', and, rather more robustly, Dr Johnson observed that 'a man who exposes himself while drinking hath not the art of getting drunk.'

 This meaning of the term continues comfortably enough in our own time, and most people are aware that we retain this old

descriptive use, as in *the art of Torville and Dean, the art of the tightrope walker, the art of Ken Dodd* or *the noble art of self defence*.

c. **An approved process.** The skills involved in producing certain kinds of artefacts and constructions which the Influential deemed particularly desirable were separated out towards the end of the nineteenth century in Britain, when 'art' or 'high art' came to mean a specially approved process, yielding something which Influential opinion holds to be uniquely true, beautiful or persuasive. Thus *the art of Handel, the art of Tennyson* and, after struggle for such recognition, *the art of Henry Irving* came to be understood as a quite different benediction from discussing 'the art of Ducrow', 'the art of Jenny Lind' or 'the art of Marie Lloyd'. New words such as 'artistic' cluster around the new use of the word 'art', which makes its first single appearance in English Dictionaries. It is now, in this new sense, primarily a judgemental, not a descriptive, term.

That judgement between 'high' and 'low' art, made by most twentieth century cultures, varies over time and between countries in its application. Had we made the distinction in the time of Elizabeth the First we should have put all our efforts into saving the 'high art' of the Masque while ignoring the ordinary vulgarity of the plays. If we had created an Arts Council at the end of the Eighteenth Century, it would have turned its attentions to preserving the approved arts of gardening, swordfighting, needlework and dancing, while letting such commonplace arts as novel-writing and drama fend for themselves on the commercial market. In like manner we might notice that the art of juggling is state-supported as a high art in the Chinese People's Republic, and the arts of circus are state-supported as high arts in the U.S.S.R. In Britain we support neither. We might therefore conclude that the division between 'high' and 'low' art, as it came to be made at the end of the nineteenth century in Britain, is to a degree arbitrary; depending upon the perceived notions of rank, the resources available to legislators and the current standing with the ruling elite of the key spokesman, as much as it depends upon the intrinsic qualities of the subject.

d. **Products** We group together as art both those things produced in past times by the application of skill (b. above), *and* those things produced in our own or past times by the approved processes of

'high' art. We thus acknowledge as art products the furniture of eighteenth century craftsmen, the samplers of nineteenth century needlewomen or some films of the early twentieth century, while being reluctant to concede that woodcarving, sewing or film-making are approved contemporary high art processes in the sense that composing an opera or writing a ruminative novel unquestionably is. Art in the sense of 'a product' is therefore, in its contemporary application, *also* a judgemental term. Something will be judged to be 'art' by critics (or, as we shall later argue, judged to be so by experts from the presiding bureaucracy) well before the public has a voice in the matter. Thus, as the expert judgement precedes the public reaction, it is hardly to be wondered at that both the processes and product of contemporary high art seem to be at some distance from the public, often uncomprehended and where comprehended, often rejected.

However we rarely use the word so that it clearly refers to one of these four distinct senses of art. We use it smearily, so that it refers simultaneously to all four modes of art – and other meanings too gather on the term like moss. 'The arts' embrace not just the creation of art, or the constructs of artists, but all those persons engaged in the presentation, diffusion, preservation or even animation of art.[3] Stage designers, exhibition consultants, agents, television moguls, editors, teachers are all a part of 'the arts', all vaguely referred to by the term. 'The arts' embrace audiences, onlookers and participants also. For example, the Greater London Council,

'wanted to turn the popular arts, the community arts and the contemporary media into better equipped and more sharply focussed activities and to ensure all the activities it funded related closely to people's lives and were responsive to their needs. It wanted to fund activities which not only benefitted that long list of people who are discriminated against in our society – the working class, women, black people, people with disabilities, Irish people, gays, lesbians, the elderly, the unemployed, young people – but which also linked the cultural campaigns fighting to overcome the reasons for their oppression. It was a broad spectrum, and one

across which it was not always possible to be vigorously consistent.'[4]

And, as we have already seen, the term nowadays refers to the management of all of these processes, the political posturing which attends it, and a new arts bureaucracy (used here to describe the characteristic features of arts politicians at work, rather than in the sense of necessary desk-bound administration). If the term refers nowadays to anything precise at all, it generally denotes *that*. Thus one of our best novelists, Kingsley Amis, may be described by the the Secretary-General of the Arts Council at the time, Sir Roy Shaw, as 'an enemy' of the Arts, and described as such without irony, because he dislikes the workings of the Arts Council.[5] 'The Arts' usually denotes nothing at all precise; a wisp of cloud, a distant shadow in whichever direction the speaker happens to be looking.

The *connotations* of the word however are more easily described. To whatever blurred coagulations 'art' refers, the associations are always positive; 'art' is invariably beneficial, enlightening, improving, uplifting and good. In this the Office of Arts and Libraries, the Arts Council, and the now-defunct GLC are as one.

But it is not necessarily so. If we revert to the older descriptive use of the term then we should remind ourselves that although some art has always been *Apollonian*,[6] inspirational, aspiring to high ideals, reinforcing our noblest visions, pure and good, there has always been another kind of art which Professor Wilson Knight termed *Dionysian*, the dangerous, disruptive, violent and shocking arts which, in the words of another modern critic 'provoke, question and even distress people with their unexpectedness'. We choose to pretend that all contemporary art, and certainly art paid for with the public's money, is Apollonian, but it is not, and cannot be. The Dionysian artist will always bite the hand that feeds, challenge the patron, mock the state bureaucrat. And we may try, whatever the phrase exactly means, to 'relate the arts more closely to peoples' lives' but it will not necessarily give them a clearer or less confused voice, and the arts will not necessarily make them whole.

In these few opening remarks we have referred to a habit of speech, noting that it is allied to a characteristic new form of British behaviour – speaking and acting as if the 'arts' are synonymous with the politics and

management of the arts, and as if the politics of subsidy is a kind of substitute for the arts themselves. This usage we shall now try to distinguish by referring to state-subsidised arts-related activities as the Arts, with the capital A. Elsewhere we shall try to make it clear which kind of art we are referring to by context, but in general when we speak ordinarily of 'the arts' we shall be returning to the earlier descriptive use of the term, and including *all* creative activities that give benefit.

'If you gotta ask,' said Louis Armstrong, when he was asked what jazz was, 'you'll never know.' In this book we have to ask, and we have constantly to question whether our multi-layered bureaucracies know what it is they are talking about. However we should retain the consoling thought that in spite of all the strictures on our British systems of Art support there are in each of the art forms, amongst all the poseurs and imitators and between all the shrill critical pulpits, groups of people who *do* know what each of the arts are, people who can tell what a poem is, can recognise a good painting, can hear the authentic note of the genuine musician and can distinguish good drama from modish cant. They exist, but unfortunately for us, they exist too rarely in our postwar Arts bureaucracies.

Footnotes

1. 6th March 1985. *Hansard, House of Lords.* Motion – Arts and Broadcasting; Finance. Col 1313 ff.
2. Sir William Rees Mogg. *The Political Economy of Art.* An Arts Council Lecture given on Monday 11 March 1985 at IBM South Bank, London, before an invited audience.
3. See Brook, D. 'The Nature of Art and some implications for Public Policy' in Brittan (Ed.) *A Decade at the E.A.F.* (Adelaide, 1984). Also Girard, A. 'Cultural Indicators and Cultural Policy' in Zuzanek (Ed.) *Social Research and Cultural Policy* (Waterloo, 1979)
4. *Campaign for a Popular Culture.* (G.L.C., 1986) p.17
5. In a letter to me asking why I gave comfort to the Arts Council's enemies. (I had written mild praise of Amis' pamphlet *An Arts Policy?*, in which he questioned whether there could really be such a thing)
6. G. Wilson-Knight, *The Golden Labyrinth.* (Methuen, 1965)

CHAPTER 2

WHO OWNED THE ARTS?

'We should avoid being superior about cinemas. In some ways they are perhaps better than the theatre, more vital, more willing to display novelty, and often reflecting with some accuracy the life of our time. New cinemas are everywhere and are worth dropping into, particularly if there is a documentary film, a type in which this country excels, or a Walt Disney cartoon.

As to the theatre, this is the greatest public art. But it does not seem so now. The discerning would desire to see on the stage more real subjects dealt with, to feel that the theatre was continuous with the world we live in; and they would desire also that such real subjects should be treated theatrically, that is, in a manner that made full use of the voice (not the naturalistic mumbling) with music, dance, etc. as appropriate.

The tracks in music are perhaps more definitely laid down. The important opera seasons, German and Italian, at Covent Garden come in a well trumpeted cycle, and you may be sure of doing an exclusive and fashionable thing if you attend.'

George Buchanan, Serious Pleasures 1938

It is true, as Russell said, that in the past in Britain, 'there was a small leisure class and a larger working class. The leisured class enjoyed advantages for which there was no basis in social justice; this necessarily made it oppressive, limited in sympathies, and caused it to invent theories to justify its privileges. These facts greatly diminished its excellence, but in spite of this drawback it contributed nearly the whole of what we call civilisation.' [1] However, that dividing line between the leisured and the unleisured became blurred in the eighteenth century, when a considerable leisure market grew up, and, as a part of that, for the first time in Britain, artists were able to support themselves by selling their work to the public.

In broad terms, the market place replaced the patron as the main source of income for writer, musician and poet.

Alexander Pope, for example, made £4,000 each out of his *Iliad* and his *Odyssey* (compared with the £10 Milton had made, fifty years before, from the first edition of *Paradise Lost*). The painter West made £34,000 from selling a series of small paintings to George III. Herschel made £500 a year working as a musician in Bath. Hogarth's *The Harlot's Progress* brought him £12,000. Dr Johnson made £1,575 from his *Dictionary*. Painters could charge £50 a portrait, and musicians ten guineas for playing privately. When Reynolds died he was worth more than £100,000, and in 1791 the entrepreneur Solomon gave Joseph Haydn £50 each for twenty performances in London, together with a benefit of £200: little wonder that Haydn found in the commercial air of eighteenth century London a 'sweet degree of liberty'.[2]

Audiences swelled rapidly for all kinds of leisure pursuits. Great crowds, of widely mixed social origins, flocked to the pleasure gardens, or to the concert seasons in the large cities. Museums, run commercially, were massively popular; Lever's museum in Leicester Square took £13,000 in admission fees between 1775 and 1794. In the summer the hordes went out to the stately homes, which were often open to the public, some even selling teas, prints, guidebooks and souvenirs to visitors. In London there were as many concert halls as there are today – and some indication of the popular interest in music is gained from the fact that 12,000 people paid half a crown each to hear a rehearsal of Handel's *Music for the Royal Fireworks* at Vauxhall. In their 2,000 coffee houses meanwhile Londoners read, by 1790, one of fourteen morning papers, or read their new evening paper. Outside London, in the provinces, 400,000 papers were sold each week and, in taverns and coffee houses, read by many times that number. By the end of the century there were 250 periodicals, and in the country a total of 390 circulating libraries, operating upon a commercial system. Commercial theatres sprang up everywhere, so that few towns with a population of more than 1,000 were without a theatre and the larger towns became the centre of small touring 'circuits', whose bosses became notable and usually respected figures in their areas. In the cities this was balanced by the increasing award of Royal Patents to the larger theatres (the 'Theatres Royal') which enabled them to be free of the constraints arising from the 1660 Theatre Act, and

free to present the legitimate drama; Norwich and Bath in 1768, Liverpool 1771, Manchester 1775, Bristol 1778 and Newcastle in 1788.

There were undoubtedly many fraudulent showmen whose sole aim was to exploit the gullibility of this new public and to make a fast profit. In general however, although the leisure market of the eighteenth century was commercial, it cannot be dismissed as a debasement of standards and as mere consumerism. The new novels, the best-selling poetry, or Dr Arne's music were by no means written *down* to accommodate to some notion of low common taste. There were of course the Grub Street hacks, but there were the philosophers, authors, painters and composers who were uncompromising, but who found nevertheless a ready market. 'It is with great pleasure that I observe,' wrote David Hume, 'that men of letters in this age have lost in a great measure that shyness and bashfulness of temper, which kept them at a distance from mankind.' But the artists were not at the mercy of consumers. No purchaser of their talents and their works ever succeeded in seducing from their fine sense of elegance the Adam brothers, James Gibb, Chippendale or Sheraton. And the fact that he firmly believed that no-one but a fool ever wrote anything except for money did nothing to remove from Dr Johnson the belief that the firm common sense of his fellows would mean that enough of good writing would be bought; to write for money was to write for an elevated taste, 'common' only in the positive sense that it was widely shared. [3]

There were some of course who did not altogether share Johnson's staunch belief in common sense. One such was the century's leading actor manager David Garrick, who waged a ceaseless war upon the mannerisms of his audience which he considered demeaning to his art. He won some battles – excluding audiences from sitting on the stage during performances for example – but lost others, eventually conceding that:

> The drama's laws the drama's patrons give,
> And we that live to please, must please to live.'

Elsewhere, particularly when the art form implied an elegant social context, there were efforts to attract less cosmopolitan audiences and to draw instead the refined and discriminating. The Italian Opera House, for example, from its first launch by its private syndicate on April 9th 1705, was, in the words of its most distinguished chronicler, 'built by the support of the nobility, and the nobility apparently intended their future

audiences to be drawn from the upper classes from the very beginning.'[4] In particular parliament's first venture into financial support for the arts was marked by a clear wish that the common citizenry should be excluded from such a rarified sphere. In 1753 the state purchased Sir Hans Sloane's collection of paintings,[5] and in 1759 presented them as the nucleus of the new British Museum. Gaining entry to view them was however strictly limited; the would-be viewer had to apply by letter, with a curriculum vitae and references. Even then there was a doorcheck to make sure the visitor was suitably dressed for the occasion.

Over large sections of the new leisure economy however, where everyone practised, by the old definition of the word, their chosen arts, there were as yet few social inhibitions. Drawings of the crowds at the pleasure gardens or at the play, the cricket match or the concert, suggest that they dressed pretty much as they liked, and imposed as many conventions as they observed. Boswell's account of an evening at the playhouse suggests something of the cheery give-and-take of these occasions, suggests too a sense of communality within the audience, a collective sense of judicious discrimination.

> 'We had some port, and drank damnation to the play and eternal remorse to the author. We then went to the Bedford Coffee-House and had coffee and tea; and just as the doors opened at four o'clock, we sallied into the house, planted ourselves in the middle of the pit, and with oaken cudgels in our hands and shrill-sounding catcalls in our pockets, sat ready prepared, with a generous resentment in our breasts against dullness and impudence, to be the swift ministers of vengeance. About five the house began to be pretty well filled. As is usual on first nights, some of us called to the music to play *Roast Beef*. But they did not comply with our request and we were not numerous enough to turn that request into a command, which in a London theatre is quite a different sort of public speech.
>
> However we kept a good spirit and hoped for the best. The prologue was politically stupid. We hissed it and had several to join us . . . We did what we could during the first act, but found that the audience had lost their original fire and spirit and were disposed to let it pass. Our project was therefore disconcerted, our impetuosity damped. As we knew it would be needless to oppose that

many-headed monster, the multitude, as it has been very well painted, we were obliged to lay aside our laudable undertaking in the cause of genius and the cause of modesty. [6]

This cheerful sense of being a part of 'the town' disappeared in the nineteenth century.

No lack of a cultural education prevented rural audiences from flocking to their vivid barnstorming theatres, and not even the fact that they could not read prevented many from enjoying the latest Fielding or the latest Smollett.

> 'The poorer sort of farmers, and even the poor country people in general, who before that period spent their evenings in relating stories of witches, ghosts, hobgoblins, etc., now shorten their winter nights by hearing readings. In their houses you may see *Tom Jones*, *Roderick Random*, and other entertaining books stuck up on their bacon racks.'[7]

It is easy to fall into a prelapsarian fantasy about the common joy in the eighteenth century arts – to forget the gruesome miseries of much rural life, and the rigours of the new factories – but there was, in that first age of common leisure, a sense of a shared culture which the nineteenth century was to destroy. There were few social wrappings in the presentation of the arts – *too* few in the opinion of those who deplored the noisy enthusiasm of the theatre pit, or the lack of social graces at country balls – and neither the lack of education nor the lack of breeding prevented quite extraordinarily large gatherings for the museums, waxworks, touring theatre companies, choral recitals, organ concerts, dances and public lectures that could be readily enjoyed in any small town.

The *instinct* of those arts entrepreneurs, whether motivated by vulgar greed or civic high-mindedness, was always to work on the largest possible scale. This instinct carried over into the early nineteenth century, as the great drift from the land into the new industrial towns and cities began in earnest. Civic provision, no less than commercial opportunity, was based upon the belief that most, if not all, of the citizens of a town would want to visit the play, the museum, the concert or the travelling sideshow. There was therefore, for a considerable part of the nineteenth

century, a certain amount of night life in our cities, and at fair or holiday times, in our small towns as well. Sideshows of curiosities would stay open, like the theatres, until well into the early morning. Beer would be on sale in the fairground as long as there were revellers, and travelling museums and art shows would be open for twenty hours a day, if there were potential customers about.

More important than that even was the fact that many facilities were built on the assumption that they would cater for huge crowds. The Pleasure Gardens could often take 15,000 – 20,000 people at the same time; the dance floor at the Cremorne could take 4,000 couples and a band of fifty. At the time of the 1843 *Theatres Act* the average size of the patent theatres was over 3,000. When a boy star called The Infant Roscius played in London in 1804, he played in *both* major theatres alternately, and huge crowds gathered at the entrances as early as one o'clock each day in the hope of getting in to see him; at the opening of the doors 'hundreds were in danger of suffocation from the mad endeavours of those behind them to force themselves forward. Although no places were unlet in the boxes, gentlemen paid box prices to have a chance of jumping over the fronts of the boxes into the pit; and then others, who could not find room for a leap of this sort, fought for standing places with those who had hired the boxes days or weeks before.' From fifty six performances the managers took nearly £35,000.

Audiences felt no less constrained in the early part of the nineteenth century than they had done in the previous one. When Kemble raised prices at Covent Garden, to help pay for the cost of its restoration after a major fire, the audiences took united action, shouting Kemble down on what was to have been its triumphant night of reopening – September 17th 1809 – with volleys of hooting, groaning, whistling, use of cat-calls, and repeated cries of 'Old Prices, Old Prices'. The rioters kept it up for three months, forced a trial of the issue in Westminster Hall, and eventually the management was forced to yield.

In other areas demand was great enough to force managers to keep enlarging their galleries or halls; Astley's, for example, the home of circus, was enlarged several times early in the century, until it held nearly 5,000. So great was the demand to see a mermaid 'caught somewhere north of China by a fisherman' in the summer of 1822 that it was taken away from its makeshift booth in the Strand and exhibited in the sumptuous coffee

house in Piccadilly, where more than 300 people a day, over a period of several weeks, paid to view it. So many people wanted to see and hear the presentations by the Royal Academy of Arts, which George III had founded in 1768 to encourage painting, sculpture and architecture, that it had frequently to enlarge its public facilities or to move; in 1836 it moved from Somerset House to the National Gallery, and in 1867 moved again, to Burlington House.

A remarkable fact about the teeming galleries, the crowded theatre pit and the thronged pleasure gardens was the virtual absence of any precise system of legal control over such gatherings. No licensing act stipulated how many people could gather in one place, or how many exits there should be, or what precautions should be taken about fire. Nor was there any managerial control system over the booking for concert halls or theatres; except for the subscription seasons, no general system of advance booking existed. Most gatherings at arts events were 'passing trade', which lent an additional precariousness to management. At Sadler's Wells theatre, for example, Charles Dickens was among those who at various performances had to stand up in a box and beg some members of the overcrowded auditorium to go home so the play might begin in reasonable comfort. In other places – at the annual summer exhibition of the Royal Academy in one case – voices began to be heard demanding some segregation of the teeming audiences. 'It is impossible that the pictures may be properly seen.'

This chimed with an important element in the mentality of the new elected councils of the major cities – a fear of the mob. This fear was understandably fuelled by the growing success of the Chartist movement in the early forties; the French revolution in 1848 further exacerbated official foreboding, and in that year the authorities in London feared mass revolution. A great demonstration had been called for April 10th on Kennington Common to show the power of the Chartists. Preparing to meet what they expected to be massive insurrection, the authorities swore in an extra hundred and seventy thousand special constables, distributed two thousand stands of arms to such official bastions as the General Post Office, Bank and Exchange, mounted the Tower guns, threw sand bags around every official building in London and waited for a civil war which, in the event, never started. Only about ten thousand Chartists arrived, and they were equalled in number by spectators and hangers-on, and,

cowed by the presence of some 5,000 troops assembled round the common, they held no rally.

The Anti-Corn Law Association, which grew with the Chartists but was separate from it, proceeded by less physical means. The centre of the movement was in Manchester, where, in 1840, the Free Trade Hall was built as a centre of operations on the field where the Peterloo Massacre had occured in 1819. Funds were raised in meetings there and in many theatres; a bazaar at the Theatre Royal, Manchester, in 1842 raised £25,000. So well organised and wealthy did the group become that in 1843 they took Drury Lane for twenty nights and Covent Garden later in the same year for fifty. The authorities were apprehensive about such mass agitation – particularly as it seemed increasingly successful – but had no power to intervene in properly convened public meetings, nor any way of regulating admission. The repeal of the Corn Laws, in 1846, seemed to some a disturbing demonstration of the new political power of the mob.

Such fears throw into vivid relief the success in terms of scale and general accessibility of the Great Exhibition of 1851. In many ways this was the zenith of large-scale popular provision. Housed in a vast glass and iron construction in Hyde Park, it attracted six and a half million visitors during its five and a half months. At its opening on May 1st the Queen stood amongst half a million people who had gathered for the ceremony:

'The tremendous cheers, the joy expressed in every face, the immensity of the building, the mixture of palms, flowers, trees, statues, fountains, the organ (with six hundred instruments and two hundred voices, which sounded like nothing) and my beloved husband, the author of this peace festival, which united the industry of all nations of the earth – all this was moving indeed, and it was and is a day to live for ever. God bless my dearest Albert!'

She stood unarmed, and open to the huge crowd, demonstrating immediately the accessibility of the Exhibition and its myriad displays to all visitors. Trust in the populace was rewarded; there were no serious incidents either on the 'five shilling days' or the 'one shilling days' which were in general suffocatingly crowded. None of the thirteen thousand exhibits was harmed.[8]

The £200,000 surplus on the Exhibition was put by Albert to the purchase of the South Kensington Estate on which the Victoria and Albert

Museum now stands. He had originally wanted there to be a national network of twelve such museums, but in the event funds limited it to one. In other respects however the general instincts towards provision on a large scale were sustained. In 1857, following the impetus given by the Exhibition's displays, the national Schools of Art were founded; in that first year there were 17, and the annual parliamentary grant was £6,850. In 1863, the number had risen to 90, the annual grant reduced to £4,005. The year after they flourished so well that the Privy Council accepted that they should be left to their own resources thereafter. In parallel, John Hullah established the National School of Music in St. Martin's Hall, and began to create a similar national network; in less than 20 years 25,000 people had passed through his system. In drama however there was no such school. Indeed the leaders of the theatre had begun to feel that their 'art' in some ways was lagging behind music and the visual arts in public recognition.

In general terms the great wave of civic development which followed – most particularly the nationwide effects of the *Education Act* of 1870, and the new responsibilities for work and leisure given to the new local authorities by the *Local Government Act* of 1888 (which set up County Councils) and the similarly named act of 1894 (setting up Urban and Rural District Councils) – were more restrictive, less open to the *vox populi*, more consciously aimed at order and improvement than the broad gestures Prince Albert made. In the provinces the new civic authorities built their museums, their reading rooms and, after the opening of the Albert Hall in 1871, their concert halls. In general however, they were not only smaller in conception but narrower in their purposes, and their appearance, generally gothic, with mean and forbidding entrances, contrasted with the brilliant openness of the Crystal Palace.

This was in part because a new definition of 'art' was separating itself out from its former general meaning of 'all those skills which give pleasure'. The new art was a consciously improving activity, to be indulged in only by the cultivated. Only by applying yourself to serious education could you now become 'artistic' in the new superior sense of that new word. And although the ordinary sense of the word 'artist' meaning 'skilful chap' did not altogether disappear from the language[9], the new sense of 'artist' meant 'apart from ordinary people; one endowed with special creative powers'. In the National and Board schools they did

23

not study the songs of the music hall, or the novels from Mudie's, or the vivid artists whose work decorated the new magazines. Instead they studied, joylessly and by rote, chunks of sanctimonious verse, improving prose and pious music designed to prepare coarse minds for a glimpse of the sublimity of great art. Above all else, the arts ceased to be fun, and entertainment ceased to be respectable. Symbolically enough, in the year of the education act, all school dramatics were banned at Eton.[10]

The dividing line between 'art' and common pleasures everywhere became sharper. In 1871 Lord George Sanger bought the old building at Astley's, but was quick to reassure everyone that it would now be used for an improving purpose and be an exhibition hall and gallery. He had begun to sense the hostility of the new civic authorities towards entertainment. In 1872, as if to back his instinct, the largest touring circus in the country, Wombwell's, was sold up. It was getting much harder for the showmen. Local authorities were seeing the traditional fairs and touring entertainments as distractions from the serious use of the leisure the shift system gave to their citizens, and were harrassing the touring folk. Indeed powers of abolition of the centuries-old rights to hold fairs were granted to the Secretary of State by the *Fairs Act 1871*. The act announced that fairs were 'unnecessary, and are the cause of grievous immorality and are very injurious to the inhabitants of the towns where the fairs are held.'[11] In 1874 showmen were prohibited from selling liquor without permission on their showgrounds and had to apply for occasional licenses before local magistrates. In the 1880s George Smith presented a series of bills to parliament designed to curb further the freedoms of travelling showmen (largely through a proposal to license their vans through municipal authorities). This was defeated, because of the campaigning of the newly-formed United Kingdom Showmen and Van Dwellers Association (later the Showmen's Guild). But, by forcing Sanger, Collins, Bostock and the other eminent showmen to band together in their own association, it deepened the divide. The new association had no links with the Theatrical Managers' Association, with whom, in other circumstances, they might have had much in common.

The leading actor managers were meanwhile determined to have the top echelons of the theatrical profession at least recognised as artists. In the 1870s the Bancrofts were busily turning their small theatre, the Prince of

Wales's, into 'the most exclusive' in London. They replaced the ground floor pit with stall seats, which were soon selling at 10 shillings each, carpeted the aisles, costumed their front of house staff handsomely and – instead of the old bill of several plays, which meant working folk could come in 'half price after nine o'clock' and still enjoy the show – they presented one play which began at seven thirty each evening. When in 1880 they moved into the Haymarket Theatre and once more got rid of the common pit, and replaced the area with stall seats, there was some commotion. The first night audience hooted Bancroft, but the outcry did not compare with the Old Price Riots. *The Theatre* on March 1st commented tellingly that 'Mr and Mrs Bancroft ought to be at the head of the first company of comedians in the country, and by that I mean a company acceptable to the public at large and not only to the upholders of a fashionable and fastidious exclusiveness.' In general however it was acknowledged that a 'fashionable and fastidious exclusiveness' was now a necessary wrapping for true refinement and, if the theatre wished to be considered an art, that was the only way to present it.

So the Bancrofts, and Hare and Kendall, and Irving at the Lyceum courted the rich and influential, and endlessly stressed the improving, educational qualities of the theatre. On the other side of the wall, in the Music Halls and in the burlesque theatres, the theatre was 'mere entertainment'. Crossing from one side to another was difficult. When the famous manager of *The Gaiety* had the notion of running the Victoria Tavern as a reformed Music Hall, he found that the idea could not go forward if he were associated with it. 'My connection with the Gaiety was not considered a good and safe qualification for me to take a leading part in carrying out my idea.' In the event the 'Old Vic' reopened under Emma Cons on December 27th 1880, as The Royal Victorian Coffee Music Hall, with prices ranging from 3d to £1.1s. The promotional circulars are still of great interest:

'Many persons have for some time desired, and in various ways endeavoured, to provide for the working and lower middle classes recreation such as the music hall affords, without the existing attendant moral and social disadvantages. It is believed this may best be effected by opening music halls in various parts of London, where the prices of admission shall be the same as at those now

open, and at which a purified entertainment shall be given, and no intoxicating drinks be sold.

It is not proposed to provide for a higher class of audience than that which at present frequents music halls but only to offer that class an entertainment which shall amuse without degrading them, and to which men may take their wives and children without shaming or harming them.

It has long been felt that the influence of the existing music halls is for the most part far from elevating or refining. General complaints have recently been made as to the impropriety of many songs now sung at these places, and the present Home Secretary, Mr Cross, has just addressed a circular letter on this subject to all the licensing magistrates.

The necessary music licenses, now refused in all cases by the magistrates to new applicants for ordinary music halls, will, there is every reason to believe, be readily granted to this Company for the purposes specified.'

We shall examine later in more detail the way in which the civic authorities sought to suppress music hall as they sought to keep down the showmen, but in such statements it is possible to catch a little of the authorities' fear of the Dionysian qualities of popular act, and their determination to castrate its vigour, and replace it with 'real' art which is of a character approved by the civic authorities. 'The great object of these attractive entertainments,' said Samuel Morley M.P. on a later visit to the Vic, 'is to win people from the public house. I am not a theatre-goer, but I did most heartily enjoy the real fun, absolutely divested of anything gross or immoral.'[12]

Of all the arts music suffered least from the nineteenth century 'divide'. Popular music still meant the 'Classical Monday Pops' where standard classics were played. The eighteenth century musical tradition flourished still in the form of large popular festivals. The Crystal Palace, now moved to Sydenham, housed huge Saturday symphony concerts and a triennial Handel Festival. Quite the biggest and best-run manifestation of the the amateur arts was the National Operatic and Dramatic Association, which brought together the major societies presenting operettas in their local theatres, and which was convened at the Grosvenor Hotel, Manchester on

February 15th 1898. From 1875 Gilbert and Sullivan's work was hugely successful in the professional music theatre; it was not at first suggested, as was later the case, that their popular operettas were by their nature mere 'entertainment' and intrinsically inferior.

Credit for the continuing popularity of all kinds of good music is generally given to Sir Henry Wood, whose most notable contribution to the musical calender was the inauguration in 1895 of the annual London Promenade Concerts, at which a catholic range of work is played, but to which admission is cheap, and the dress and behaviour of the audience informal. Other forms of popular music however flourished. In 1900 the first national brass band festival was held at Sydenham (after 1906 it became an annual event). Military and dance bands played in the civic parks (though not often on Sundays, whose sanctity was still stoutly defended) and on holiday bandstands; their repertoires covering the range of all that we should now call 'classic' to 'popular'. Orchestral concerts were usually thronged, particularly in the northern industrial cities of Manchester, Leeds and Liverpool. The last great evangelical movement in Britain, William Booth's Salvation Army, relied heavily from its 1878 inception upon rousing street bands and community singing to draw its congregations together.

One art form, ballet, had curiously fallen on the 'wrong' side of the divide at the end of the nineteenth century. From its comfortable position as an art for the discriminating, which it had held earlier in the century, it had now become a mere fill-in act in music hall and variety. In other spheres however the new technology had widened the divide. The coming of popular photograph had, in the view of many, given the lower income groups their own second-rate art. Paintings were now promoted pointedly as 'originals'. In 1871 Macmillan's Magazine observed condescendingly that 'the sixpenny photograph is doing more for the poor than all the philanthropists in the world'. G.M. Trevelyan comments:

'Its effect on art was of more doubtful benefit. Many thousands of painters had formerly lived on the demand for portraits of persons, for accurate delineations of events, scenes and buildings and for copies of famous pictures. Photography henceforth supplied all these. By reducing the importance of picture-painting as a trade, and surpassing it in realistic representation of detail, it drove the

painter to take refuge more and more in theory, and in a series of intellectualised experiments in art for art's sake.'[13]

The steam press, the national railway network and the lifting of the newspaper tax combined (simultaneously with the printing of much improving reading matter for the new schools) to give birth to a vast new popular press. 'The new journalism', as Arnold called it, grew in both London and the provinces during the last years of the century, supported by the Press Association, which from 1868 helped to supply copy quickly and nationally. Most of our existing popular newspapers were founded in these decades, The Sun in 1893, the Daily Mail in 1896, the Daily Express in 1900 and the Daily Mirror in 1903 (initially as a woman's newspaper). The largest-selling evening paper, the London Evening News was 'modernised' and restarted by Northcliffe in 1893.

The picture is sometimes painted of a philanthropic state bringing universal literacy, by means of the 1870 Education Act. Then the virgin tastes of the new reading classes were debased by scurrilous commercial publishers, with their crass popular newspapers, sensational magazines and cheap fiction. This cannot however be a wholly satisfactory account of what occurred. First, there was a vast market for sensational fiction earlier in the century – James Catriach's 'Last Dying Speech and Confession' of the Murderer of Maria Martin sold 1,166,000 copies in the 1830s – and that coexisted with the market for more sophisticated matter; Dickens sold 100,000 copies of each part of his novels. That market for good fiction did not disappear after 1870; it grew. More importantly, it will in any case hardly do to characterise the British as illiterate prior to 1870. As Raymond Williams points out,[14] it was an age in which reading was more commonly taught than writing. but even so in 1873 81.2% of men and 74.6% of women were able to sign the church register at their marriages.

It is indeed possible to take the view that some of the instincts behind the act were instincts for social control rather than for popular enlightenment. To quote Trevelyan once more, 'The new education was devised and inspected by city folk, intent on producing not peasants but clerks. Before Victoria died, the Daily Mail was being read on the village ale-bench and under the thatch of the cottage'.

Refinement and the new art were urban in source and character; they

walked, like the arty hero of Gilbert and Sullivan's Patience (1881), down London's Piccadilly, something apart from 'everyday young men'. Gilbert's yellow-paged hero is left in the unwordly realms of the higher art:

A pallid and thin young man
A haggard and lank young man
A greenery-yellery, Grosvenor Gallery
Foot-in-the-grave young man!

Conceive me if you can,
A crotchety, cracked young man,
An ultra-poetical, super aesthetical,
Out-of-the-way young man!

2.1 The Twentieth Century

By the earlier definition, the British public's involvement in the arts in the twentieth century has greatly increased. In their homes the British people read more, are involved in a far greater range of domestic craft skills and play many more sophisticated games. The radio and television mean that much more music is heard, more plays are seen and more interest is shown in a vast range of visual stimuli. Outside the home the range of activities in which people take part – amateur drama, community welfare, discos, theme parks, rallies, garden festivals, parades, fashion shows, pop festivals, carnivals, residential courses, skateboarding, pub jazz, street bonfires, sales, city marathons, village fetes, walking holidays, amateur choirs, residents' associations and working men's clubs, to name but a few – is enormously larger than the range of communal activities of any previous age. Whether by choice or not, less and less time is devoted to work. Of our free time remaining we choose to designate large segments of it to a range of actities many of which involve our active participation in some communal pursuit, and some of which are private and domestic pleasures. Comparatively little of our free time in Britain is however devoted to 'the arts' in the new late-nineteenth-century definition. A small minority of people – less than 5% of the population – is continuously involved with the arts in this new sense; for the majority, it would be true to say that their lives may be productive, rich, creative and

satisfying, but that they do not necessarily attain those states through any contact with the special kinds of constructs which we choose to term 'Art' at this time.

That special definition has perceptibly narrowed and further changed during our own century. Against each of the new media in turn Art has felt it necessary to build defensive barracades, and thus to occupy an ever-shrinking base. The cinema, for example, was seen by the Arts establishment as an untutored upstart. 'I don't wish it to be thought that I am disparaging the cinema as a profession,' wrote the West End actor Fred Kerr in 1930, 'People take up a profession to make money, and I know of no profession in which they can make more; therefore, it is a good profession. But if only we could be spared the ravings of the press about its artistry!' In similar fashion, radio was disparaged as mass art,[15] and thus inferior. The B.B.C. indeed in its early years accepted the view that real art was 'out there' and could not be conveyed in its essence by mass means; its plays were presented with overtures and even the swish of a curtain rising, its music presented as if it were being played in a 'proper' concert hall; in both cases the microphone adopted the servile posture of being a humble intruder at a 'real' art event. In its turn television too was, and is, considered to be, by its mass appeal, intrinsically inferior, of a nature that could not be Art and could not convey more than a shadow of Art's true refining nature.

The efforts to spread 'the Arts' to which we usually pay attention are therefore those earnest, small-scale agencies with impeccable middle class roots which offer, it must be said, little chance of confronting, still less converting, the majority of Britishers. At the outbreak of the first world war there were in London alone 300 cinemas, but a serious history of the development of 'the Arts' in war time would not point to their influence, but rather to those few earnest troupes that gave improving entertainments to soldiers and factory workers on small War Office grants.[16] Between the wars, the significance is not usually ascribed to the cinema chains, or to the growth of the radio system, or even the marketing and huge sale of cheap paperback books, but to those 'brave pioneers' of Eleanor Elder's Arts League of Service, with their nineteen years of one-night stands, or to the middle class conclaves that 'kept alive' Britain's arts festivals, or who ran the Ministry of Labour's Social Service Clubs for the unemployed, putting on one-act plays of 'good quality'.[17] These

worthy activities were like the growing concert circuit or the forty-odd good commercial repertory companies which thrived in Britain, not seen as supplementary to the B.B.C. music programmes, the Penguin book or the cinema epic, but somehow fighting against them. Any possible influence for good the new media had was likewise denied by the state education system, which tended to frown upon visiting the cinema and promoted drama as something read and analysed in school desks, tended to prohibit visits to dance halls and jazz concerts and instead taught a sanitised mulch of school songs, hymns and safe bits of the 'classics' as our musical heritage. Schools instinctively reacted against the contemporary and the mass-produced; paperback books were supposed, by their nature, to destroy your proper reading habits as ball point pens were later held to harm 'proper' writing. The greatest goal of the state education system was to draw one or two high flyers from the common culture and to set them within the world of the metropolitan arts; popular literature from Wells to Winifred Holtby to Emilyn Williams wryly describes that kind of triumphal ascent.

It may not nowadays be necessary to insist upon the fact that in the first half of the twentieth century the metropolitan Arts establishment did not in fact have a wholly superior civilisation, did not have in 'the Arts' the sole elixir of all refinement and taste. Sufficient time has elapsed for us to be able to see the brittleness of some of the 'best' books, musical pieces and paintings adored by the artistic elite of the twenties and thirties, and the more substantial value of some of the work in film, on radio or in popular fiction. Sufficient time too has elapsed for us to gauge the class contempt with which some of the war for the 'best things' in Art was waged. Of his Cambridge associates Lord Keynes, for example, wrote, 'we enjoyed supreme self-confidence, superiority and contempt towards all the rest of the unconverted world.' When D.H. Lawrence, the miner's son, visited the Cambridge/Bloomsbury group, Keynes observed, 'It overwhelmed, attracted and repulsed him – which was the other emotional disturbance. It was obviously a civilisation, and not less obviously uncomfortable and unattainable for him – very repulsive and very attractive.' Yet, as the critic Dr Leavis observes of Lawrence:

'He had been formed in a working-class culture, in which intellectual interests were bound up with the social life of home and

31

chapel, and never out of touch with the daily business of ensuring the supply of the daily bread. . . . Nothing could be more ludicrously wide of the mark than the assumption that Lawrence must have felt inferior and ill-educated when introduced in Russell's rooms to the dazzling civilisation in Cambridge.'[18]

The high 'Arts' as professed by Keynes' circle, by the Bloomsbury Group, and by other pockets within the metropolitan establishment, were in some senses not merely hostile to the processes of the mass media and or hostile to the common culture of which the cinema, popular journalism and the radio were new tributaries, but hostile to the common people. The contempt the Apolostles felt towards the 'unconverted world' of common humanity has surfaced repeatedly in the pronouncements of the Art experts of the post-war world, and has coloured and distorted the efforts of those people who have tried to work within the British arts subsidy structure to create a more equable and open system of arts markets. The converted world of the post-war Arts establishment has meanwhile continued to preserve its territory by surrounding the presentation of the Arts with inpentetrable layers of protective social sophistication, so that, although it has always been correct form to proclaim a desire to increase Arts audiences, the actions of architects, designers, promoters, producers, subsidy officers, copywriters and publicists have shown that there is nevertheless a deepseated desire to remain an exclusive club for the converted. We have progressively built our Arts auditoria smaller, surrounded the Arts with exclusive language codes, made booking ever more complex, and written about our work, in advertising copy and even programmes for 'the young', in a form of English that requires, to be fully understood, a reading age possessed only by ten per cent of the population.

Above all, we have cocooned the Arts in a protective layer of specialised social rituals with which only the converted can feel comfortable, rituals which are an 'essential' part of the Arts world, and which are designed to give pleasure in part because they are exclusive and because they bestow upon participants a sense of communion with the converted. Thus ordinary folk read books; members of the Arts world go to signings, publishers' parties, book launches and literary luncheons. Ordinary folk enjoy taking photographs and looking at pictures; the Arts world has

private views, studio parties, visits to private collections, limited print editions sales. The mass of people[19] enjoy a good play; the 'World of the Theatre' is however seen at first nights and in green room gatherings, or gossip-swapping in West End watering holes. That divide is loudly deplored of course by the very people who strive by their actions to perpetuate it, and those people are more usually the Arts bureaucrats than the artists, few of whom seem to relish the milieu in which their work is presented in contemporary Britain. Indeed in the greater art of the twentieth century – in the writing of Lawrence or of Eliot, the operas devised by Tippet or Britten, the work of Hockney and Bacon, the poetry of Auden and Larkin, the films of Lean and Frears, the music of Dankworth or Lloyd Webber, the comedy of Hancock and Wilton – one can discern a desire to break free of such restraints, and to speak to unconverted and converted alike, to pull the arts out from their protective social wrappings and restore them to common stock.

Footnotes

1. Bertrand Russell, In Praise of Idleness. (Unwin, 1935)
2. For a fuller account of 'Having and Enjoying' in that century, see Roy Porter, English Society in the Eighteenth Century. (Pelican, 1982)
3. Johnson's milieu is definitively described in Plumb, England in the Eighteenth Century. (Pelican, 1950)
4. Daniel Nalbach, The King's Theatre 1704–1867. (Society for Theatre Research, 1972)
5. Typically enough, with insufficient funds. A public lottery had to be laboriously organised to pay for the remainder.
6. James Boswell, Diary (London, 1763)
7. James Lackington, 1792. Quoted by Porter.
8. Asa Briggs, 'The Crystal Palace and the Men of 1851' in Victorian People. (Pelican, 1965). See also David Thomson 'The Forces of Change' in England in the Nineteenth Century (Penguin, 1971)
9. See Partidge, Historical Slang (Penguin, 1982)
10. A full account of earlier dramatics organised by the boys at Eton is in W.G. Elliot, Amateur Clubs and Actors (Arnold, 1898)
11. Duncan Dallas, The Travelling People (Macmillan, 1971)
12. John Booth, The Old Vic (Strad, 1917)
13. G.M. Trevelyan, English Social History 4. (Pelican, 1964)
14. Raymond Williams, 'The Growth of the Reading Public' in Melnik and Merritt (Eds.), Reading. (Open University, 1972)

15. The Theatrical Managers Association banned radio broadcasts from their theatres, and, for disobeying the instruction, C.B. Cochran was for some time denied membership. A fuller account is in my own West End: Mismanagement and Snobbery. (Offord, 1983)
16. There was a considerable 'troop entertainment' movement in the first world war. Ellaline Terriss describes how she and her husband Seymour Hicks were partly funded by the War Office, partly by a friend from the Daily Telegraph, and backed by Kitchener and French before their Christmas 1914 visit to France. E. Terriss, By Herself (Cassell, 1928). By the end of the war there were 25 troupes from the Actesses' Franchise League giving approximately 1,400 performances a month in France, Malta, Egypt and Palestine. The full story of other parts of that movement, and the Garrison Theatres, has not yet been told.
17. George Makin, 'Drama Among the Unemployed' in P. Carleton, The Amateur Stage (Bles, 1939)
18. F.R. Leavis, 'Keynes, Lawrence and Cambridge', in The Common Pursuit (Peregrine, 1962)
19. As Raymond Williams reminds us, 'mass' is only a new word for 'mob'.

CHAPTER 3

THE ESTABLISHMENT OF THE ARTS COUNCIL

'Business men are fond of saying that they have no use for elaborate organisations, but go on the principle of giving a man his job, leaving him alone and judging him by results. In the public services, which in the main operate on a much larger scale than most businesses, we cannot proceed on that simple plan any more than an army could operate without a cadre of commissioned and non-commissioned officers. There must be co-ordinated action. This, however, raises the question whether, when once the co-ordinating organisation is set up, there is not a tendency to use it for other and less desirable purposes.'

Sir Henry Bunbury, Public Administration *1928*

The Arts Council of Great Britain was not established as the result of any popular will, nor as a result of pressure from any particular political party. It did not in any sense 'replace' patronage from earlier ages – indeed the realms in which it was able to make some impact in its first years were generally arts activities which had previously been wholly commercial, or promoted, like opera, by commercial syndicates. Nor did it represent the beginning of government subvention in the arts in Britain. Since 1753, as we have seen, the government had owned art collections, and throughout the nineteenth century had given increasing support to the visual arts in particular, while local authorities had supported musical festivals and public concerts in some cases for more than two hundred years. The city Fathers themselves built and supported museums, galleries, libraries and concert halls in great profusion towards the end of Victoria's reign, and so, well before the second world war, at both local and national level, there were the twin traditions; of *direct* government control, and of *indirect* control (by which government gave monies to be administered 'at arm's length' from the politicians).

The national government's direct control was largely in the visual arts. Here the national galleries were funded direct from government and their staff were in effect civil servants. Before the second world war the prime example of indirect control, by which public monies were administered at 'arm's length', was to be found in the new mass media. As early as 1916 the War Office had passed government grant-in-aid to the Cinematograph Board for the production of films, but had yielded all artistic choice and control to the independent Board members. (The process by which the film industry avoided direct legal, as well as direct financial, government control is illuminating; they set up their own British Board of Film Censors, and thus controlled the content of films from *within* the film industry – whereas the theatre had to wait more than half a century to free itself of government censorship). Indirect control existed too in the B.B.C. When the new corporation was formed out of the old private company in 1926, the government ceded direct control of programme content to the independent Board of B.B.C. governors. This also created a modest degree of independent government support for the arts, and music in particular – as the new Corporation ran an orchestra, choral group, bands and commissioned singers – for musicians were working on money from government but without direct government control.

The B.B.C. remained throughout the second world war the largest single instrument by which the arts were made accessible to the British public. Indeed, until the early fifties, listening figures for broadcast music, plays, talks and light entertainment remained prodigiously high. If there was expectation that post war Britain would have a homogeneous culture of high quality, then the evidence might more reasonably have been taken from B.B.C. listening figures – it was not uncommon for a third of the entire adult population to listen to a Saturday night play, or a midweek concert – than from the enthusiasm of much smaller audiences for live performances. It might also be thought that the B.B.C's rôle in supporting British artists by taking them on to its staff and commissioning work is the single most significant element in the forties of state support for the arts – an achievement on a far greater scale than the post war Arts Council could conceivably have attempted.[1]

However, concurrent with the B.B.C.'s wartime work, a number of other organisations were set up during the second world war for the promotion of the arts. Largest amongst them was ENSA, the Entertain-

ment National Service Association, which took over Drury Lane theatre as its headquarters and proceeded from there to run an entertainment and performing arts programme on a larger scale than anybody has since attempted in Britain. Its director, Basil Dean, had run the Garrison Theatres during the first world war, and long experience as an impressario and theatre producer equipped him for a job which, in the circumstances, was inevitably chaotic and stressful. By the end of 1944 ENSA had voluntarily mobilised much of the entertainment industry; it had nearly 4,000 artists under contract, sending them out all over the world in revues, variety, concerts and straight plays to entertain the war workers and the armed forces. ENSA cost £14,000,000 to run, played to more than 500,000,000 people and during the war four out of five professional performers had worked for it at some time. It was run, somewhat too dictatorially in the view of his detractors, by Basil Dean himself, and although the money came directly from government through the armed services vote, control remained with Dean and his committees.

There was considerable competition for ENSA. In Southern Command Charles Smith, director of the Brighton Theatre Royal, ran MESA, Mobile Entertainments for the Southern Area, which every day except Sunday sent out two plays, two concert parties and a film show. By 1941 the resentment within some parts of the services over Dean's dictatorial powers had reached such a pitch that they enthusiastically supported a major new army concert party, *Stars in Battledress*, run by Basil Brown, which started life in October 1941. The R.A.F. meanwhile supported the *RAF Gang Show*, directed by a former dancer, Ralph Reader.

Rough though many of the stages were, and however limited the technical facilities, it would not be fair to say that the shows which went out under these banners were all – as they have been later described – rough cuts from the mouldy end of the entertainment business. The stars touring in the plays and concerts sent out by ENSA were impressive enough – John Gielgud, James Mason, Vivien Leigh, Michael Wilding, Gracie Fields, Jack Buchanan, Elizabeth Welch, Henry Hall, Adrian Boult, Eva Turner, Robert Donat – and some tours (those undertaken by Noël Coward, for example) have passed into legend. It was however all fatally *entertaining*, presented without that conscious desire to elevate and improve which, in the upper cavities of the British mind, had become the hallmark of true art. ENSA, MESA and all the rest were inevitably seen

by elements of the metropolitan cultural establishment as merely providing, in Sir Kenneth Clark's words, 'the kind of entertainment that is supposed to be more suitable in a national emergency.'

So agencies more attuned to the promotion of 'art' were set up. Prominent among them was the Army Bureau of Current Affairs Play Unit. This had its genesis in the weeks after Dunkirk, when Sir Ronald Forbes Adam, seeking ways to counter the lowering of morale in the army, hit upon the notion of promoting weekly open discussions in which the men would talk about the values of the civilisation for which they were fighting, argue about current affairs and hold discussions on moral and ethical questions. Forbes Adam asked W.E. Williams, a distinguished pre-war figure in the British Adult Education world, to be the civilian head of the new unit.

Williams in turn decided that it would be more stimulating if issues could be dramatised, and so he approached two well-known actors, Stephen Murray and Michael MacOwan, both in the army, to run an ABCA play unit. They used the tchnique of the living newspaper, a documentary drama technique that had been developed by the Federal Theatre in the U.S., and which had been used in pre-war Britain by the Alternative Director Joan Littlewood, to present short stark dramatisations of contemporary issues. None lasted more than forty minutes. All were followed by discussions. Again, although the unit was generously funded by officialdom, and might have been thought to be dangerous, with its manifest desire to educate, stimulate and improve rather than 'merely' to entertain, Williams and his actors and teachers were given a free rein.

Of more ultimate significance than any of these units was a small London-based organisation termed the Committee (later the Council) for the Encouragement of Music and the Arts, CEMA. This was first formed on a £25,000 grant from the American-based Pilgrim Trust, as a small gesture of cousinly consolation for the hardships we were enduring. It was set up,

1. To provide opportunities for hearing good music and for enjoyment of the arts generally among people who, on account of wartime conditions, are cut off from these things.

2. To encourage music-making and play-acting among the people themselves.

There are several interesting circumstances attending that first innocuous-seeming statement. First was that government had matched the American money, and London officialdom had a hand in drafting the objectives. Second was the assumption, clear enough in the first aim, that the B.B.C., ENSA and the rest were *not* providing 'the arts' as the new organisation understood them. Third was the unequivocal statement that the new organisation existed as much to help amateur work as professional performances of music and drama. Underlying all of these things was the hidden assumption that the new organisation was really to be concerned with the civilian population, rather than with the armed forces.

For a year and more CEMA did indeed promote amateur work. It advertised its existence in the newspapers and gave out – unseen and without any 'assessment' of its clients – dozens of small grants to choral societies, lecture groups, amateur dramatic societies, play-reading groups and the like to enable them to buy books, music stands, a few lanterns for performance. It also, quite early, began to promote musical and dramatic performances at small venues for those cut off from those things. Then, abruptly, the organisation changed tack and decided to concentrate entirely upon professional performances. After fifteen months or so it stood for the embodiment of the late Victorian notion of 'art' – small-scale, professional performances of classical pieces were presented to small, predominately urban, audiences; everything CEMA supported, or directly promoted, was 'Art', improving, refined, in conscious opposition to the broad populist vulgaries of ENSA.

Even in wartime the tensions involved in promoting according to the different British notions of 'art' became apparent; between the desire to raise standards in artistic presentation and to spread its improving and beneficial effects there lie great conflicting pressures. This was evident in the wartime touring of the Sadler's Wells company, which began with a small guarantee against loss from CEMA in 1940. A small cast and an orchestra of four took to the road, aiming to play in the small industrial towns which Eleanor Elder's Arts League of Service Company had worked in so extensively between the wars.[2] Before the year had ended the company had grown to 35 and the orchestra to 14 – 'Pitifully few' in comparison with the numbers engaged before the war, said Joan Cross[3] – adding with wonderment that several singers were giving 'an average of

five performances a week!', the kind of sacrifice undreamt of in peacetime, apparently. At the end of 1941, now touring a permanent set, the orchestra had increased to 24. The company was able then to play a London season, which finally restored their artistic credibility. During 1943 and 1944 it became the largest touring theatrical organisation in Great Britain, with three 50-foot trucks transporting their scenery, and more than a hundred travelling personnel. Of course, 'standards' were now so high, it became 'necessary to omit the smaller towns from our tours, since they could no longer house us.' As was to happen so often in post-war Britain, resources were applied to raising technical standards and this narrowed. not spread, the accessibility of the work.

CEMA from its earliest days adopted a stance which, like so much else, passed into the traditions and language of the post-war Arts Council – the habit of pretending that everything it did was pioneer work. If a play tour went well, it was bringing light where there had hitherto been only darkness – nobody in CEMA's audiences had ever gone to the pre-war theatre, listened to plays on the B.B.C. or seen any of the massively successful productions sent out by ENSA. Well-received lunchtime concerts in blitzed London were talked about as if they were the only good music heard by their audiences for years. Applauded concerts given in factories showed the unprivileged had, deep down, an instinctive love of great music – rather than demonstrating the effect the B.B.C. and local authority music promotions had been having on musical taste for some years.

People began to speak as if the British, for centuries theatregoers, music-makers, lovers of good stories, were experiencing plays and music for the very first time, and it was all a result of the financial aid the government was giving to CEMA (The Pilgrim Trust had now withdrawn), aid which in size was a twentieth, *five per cent*, of the government aid given to ENSA. Tyrone Guthrie wrote:

'CEMA has been set up under the aegis of the Board of Education (N.B.) and financed by the Treasury. It has power to offer such managements as it sees fit, both status and financial aid. As yet the status is a little vague, and the aid is no more than a limited guarantee against loss. Nevertheless, the principle of State patronage of the Theatre is established and the practice is working well.

Brittania, waging her most desperate war, has decided that the pen, the harp and the buskin must be added to shield and trident.'

The serious journalism took up the theme; ordinary Englishmen had never previously attended the play, listened to a choir or attended to their poets. It was as if the popular novelists, from Fielding to Dickens, had never existed, as if the country had never had its hundreds of large and small music festivals, as if there had been no great popular theatre. Until CEMA all was darkness. 'It was a moving experience', declared one of CEMA's in-house assessments, 'to observe hundreds of factory workers rapt before the magic of Beethoven enjoying the music as if they had been going to concerts all their lives.' 'She is a legend now in the mining valleys of Wales,' wrote J.C. Trewin of Sybil Thorndyke, 'they had been starved of the living theatre, and Sybil Thorndyke brought life to them.'[4]

This kind of grotesque overstatement, by which an actress brings not just a powerful performance but life itself (*life* to a Welsh miner! – now there's patronage for you) was, at best, a kind of amiable self-delusion by the stranded cultural sahibs of West One about the importance of their work. At worst, it might be seen as an exaggeration intended to expatiate the guilt of tending a private garden in the midst of a public battle. Of *course* there were good things done, and certainly there were times when CEMA promoted work of a fine and bracing excellence – but it was the desire to be totally separate from the vulgarians which is galling, and the desire, which grew with the years, to gather into the CEMA cotarie all powers of judgement, all of the higher enlightenment and all benediction all at once. In Guthrie's telling phrase, CEMA offered *money and a particular kind of status*. The power to award status bestows an unearned critical authority upon the body making the award. CEMA was not just an agency for promotion of 'the arts'; it had become a special kind of cultural tool. That process which has sustained and finally flawed our Arts Council had already begun; CEMA and its followers were moving into a position of social control on 'the Arts' while they narrowed and revalued the term.

The process was recognised plainly enough by the London establishment. On January 2nd 1943, W.E. Williams wrote from ABCA a lengthy article for *Picture Post* entitled 'Are We Building a New Culture?' It did not mention ENSA or the B.B.C., but it mentioned the successes of

ABCA and took up the well-worn theme of CEMA bringing 'the arts' into a hitherto witless and dormant population. CEMA had developed 'new audiences', and had instigated 'a wide and catholic foretaste for the arts,' by its small-scale presentations. He looked to the post-war Britain, in which the foretaste for the Arts stimulated by the small CEMA organisation would apparently be taken up and made bricks and mortar by the enlightened new civic authorities:

> 'It must institutionalise itself in the best sense, it must recognise that bricks and mortar, canteens and coalfires are reasonable amenities for people who want to discuss current affairs or unravel the mysteries of music and painting. Instead of our present dispersal of the Public Library down one street, the art gallery (if any) down another, the Workingmen's Club somewhere else and so on, let us plan the Civic Centres where men and women may satisfy the whole range of educational and cultural interests between keeping fit and popular argument. Let us so unify our popular culture that in every considerable town we have a centre where people may listen to good music, may look at paintings, may study any subject under the sun, join in a debate, enjoy a game of badminton – and get a mug of beer or cocoa before they go home.'

It is a curiously unappealing notion, not least because of the matey way the various improving activities are extolled as being 'our popular culture,' when they are in fact a narrowly representative programme of a specialised Adult Education Centre. The *scale* of the vision means it can only be intended for a minority seeking self-improvement; his 'reasonable amenities', with their depressing cup of good-night cocoa warming by the door, are there only for the five per cent of class attenders that such premises choose to attract. This is a dry schoolmasterly redefinition of our popular culture, which, by another definition, T.S. Eliot said:

> 'includes all the characteristic activities and interests of a people; Derby Day, Henley Regatta, Cowes, the twelfth of August, a cup final, the dog races. . . . boiled cabbage cut into sections, beetroot in vinegar, nineteenth century Gothic churches and the music of Elgar.'[5]

Includes in a word the characteristic activities they are inward with, that

they know and own as a part of their common life, and draw day to day pleasure and benefit from. By *this* definition 'the arts' are not simply a superior culture owned by a highly educated class and whose 'mysteries' have to be unravelled, but, in greater or lesser degree, include all the creative and pleasurable activities in which we develop knowledge and skills. Williams' vision is thus radically different from one offered twenty years afterwards by Joan Littlewood, here writing (with an unwitting prescience) of an imagined fun palace of the future:

'Politicians and educators, talking about increased leisure, mostly assume that people are so numb or servile that the hours in which they earn money need be made little more than hygienically bearable, while a new awareness is cultivated during the hours of leisure. This is to underestimate the future.

In London we are going to create a university of the streets. It will be a laboratory of pleasure, providing room for many kinds of action.

But the essence of the place will be its informality; nothing is obligatory, anything goes. There will be no permanent structures. Nothing is to last for more than ten years, some things not even ten days: no concrete stadia, stained and cracking; no legacy of noble contemporary architecture; no municipal geranium beds or fixed teak benches.'[6]

Williams' preachy earnestness seems, like his belief in others' improvement, to set him apart from the fastidious Kenneth Clark, the youthful Director of the National Gallery. Clark, like Williams, helped to create the climate in which the postwar Arts Council of Great Britain was formed. Like Williams too he was an entrepreneur and a teacher – but from apparently quite different motives. Afternoons enjoying the visual arts,

'confirmed my belief that nothing could destroy me as long as I could enjoy works of art, and for 'enjoy' read 'enjoy'; not codify or classify, or purge my spirit or arouse my social consciousness, just enjoy. From this hedonist, or at best epicurean, position I have never departed. It is true that I have tried to communicate my pleasure to other people, but that is not because I feel it is my duty to do so, but simply because I cannot contain myself.'[7]

Unlike Williams, he was an indifferent politician, finding meetings at the Arts Council 'negative and despondent' in character. He never deviated from the 'old fashioned point of view' that the aim of state patronage was not to make artistic activity a kind of public placebo, as in State-supported public mural schemes, but 'to produce good works of art'. Williams wanted it both ways, insisting, like his successors, when he became Secretary-General of the Arts Council that its function was to raise *and* spread.

Neither doubted however that 'the Arts' were the preserve of the Highly Discriminating, who understood them through educated eyes, and whose duty was by all means to preserve them, although a secondary duty was to aid others towards comprehending their sublimity. Neither did either doubt that the maintenance of a salon of the Knowledgable and Discriminating somehow brought lustre upon the whole British culture. As the end of the war approached they, and the senior economist who was now fronting CEMA, Lord Keynes, lectured, broadcast and wrote about a post-war organisation that would do in peacetime what CEMA claimed to have done in the war, bring 'the Arts' of Britain for the first time before most British people. And the decision was taken, though untested on public opinion, that the correct way to do this was by continuing CEMA into peacetime. The other funded organisations either ceased operations at the war's end, or reorganised themselves in civvy street as commercial shows.[8] ENSA was brutally cut off, and disbanded totally. It was the only wartime organisation of national standing not to be given a place in the Victory Parade. Questions were asked in parliament about Dean receiving, after five years' gruelling work, only a CBE.[9]

CEMA however had already organised itself as the head of a fragile, but highly influential, bureaucracy, which could gather together the skeins of high art organisation in peacetime. It had already organised advisory panels to give weight to its judgements. Outside London it had placed regional officers – who were eventually replaced by the RAAs – in each of the defence zones the government had set up of a size which enabled civil defence to organise itself against enemy bombing. More important than either, it had established as an axiom (there is some doubt about whether the law demands it must have been so) that only registered Limited Companies with Charitable Aims (that is, non-profit-making organisations with educational purposes) could receive CEMA grants in aid.[10]

In every organisational sense CEMA was the opposite of ENSA. ENSA dealt wholly with commercial organisations (nobody ever suggested that its theatre companies should constitute themselves as charities, although their work was often markedly similar to that aided by CEMA). ENSA was run by professional music and theatre people and run by an overall director; CEMA was run by panels and had a secretary-general who carried out their general wishes. Most basic, ENSA had no pretentions other than offering entertainment *en masse*; CEMA was by its avowed aim and its professed legal constraints there as a charitable/educational service to a minority. In only one respect were they similar – both were involved on their different scales in direct promotion. (However CEMA and, later, the Arts Council always entered this field with a show of reluctance).

The curiosity then, as now, is that neither the public nor the artistes cared very much about the nature of the bureaucratic structure which brought them together. A very large number of good singers, musicians, actors and dancers worked for both organisations. In similar fashion their two audiences overlapped, as did the broadcasting publics for serious music, news commentaries and Tommy Handley. Only political minds saw the differences as crucial.

3.1 Fabianism at the Arts Council

The Arts Council came gently into this world on 12th June 1945, when the Chancellor, Sir John Anderson, replied to a planted question in parliament that the organisation was to be formed from CEMA. The news was received with mild interest and there was no very strong opposition. CEMA's Mary Glasgow became the first Arts Council Secretary-General – and the last woman to hold the office. Lord Keynes was the first chairman, albeit only briefly as he died shortly afterwards, and the first Council included a roster of worthy establishment figures:

THE FIRST POST-WAR ARTS COUNCIL MEMBERS

Lord Keynes (Chairman)
Ivor Brown
Lord Esher
Sir Stanley Marchant

Managing the Arts?

Dr. B. Ifor Evans
Sir Kenneth Clark
Mr John Maud
Dr. R. Vaughan Williams
Lord Harlech
Dr. O.H. Mavor

Secretary-General: Mary Glasgow

From the first the Council began to exhibit two traits which it would, like much else, carry down the decades. It desired to keep small. ('We worked in a low key' said Sir Kenneth Clark, who also gave it as his opinion that if the post-war Arts Council had been given twice the money it was it would have wasted it). Within its own small world it soon attached great symbolic importance to the occupancy of various positions with its organisation, and fell into internecine strife. Keynes' successor, Sir Ernest Pooley, for reasons which have never been revealed, set himself to get rid of the Secretary-General. Sir Kenneth Clark again:

> 'I was lucky to be away at the time . . . How it was achieved I never asked; it must have been a painful process, as the Arts Council was her whole life and, although sometimes a little governessy, she seemed to carry out her duties in an exemplary manner. She was succeeded by W.E. Williams.'

From Williams's arrival the Council at once assumed a slightly more interventionist stance. In its very earliest years it assumed that the arts were 'out there', and that, in the Keynsian tradition, the Council existed to make sure that the very best survived. 'He was not the man,' said Clark of Keynes, 'for wandering minstrels and amateur theatricals. In four years he transformed CEMA, the social service, into a universal provider of the arts known by the title, which I am said to have invented, of the Arts Council.' Williams was also firmly committed to the maintenance of 'the best', but drew into the threads of Arts Council language the notion that maintenance of 'the best' improves the whole:

> 'The Arts Council believes, then, that the first claim upon its attention and assistance is that of maintaining in London and the larger cities effective power houses of opera, music and drama; for

unless those quality institutions can be maintained the arts are bound to decline into mediocrity.'[11]

We begin to see in such considered statements the first evidence of a continuing process; the persuasive redefining of what is referred to as 'the Arts' so that not only does the term begin to exclude more and more – does novel-writing or poetry decline into mediocrity if a few urban *institutions* are not maintained? – but it is set within phrases so formed that they are either meaningless or self-evidently true. Thus if I protest that the statement is not true of all the arts, which the last sentence implies were under discussion, I shall be told I am missing the point, which is that obviously subsidised music, opera and drama is what is being discussed. If I offer the view that some forms of music are of high value even though no central institution exists to promote them I shall be told I am being perverse and am mistaken. The Arts Council apportions value, so the axioms they offer about centralised power houses are caused, by the values put on institutions by that same Council, to be true.

The earliest power house of the Council's was the Covent Garden Opera House. The first step towards its new post-war life was taken by Sir Kenneth Clark:

> 'During the war the Covent Garden Opera House had been occupied by Mecca Cafes. But after the war it evidently ceased to make money, and the lease was taken over by Messrs. Boosey and Hawkes. They asked for an interview with the Arts Council. Keynes was away and I, as vice-chairman, received the deputation. Mr Boosey explained what they had done, and suggested that the Arts Council might be willing to put on a short season of opera, say in August. As with Myra Hess and the National Gallery concerts, I said, 'No: we will take on Covent Garden altogether, giving your firm full representation on the Board.' I had long dreamed of seeing Covent Garden established as a national opera, and the moment had come.'[12]

He wired Keynes and got his assent, although on this occasion the economist was studiedly vague about the likely cost, and the project went ahead. Following Keynes's death, the former Chancellor Sir John Anderson followed him into the Chair at Covent Garden as Pooley

followed him at the Arts Council. 'His official duties had allowed him no time for music,' mused Clark, 'but his wife saw the Chairman's box at Covent Garden was a social asset and persuaded him to accept.'

Before taking office, Anderson faced an immediate difficulty. The new Socialist Chancellor in the Attlee government, Hugh Dalton, had withdrawn the concession by which surtax payers had been able to set off covenanted donations to charitable institutions against tax. Private donations to the embryo state opera house were as a result much less likely to be forthcoming. It had to be the state therefore. Anderson at once sought an undertaking from Dalton that would bind the government to supporting the Arts Council provided that they did not renege upon *their* obligations to their major power house, the Covent Garden Opera. This was the letter Dalton wrote:

Treasury Chambers,
SW1.

1st August 1946

Dear Anderson,

This is in reply to your letter of 26th July, in which you ask me to review my attitutde to the Covent Garden Trust as expressed in my letter to Pooley of the 15th July.

The assistance which the Covent Garden Trust receives from the Exchequer will, of course, come to it through the Arts Council. You will understand that in general I would wish the Council to feel themselves responsible for the allocation of funds which Parliament puts at their disposal, and to plan their work ahead in the expectation of an assured but limited grant.

I recognize however that the magnitude of the Covent Garden undertaking and the difficulty in present circumstances of estimating its future needs places it in a special position, and that the State will be assuming a definite obligation to see to it that, subject to others playing their part, Opera is not let down. I do not therefore rule out the possibility that the fulfilment of this obligation might in certain circumstances make it necessary to increase the Treasury

grant to the Arts Council still further than I undertook in my letter of 15th July. It would, I think, be agreed that these circumstances would not be held to have arisen unless in any year the Trust could show a need for a grant from the Arts Council of an amount exceeding £60,000.

I am sending a copy of this letter to Pooley.

(Sgd.) Hugh Dalton.

The Rt. Hon. Sir John Anderson G.C.B., G.C.S.T.,

The notion that about a quarter of the Arts Council's grant (in that first full year, £255,000) should go to 'National' concerns has been maintained, although there are now four national companies.[13] The Covent Garden Opera, which became the Royal Opera House and a non-profit-making limited liability company in 1950, has remained the Council's major beneficiary. Opera has not been let down.

By its size, and by its nature, the national Opera House is of course an exclusive *institution*. At its post-war reopening Randolph Churchill reflected the establishment desire for it to become once more the home of high fashion and cultivated style:

'In my grandmother's Edwardian days the Opera House admittedly presented as brilliant a spectacle as could be found in Europe – two tiers of boxes running all round it, replete with beauty and fashion. The women wore tiaras; the men white kid gloves.

Then change and decay set in. Milton tells us how best things get perverted 'to worse abuse, or to their meanest use', but no doubt the quotation is too severe, for Covent Garden never became anything worse than a *Palais de Danse*. Still, it was a come-down. Now the new management has restored the beautiful auditorium almost to its old splendour – not quite, for though the gold and crimson may have returned, the boxes have shrunk to a mere dozen or so on one tier only; and though the audience, headed by the King and Queen and the Prime Minister, contained figures of every known form of distinction, they were not on the whole much to look at; for nowadays nobody has any clothes worthy of the name. It was an 'austerity' opening.[14]

Soon however, thanks in part to that pecularity of finances in the opera world which means, in Sir Kenneth Clark's words, that 'the moment you move into a grand opera house a production costs twice as much as in a more modest theatre', austerity disappeared. In 1971 Michael Wood looked back over the Royal Opera House's intervening twenty five years; the nature of the established commitment to opera becomes clearer in nature:

> 'State performances are in a way almost glimpses of fairyland – the whole theatre decorated by some great designer like Oliver Messel, Cecil Beaton or Dennis Lennon, the huge Royal Box, the ladies in their beautiful dresses, jewels and tiaras, and the men in full evening dress with orders and decorations. For a brief moment one is transported back to those pictures of the pre-First World War period when people lived and looked like that most of the time.'[15]

The absurdity of saying that prior to the first world war 'people' wore full court dress 'most of the time' may be left without further comment. More interesting is the way in which the high fashion of the audience becomes synonymous with national glory. From each expensively occupied stall comes the whisper, *L'Etat, c'est Moi*! In the fullest sense of the terms, this is indeed a state performance.

The Arts Council's first male Secretary-General sought nevertheless to give this a wider significance; such power houses were raising *all* standards, reflecting a general glory. This belief was enshrined in a series of horticultural metaphors; 'Few but roses' (implying, which is not in fact the case, that other kinds of flower are encouraged to grow by the distant proximity of a few Fragrant Clouds) and, more puzzling still, 'Raise and Spread'. As with gardening proper, the seedlings who do not find themselves under glass, the prunings, the weeds and the plants thinned out from the borders are given little sympathy. The early Arts Council affected a reactive posture, claiming the arts world was 'out there' and that the Council could only *react* to requests, and help by its arm's length support. However, the nature of the reaction increasingly made it clear which were considered to be roses and which weeds. As the spreading media ate up the time and spending power of audiences for variety, circus and cinema, and destroyed attendance figures for ice rinks, dance halls and, later, some seaside entertainments and segments of Northern

clubland, all their discreet enquiries about state aid were quietly smothered.

The Council adopted, quite naturally, a view of the world which saw the Arts as being of a self-evidently different nature from mere pastimes and entertainments; they took over and made ever greater that gulf which John Stuart Mill had sought to create with his distinction between higher and lower pleasures. The higher pleasures, the Arts, have to be learned about, their worth may only be transmitted through the education system, with its special enclosed languages which alone convey the essence of Art. Lower pleasures may be gained instinctively, may indeed be indulged in at times without being preceded by an educational induction. They give immediate and, it is to be supposed, transitory pleasure. The higher pleasures on the other hand must be worked for; the pleasure they ultimately give however is deeper, greater, longer-lasting, and, we are also assured, of a greater divine significance.

Only a fool would of course deny that such extremes exist, and that there are works of art of the highest sublimity which reward the effort of learning fully about their riches by yielding a lifetime's pleasure. Nobody would deny either that there are other art works which give us a moment's immediate satisfaction and then give us nothing more, for there is no pleasure in repeating the experience, and no enrichment to be gained from their further study. There is not however a great gulf between the two and most art does not simply fall into one category or the other. We often find that in even the most ephemeral kind of popular art there are unexpected pleasures at a second or third acquaintanceship – we see the Carl Giles cartoon afresh, hear richer tones in an old Louis Armstrong record, unexpectedly find an aesthetic pleasure in a long-neglected novelist, like E.F. Benson. In opposite fashion we find a second experience of stuff that was vaunted as being true Art shows it to be meagre fare – Britten's *Gloriana*, the poetry of Edith Sitwell, Sutherland's Coventry Tapestry, each of us would have a different list. The Arts Council however chose always to speak as if the divide were absolute, as if the fuel for the 'power houses' of our national culture were clearly recognisable. It was forced moreover by the size of its annual grant, the way it had to be distributed, and the extent of the subsidised Arts constituency, to determine in advance how much Art there would be each year, and how much activity would be disappointed to find itself outside the stockade of state-approval

and financial support. In some cases the results were enervating for the general public. In organisations which periodically had their Arts Council grants withdrawn and restored, the public would have the perplexing experience of seeing similar programmes of plays that one year were Art, subsidised and improving, and the following year were merely art, poor pastimes without socially improving content.[16]

The Council then was in the business of making only one kind of judgement, how certain traditional forms of Art could be 'raised', and how *they* could be 'spread'. Everything else – new arts, amateur arts, media arts, traditional folk arts, the arts of our ethnic minorities, the arts of our showmen – were not then a part of what Williams, with a symptomatic religious fervour, referred to as 'The Cause'. They were amusements, to be tolerated briefly during the Festival of Britain and at other feast days and holidays,[17] but not a part of what he and his successors have at times referred to, with its revealing Mafia overtones, as 'The Family'. 'All professions,' as Shaw remarked, 'are conspiracies against the laity' and the fledgling arts bureaucracies acted as a new profession; critics, financiers, censors rolled into one.

The financial aid helped however to produce some good things. The Royal Festival Hall was built and developed as a musical centre for London; the Old Vic company were restored to their former home south of the river; the Burlington Gallery was acquired to ease the shortage in London of gallery space. By 1950 the (then) Covent Garden Opera Company had brought its repertoire up to 28 operas, and the Sadler's Wells Theatre Ballet had in the same year, under its resident choreographer John Cranko, devised three new ballets for the company. But as early as 1950 the new Council was asking itself the inevitable question.

'The Charter of the Arts Council . . . enunciates a double purpose – a) that the Council should seek to elevate standards of performance in the arts and b) that it should endeavour to spread the appreciation of the arts. The Council has sought to observe both these injunctions. But the size of its budget in a period of rising costs may require it to re-examine how far both these objects may be simultaneously secured. Is it wiser, in such times as these, to consolidate standards, rather than pursue a policy of wider dispersal?'

In the next thirty five years the question was never resolved; invariably, with different emphases the Council resolved to act as if it could simultaneously raise *and* spread. Inevitably this meant that the Arts world narrowed in inverse proportion to the social and educational benefits claimed to flow from it.

The gap between the commercial arts world and the subsidised Arts grew deeper. The arts world in general had for nearly forty years been protesting against the injustice of the entertainments tax, which had been levied on all kinds of public entertainments during the first world war, and had remained in force ever since. There had been some exemptions allowed – presentations that were 'wholly educational' had always been exempted, and after 1946 'partly educational' organisations had been officially exempted (which had allowed commercial organisations like H.M. Tennant to wear two hats, one 'partly educational', and thus qualify for state subsidies and exemption from the tax). More curiously still 'revivals of national pastimes' were excluded from tax payment, although there was no very clear direction as to which kinds of national pastime were thought suitable for revival.[18] The majority of the arts world was however still paying this tax in the nineteen fifties – but the state-supported sector, the Arts, that is organisations with charitable *educational* status, was not.

A powerful lay committee had been formed, the *Theatres Entertainment Tax Committee*, to try to persuade government to get rid of the tax, which was yielding two and a half million pounds a year but appeared to be seriously damaging theatres, cinema and some parts of the music business. It was however suspected by the committee that the Arts Council rather felt that only state-supported Art was of serious concern to the nation, and that the rest of the arts were beneath intelligent notice; their anxieties were fuelled in particular by the oddly patrician tone of the Council's 1964/5 Report. The chairman of the committee, Dingle Foot, wrote to W.E. Williams querying the offending passages:

> 'They seem to suggest that all theatrical enterprise outside the special protection and patronage to be afforded by the Arts Council is unworthy of support or encouragement.'

Williams's replies fanned the flames further. 'The distinction must be drawn,' he wrote, 'between art and entertainment.' Apparently the

distinction was in the minds of the Arts Council gurus obvious and absolute; commercial managers were 'interested in business and not in art.' The Arts Council would *not* join the general campaign (although its Charter empowered it to cooperate with any other body in support of the arts) because 'We are conscious of the fact that, were the tax to go, our own particular chicks would be in dire jeopardy.'[19]

To many observers Williams's replies seemed absurd, even infantile. It would however be more fair to see them as a candid statement of the kind of neo-governmental interests the Council was protecting. 'Parliament,' Williams wrote elsewhere in his corespondence with Foot, 'has accepted the principle of protecting non-profit-distributing companies, and it is with these that the Arts Council is concerned.' It was nonsense to assert that removing entertainments tax from cinemas would put subsidised theatres in dire jeopardy, if by that was meant that production costs would rise overnight, or that the public taste was so fickle that a slight decrease in cinema admission prices would cause them to desert the theatre in thousands. It was not however so absurd to point out that the *Arts Council's* existence, and by extension the existence of its brood of state-reared chicks, depended upon an understanding with government that the barricades would be kept up. State Art, with the Opera House as its pinnacle, must be seen to be separate from the everyday commerce of the wider arts world. State Art must in broad terms embody the Apollonian Purposes of Art. Though the control is of an intangible kind, lost in the thick web of traditional practice which enmeshes gentlemen's agreements in Britain, Williams's answers give the first clear notice that the 'arm's length principle' – whereby the decisions of the Arts Council are supposed to be taken for the good of the arts world and well away from the pressures of politicians – is a tag phrase which suffices only to divert attention from the rigidly marked territory within which the Council may actually operate.

As a free agent it is hardly likely Williams could have brought himself to write such tortured blether; as the Secretary-General of the Arts Council he had no choice. Indeed, the most obvious and ultimately most depressing feature of successive Secretary-Generals' reports is their *similarity*. The same grey comparisons (even, in 1984/5, the old favourite about more people going to Britain's theatres than to soccer matches[20]) are trotted out annually. They quote their predecessors, elevate the

bureaucratic practices of the post-war Council to the status of high critical principles, pay ritual homage to long time-serving members of the subsidised Arts establishment. Through it all however, the dominent note is 'I am trying to lend an air of purposefulness to the actions of a bureaucracy which has no real room for manoeuvre. You should sympathise with me and not rock the boat.' As Lord Goodman remarked, when learning of the Council's most recent protestations that they were about to wriggle free from their traditional political restraints:

> 'The idea that the Council can develop and employ a 'new strategy' is a misleading one. It suggests that there is a latitude available to it which is not bound by rigid restraints. The truth of the matter, alas, is very different.'[21]

The Council must work within a small and predetermined segment of the wider arts world. In return for the safe annual deliverance of the government money they must attribute to that segment the kind of political effects the government of the day thinks most desirable – so the subsidised Arts must be seen as proof of post-war recovery, the answer to the problems of the inner cities, splendid examples of British self-help, the embodiment of our political maturity, or a sound investment for commercial interests – all kinds of ludicrous and fanciful effects supposedly follow from subsidising a miniscule part of our common culture.

And in the fifties, while Williams was dutifully defending his chicks, it became apparent just how tiny was the new subsidised Arts world. For in that decade 'our popular culture' changed dramatically. Television, aided by the great interest in the Coronation in 1953, and further encouraged by the beginning of the Independent Television service in 1954, entered the majority of homes. A wave of new writing – the authors termed 'Angry Young Men' for obscure journalistic reasons[22] – dominated the bookstalls and the magazines. Pop music – examplified by imported 'Rock and Roll' in the shape of Haley and personified by the more distant excitement of Presley – grew to be big business in Britain, though its first stars, Cliff Richard, Tommy Steele and Marty Wilde, seemed altogether tamer than the Americans. A 'new wave' in British films stemmed for a time the national decline in cinema attendances. And, more important than any of

these things, our city centres and town centres were being rebuilt in great haste.

Of all the opportunities missed, history may see the missed opportunity in post-war civic architecture and design as being the greatest. For, while the Arts Council's clutch of subsidised Art clients was being defended as being the supreme purpose of the Council, we were engaged upon reshaping our urban environment in a fashion so coarsely comprehended and so blindly executed that it stands as a national indictment, a testament to the meanness of spirit within British culture which has to be weighed against the best things of our post-war artists. It need not have been. When the post-war Arts Council's size and purposes were being discussed in Whitehall's wartime corridors, it is ironic that the Institution of Civil Engineers, recognising their likely central role in rebuilding Britain, were holding a series of national seminars on the aesthetics of civil design.[23] The first speaker, Oscar Faber, urged that engineering should acknowledge the importance of aesthetic considerations in their practice and in their training:

'Engineering colleges still do not indicate to their students that one of the first essentials in designing a structure is to see the site, to consider what kind of structure the site demands so as to harmonise with its surroundings, and to start from that and not from the other.'

It is sad that at that time what was conceived by the metropolitan arts establishment was a narrow and patrician representation of the Arts, which saw itself as having no direct concern with the way out cities were built or with the enveloping media, merely with their tax-exempted 'chicks'.

3.2 The First Steps?

By Command of Her Majesty, there was presented to Parliament in February 1965 a white paper *A Policy for the Arts*. It had been drawn up by Jennie Lee, Minister for the Arts in the new Wilson administration, and purported to be the first positive statement on promoting the arts to have ever been put before a British government. Certainly it was the first white paper to be devoted to the arts in its entirely – others, white papers on education for example, had frequently had much to say about the arts

in other contexts – and it implied, falsely as it turned out, that it was opening a new kind of debate, and that it would be followed by many others. It was subtitled 'The first steps'. There were no others.

It was greeted with some excitement, particularly by the new young intelligensia emerging from the rapidly expanding universities, and was even claimed to be innovative, developing for the first time the idea of 'arts as service', or claimed to be 'opening the door' to community arts to new art forms, new ideas and a new kind of freedom for art. It was in other words described as if it were directly associated with the vast development of the commercial pop world, the teenagers' fashion market, and the American-inspired 'alternative' culture of the highly educated young; as if it were a radical, new, expanding programme to make the arts generally accessible.

A cooler reading of the white paper however suggested that such claims were considerably exaggerated. It is true that there were the kinds of 'blow away the cobwebs' gestures fashionable to the first years of the Wilson government, 'No greater disservice can be done to the serious artist than to present his work in an atmosphere of old-fashioned gloom and undue solemnity'. There was too a good deal of modish kowtowing to the vanity of the young. 'A younger generation, however, more self confident than their elders . . . are more hopeful material. They will want gaiety and colour, informality and experimentation.' Or, to take a more extreme example:

'Nearly all children enjoy singing and dancing and most of them delight in poetry and in mime or dramatic exercises. There is no more excited audience at the right play. Many of them have a natural talent for painting and drawing, and for making things, that surprises their parents.'

Bliss was it that dawn to be alive, *and young*! The white paper assured us that in our schools and colleges 'the imagination and free flow of some of the writing in prose and poetry, the quality of some of the painting and pottery, the high standard of some of the choral singing and of the orchestral playing ... outshine the achievements of any previous generation.'

The white paper was moreover full of those expressions of desire to 'spread' the arts to every streetcorner with which we later became wearily

familiar. The document announced that it was going to increase support for regional associations, and decrease the centralisation of the arts upon London; it had set up (under Mr Arnold Goodman) a committee to consider the problems of the London orchestras; it aimed to 'bring the best of the arts within reach of a wider public'. The paper assured us that we could not ignore 'the growing revolt, especially among the young, against the drabness, uniformity and joylessness of much of the social furniture we have inherited from the industrial revolution' and predicted that we could direct ourselves to make Britain a 'gayer and more cultivated country'.

Such pieties were on the whole unexceptionable, but the paper unfortunately gave little evidence of any considered means by which Britain might be better cultivated through state aid. In spite of the talk of a need for a broader base, the 'arts' discussed in any kind of concrete form were the Arts of Lord Keynes. The new music in schools had its 'culmination' not in new forms of free composition, but in the National Youth Orchestra. The Royal Opera House would remain at the heart of government financing. All arts organisations were expected to maintain 'a jealous regard for the maintenance of high standards'. Radio and television could *contribute* to the arts and in time to 'local artistic activity', but were not themselves a segment of the true Arts world. More money was to be channelled into rehousing the Arts, and there, the picture that emerged was of that same institutionalised kind that W.E. Williams had envisaged in 1943. When funds allowed the new Arts buildings would have restaurants 'and lecture rooms'. Venues must be cheerful and welcoming, *and must not be left 'to those whose primary concern is with quantity and profitability'*.[24]

That implication, that developments should be primarily concerned with the maintenance of metropolitan standards ('Of course no provincial centre can hope to rival the full wealth and diversity of London's art treasures, but each can have something of its own that is supreme in some particular field'), and should be small and unprofitable, was taken up as a theme of Arts politics in the sixties and early seventies. The broader gestures towards 'arts as service', though still mouthed at conferences and public debates, became centered upon miniature arts labs, small scale touring theatre companies who, though their professed aims sometimes did not stop much short of world revolution, nevertheless played for the

most part to small audiences of the highly-educated young.[25] A national chain of small and heavily-subsidised arts centres was set up, with small spaces for a series of (sometimes exciting, sometimes tatty) youthful experiments in art. A new generation of young arts administrators lived on newly-released public subsidy, mouthing impeccable and democratic sentiments about the arts, but concerned for the most part with a tiny clientele, out of scale with their global ambitions, and falling far short of the populist ambitions of the 1965 white paper. The new language of sixties Arts politics was a kind of social/political jargon adapted from much larger welfare services – there were 'officers' examining 'needs' of 'communities' (often at a surprising distance, or on impressively brief acquaintance), taking 'initiatives' and supporting 'innovations', and, centrally, 'getting funding'. The word 'funding' (slightly misused, as it usually meant getting an annual grant) passed into the language of arts administration.

The Arts Council itself had been exhorted in the white paper to undertake a 'searching reappraisal of the whole situation in relation to cultural standards' as it 'reviewed requirements'. However, the kind of urgency that might imply did not seem to be felt in the inner recesses of the Council itself. The chairman, then Mr Arnold Goodman, spoke wincingly of the cautious reaction within its portals:

'But we had, rightly or wrongly, heard that a group of youngsters around the country had some new ideas and the rumours grew with disturbing persistence. Reverberations came from laboratories in London and nearby seaside resorts, from towns rarely associated with artistic explosions. From all over the place reports of quaint new phenomena were raced to us by carrier pigeon, mule and camel. We sat at the gates of the Arts Council to receive them. . . .

So we established the Committee to investigate, primed it with a modest grant for its researches, and the Eldritch proceedings began. Meetings were invaded by demonstrators; long and protracted arguments about protocol, propounded by citizens of terrifying solemnity, and clamourings for justice, meaning thereby a large share of our depleted funds . . .

The Council debated the matter at considerable length. We have decided not to establish a new panel, but we have equally decided to

give 'new activities' a sporting chance. An Experimental Projects Committee has been formed to deal with applications from any activity which looks 'new' . . .[26]

Indeed the Council managed through its public statements and its increasingly gay and cultivated publications to both give the impression that it viewed this 'new' art with some considerable suspicion, and that it had always done its loyal best to be *au fait* with it anyway. The first was justified – a great deal of the 'new' art of the sixties and early seventies could soon be seen to be a middle class and youthful self-indulgence, not without some merit, but far from the kind of fireball shackle-breaking explosion its progenitors claimed. And it was true that the Council from the first had tried to accommodate to the new:

'There are an increasing number of activities which cannot be classified under any of the three accepted heads of Music, Art or Drama.'

proclaimed the Art Council's *first* annual report, in 1945/6.

The difficulty was over the conflicting nations of what constituted art, and what 'new' Art might be. The white paper had hinted (no more) that a revaluation of the state definition of worthy Art might be undertaken. The educated young, liberated by a surge of state subsidy generously given in return for mouthing acceptable social and political platitudes, in general conceived the 'new' art as experimental, small-scale, activities, set up in a form which celebrated the fashionable 'alternative' lifestyles and which could be presented as being in 'opposition' to consumerism, the values of the conservative establishment and 'traditional forms'. The Arts Council tended to mean by it new work within established Art forms which recognised artists had created. All agreed that 'new' work could not possibly be anything to do with the commercial realms of art, or with the media, or with the long-established traditions of recreational provision by local authorities, and all seemed to agree that arts bureaucrats knew more about it than did critics. (Already, in the sixties, experts were becoming more important than critics).

In 1970 the Arts Council had a list of 'new' activities which it produced, rather defensively, in a publication called *Experimental Projects*. Charles Osborne, who edited the booklet, wrote:

'The total annual amount given to them in 1969/70 was approximately £53,000. This is not large in relation to the Council's grant from the Treasury of £9.3 million, and there is no doubt that much of it can be seen in retrospect to have been money unproductively spent; but it is, after all, the privilege of experiment occasionally to fail. If only a small portion of this money enabled worthwhile artistic activity to take place, the exercise will have been a fruitful one.'[27]

The list of grant recipients is interesting, not least because of the categories in which the Council chose to place their clients:

Music

To Individual artists £

Cornelius Cardew	600
Gavin Bryars	200
Peter Dockley	300
Peter Dockley	1,500
Geoff Moore	200

To organisations

Moving Being (ICA)	500
Moving Being (Artists Place)	1,725
Moving Being (The Place)	1,200
Michael White Ltd	750
Music New (5 projects)	2,400
Music Projects	60

Managing the Arts?

Annual aid to Organisations (For Experimental Work)

ICA	6,500
Park Lane Group	6,000
Macnaghten Concerts	4,000
Contemporary Ballet	5,000

Drama

Theatre Companies

Camden playhouse	3,000
Inter-Action	4,000
Brighton Combination	3,000
Portable Theatre	4,500
People Show	1,200
Warehouse La Mama	1,500
The Freehold	2,000
Soho Theatre	750
Pip Simmons Theatre Group	775
The Theatre Machine	500
Quipu Basement Theatre	250
Ken Campbell's Road Show	200

Art

For novel extensions of art forms

Bruce Lacey	750
Peter Logan	250
Keith Brocklehurst	120
Harry Biggin/Maggi Hambling/Geoff McEwan	150
Timothy Cresswell	100
Graham Stevens	150
Philip Trew	35
John Epstein	550
Carletta Barrow	100
John Lifton	250
Upday (inflatables)	50

Activities with some visual art content

Fun Palace Trust	500
Action Space Structure	300
Pavilions in the Parks	1,000

There were other activities – the new work staged by the Ballet Rambert, the Council's own Whitechapel exhibition 'Three Towards Infinity', or the Kinetics show at the Hayward Gallery – which might reasonably have been included, but the list gives a general flavour. 'New' work was uneasily apportioned to the traditional areas, and deliberated

upon by a New Activities Committee,[28] set up in that same year. The most disturbing thing about it all was the way in which 'new' activity, and the kind of radical reformulation the 1965 white paper seemed at times to seek, was now subsumed within the tight little world of Arts Council politics. The radical young travelled to London and sat upon panels in the hallowed halls of the Arts Council, and were given modest sums of money to disburse, but the loss of energy this caused was great. The 'new' and the 'experimental' tended to become the subsidised playthings of a new privileged group, the university-educated provincial young. The Chairman of the Standing Conference on Regional Arts Associations commented after the first deliberations of the New Activities Committee that the faith put by the new young arts administrators in the Arts Council was surprising:

> 'A new activist at one of those dreadful meetings at the Arts
> Council was appalled at the idea of approaching his local authority
> for a grant, though he might never have been there without the
> education provided by the same villainous authority.'

'Presumably,' he commented wearily, 'they continue to feel that the best hopes lie in entwining symbolic lavatory paper in the bumpers of Lord Goodman's limousine.'[29]

By the mid-seventies the innovations of the previous ten years were (with a few honourable exceptions – *7:84*, the *Bracknell Jazz Festival*, the *ICA*, *Inter-Action*, Bruce Lacey) either running out of creative steam or trickling into a more conventional pool. A few – such as David Hare from *Portable Theatre* - had successfully branched out into wider activities and had found larger audiences. Some of the administrators who had ridden this 'new wave' settled down into less flamboyant roles, and some of them took work on a bigger scale and shed the passion that had formerly led them to say that only small was beautiful. And many of the 'new' Arts movement disappeared altogether from that highly-politicised, brash and transient world.

In part the stuffing was knocked out of the revolutionary claims of the 'new' subsidised Arts by the much bigger, much brasher and (in quantitative terms) overwhelmingly more successful 'revolution' in the *commercial* world of the young. This was the decade of the Beatles and the Rolling Stones, of Mary Quant and Kathy McGowan, of the Cavern and

Carnaby Street, of Georgie Best and Jean Shrimpton. The youth-based cultural revolution called for by Jennie Lee's white paper took place through commercial causes, and took place in the media and in commercial establishments. By comparison with the vast audiences for rock and pop, the swinging scene in the streets as the fashion-conscious young paraded, and the new hip language of the media, the activities of the new subsidised arts centres and the tiny arts labs seemed chinzy and prim. They continued to announce that they were making innovations and 'keeping standards up', but the words of the white paper must have sounded disturbingly apposite to some: 'each can have something of its own that is supreme in some particular field'. The majority of the young had chosen rock and pop, high colourful fashion and flower power; the arts bureaucracy tended to put its faith in agitprop theatre, conceptual art and inflatables. It maintained the standards in whatever it chose to support, and pretended that the burgeoning world of new commercial art, like the all-embracing media, had not intruded upon the Arts but only upon the lower fields of mass recreation. Subsidised Art was somehow set apart from other leisure practices. Only in *subsidised* venues could there be real innovation.[30]

3.3 The Shaw years

Professor Shaw's appointment to the Secretary-Generalship of the Arts Council in 1975 marked an apparent desire to be rid of its image of fey gentility. His distinguished work as an adult educator suggested close sympathies with the ostensible designs of the Council, but in other respects his background – a gritty Sheffield-born debator used to arguing high principles in no-nonsense terms – fitted uneasily into the eliptical world of West One politics. From the first Shaw assumed that the Arts Council was really there to do just what it said it did; he assumed that the 'arm's length principle' was not just an agreeable conceit, but a practical reality (and he went on arguing for its application long after it was obvious that no-one around him believed in it any longer). His career as a teacher of philosophy and literature had led him to be careful of his words and other people's, and his semantic discussions of the nature of 'cultural democracy', or of 'community art' were of a higher order than anything issuing from the Council before or since.

He assumed, however, that his own scrupulous care for language was shared by all of his colleagues and existed throughout the politicised realms of London's Arts establishment. Thus he was wont to assert that *critics* of the Council were politically motivated, while the Council operated, in thought and speech, in a disinterested academic mode:

'It is a part of the Arts Council's purpose to ensure that a larger portion of the population enjoys some worthwhile form of artistic experience than at present. 'Worthwhile' is a crucial word here, for some enthusiasts for less demanding arts speak as though the very idea of evaluating artistic experience is a wicked elitist practice. (Is the man who can appreciate the quality of Manchester United's play also an elitist?) The word 'excellence', so long used in Arts Council parlance, is an affront to those who think (quite wrongly) that it involves a rejection of popular arts in favour of the grandest and most expensive art forms.'

Few critics of the Council would however object to the view that what goes on should be worthwhile, nor would they deny the notion of evaluation, nor of excellence. The Council's critics did not wish, *contra* Shaw, to spread rotten and worthless art across the face of the land. They were usually critical of the Council because these words were used by the Council in a particular and narrow way; Arts Council parlance was *not* disinterested critical language. The Council that Shaw led allowed only certain kinds of artistic activity to be 'worthwhile' – the Council had nothing to do with radio or with television, had turned down the chance of amalgamation with the BFI and thus being concerned more with film, little to do with folk art, nothing to do with entertainments or with crafts, or architecture, or gardens, or costume and needlework, or stand-up comedy or clowning or stage magic, or amateur dramatics or origami. Only activities subsidised by the Council were worthwhile, or 'excellent'.

And this was not the result of a disinterested critical evaluation. It was the result of political happenstance – a history which had led the radio and television to be under one Ministry, and the British Council under another; had led the Department of the Environment to be separate from the unit concerned with the Arts and Libraries; had led the Arts Council to be separate from the Crafts Council and Design Council and from the British Film Institute. It was also partly a matter of historial accident that

the Arts Council existed at all, and that it had the character it had. There had been no coherent examination of what was worthwhile in the wider sense; nor had there been any wider critical debate involving the Council in a serious and *sustained* attempt to discover 'excellence'. In Arts Council parlance the words had been hi-jacked for reasons of political persuasion, and their use accorded with the more widespread usage only occasionally.

Nowhere was this more apparent than in the use of the terms associated with critical evaluation. For an evaluation by the Arts Council is quite different from a *critical* evaluation, in the sense in which Shaw tried to use it. In his customary forthright way he asserted that the British Arts Council 'was in the business of making critical judgements', and he termed the 1980/81 Annual Report *Critical Judgements*.

But the judgements defended in that report – central among them being the Council's decision to cut the grants of 41 clients who had hitherto enjoyed financial support – were *not* critical judgements, in any sense in which the term is understood elsewhere in the arts world, that of being concerned wholly with artistic quality. Shaw himself pointed out in the report[31] that 'the needs of the regions' were considered to be of equal importance, and that amongst other criteria were 'Box Office Returns', 'the company's success in raising local authority support and other income' and 'efficiency in using available resources'. Finally it was in any case the Council's policy 'to give priority to funding full-time professional artists' so (notwithstanding the fact that the notion of what a professional artist is varies between art forms) a group which was impeccably regional, attractive to the public, aided by local authorities and industry and was mightily efficient in using its resources would nevertheless be ignored if it were not composed of full-time professional artists.

Only in the second sense of the term, therefore, were these judgements 'critical', in that they mattered to the would-be and the actual recipients. But here and elsewhere the assumption by Arts Council apologists was (and is) made that Arts Council's decisions were critical judgements (in the other primary sense). This could not be for a second reason. A critical judgement is formed, offered and debated *in public*. The making of such a judgement involves proposition and response, a collusion between viewers, readers or audience members. In the form adopted by Dr Leavis, a critical judgement takes the form of saying 'This is so, isn't it?' and of

receiving a considered response, 'Yes, but . . .'. It is an open and careful process. The Arts Council's decisions however are taken *in secret*, and although its decisions are eventually made public, the serious debate which (one hopes) precedes them, and the reasons adduced for the eventual judgement, are kept under wraps. To the massive outcry which greeted the 1980 cuts was added an outcry about the nature of the secretive deliberations which had led to them. *The Guardian* (December 23rd, 1980) put a general sense of outrage moderately by saying that, 'Since the Council has said that it may well make these axing exercises an annual procedure, there needs to be a change of methods.'

At best the Council's judgements were *expert* judgements, formed on the basis of social, financial, managerial and geographical criteria which were of equal weighting to the artistic criticism they (presumably) also indulged in. Those expert judgements meant that the Council was having, by its actions, to drop any pretence of being reactive, and having to formulate a policy. Its policy was made explicit by its actions, and its policy was *not* to act upon critical judgements alone, and to make artistic evaluation the care of its deliberations. Indeed some rejected clients found that their artistic qualities were not mentioned at all, and that they had been excluded for geographical and quantitative reasons:

> 'This need to preserve a balance of provision between London and the other regions explains a number of the Council's decisions. It is the reason for example why the Council warned the Prospect (touring) Theatre Company when it moved four years ago into the Old Vic theatre that the Arts Council could in no way fund what spokesmen for the company described to us as 'a third national theatre company' in London, a city which was already uniquely rich in theatre and had recently acquired a triple-auditorium National Theatre. This warning was repeated regularly over the next four years, but it went unheeded.'[32]

The emerging 'policy' was therefore a compound of geographical, financial and managerial axioms, the weighting of which was a matter for the collective notions of the various secret Arts Council meetings. These judgements therefore had, inevitably, a political rather than an artistic flavour. The frequent inconsistencies (the Prospect Company could fairly point out that the same objections had been made to Peter Hall's moving

the Stratford company to London in 1964, but that in their case the Council had not heeded its own warning, and had regularly increased their grant-in-aid) were met always with the response that experts had met in secret and (for reasons which would not be given) had decided upon that course of action.

The conflict between sustaining 'the best', and also sustaining the geographically-well-placed, the well-managed, the efficient and the alternatively-funded, was occluded by the vigorous assertion that the Arts Council was 'in the business' of making critical judgements. A series of words were now used by the arts bureaucracy to describe a process in which artistic evaluation is at best only one factor amongst twelve or so others, but which implies that something apolitical, disinterested and rigorous is going on – 'critical judgements' vying for a while with 'evaluation' and then giving way to a current favourite, 'assessment'. In the early eighties it became clearer that such 'judgements' were not reactive, but were instruments of a hazy and semi-secret kind of social policy. The Council became more dictatorial in its dealings with clients. The easy-going warmth of the relationships between many clients and their supportive Arts Council officers disappeared, and within the interstices of the Council, amongst officers now asked to operate in some cases like a cross between store detectives and school H.M.I.s, morale plummeted.[33]

A metaphysical casualty of the early eighties was the 'Arm's Length Principle', the notion that the Arts Council existed to make disinterested artistic judgements 'at arm's length' from politicians. As it became ever clearer that the Council's judgements were (by force of circumstance more than through ineptitude) themselves political in nature, the need for the 'distance' between them and expert politicians seemed to lessen. Indeed, as the then Arts Minister, Norman St. John Stevas, made no secret of the fact that he found the manner of the 1980 Cuts crude and arrogant, one had for a time the curious spectacle of a politician, the Arts Minister, apparently defending the arts world from the coarse depredations of the Arts Council, which was a reversal of the supposed 'arm's length' idea.

More centrally, as the Council had now obviously abandoned the high ground of being 'in the business' only of making artistic judgements, and as it was more plainly acting in a political realm, it exposed itself more directly to overt political manipulation. St. John Stevas's successor, Paul

Channon, did not permit Dr. Richard Hoggart, whose sympathies were close to those of (by now) Sir Roy Shaw, to remain on the Council itself when in 1982 his time as Vice Chairman neared its close. The Office of Arts and Libraries (the unit in the DES which administers central government arts financing) denied this was an attempt to shift the Council to the right, and said there should be no concern about political bias.[34] Shaw said that he hoped it would prove only to be one step 'in the wrong direction.' He continued – as evidence began to mount that the Arts Council was, like other quangos, being stacked with supporters of government policy so that it began to seem like a ministry of government – to offer a brave defence. When I suggested in the pages of *Classical Music* that nobody I knew believed in this principle any more (adding that as it was not a scientific or legal principle, but a kind of principle of etiquette, it depended upon most people believing in it for it to exist at all) Sir Roy replied stoutly that I knew him, and that he believed in it. In the face of impending disaster, he continued to defend the notion with his usual lucidity, and also to imply that, after a few temporary trips, the system could soon be running smoothly again.

As with the 'critical judgements' a defence of the 'arm's length principle' sounded by then like the defence of a platonic ideal, an academic conceit which had less and less bearing upon the overtly political, managerial and social concerns of the Council. There was plainly a great gap between Sir Roy's luminous account of a feasible system, and the depressed and confused political organisation that he actually led. It is a kind of conflict often seen between the aspirations leading arts administrators hold for their organisations and the reality, a conflict Tom Burns noticed in his study of the B.B.C., '*Cultural Bureaucracy*':

> 'the widespread distinction made between the Corporation as it is and a platonic idea of the BBC which shows in depreciatory references to 'the way the BBC does things', 'Broadcasting-House mindedness' and 'the kind of line being taken by the people on top now' by the same people who see 'what the BBC stands for' and 'the public service idea in broadcasting' as altogether admirable.'[35]

The crucial point about the Arts Council's accelerating collapse and the fading of belief in the 'principle' was made by Dame Mary Warnock in the *Times Educational Supplement* (April 9th 1982). Summarising the debate

between Sir Roy and myself, she said of the Arm's Length Principle, 'My answer would be that if we don't believe in it, we ought to. If bodies like the Arts Council have lost credibility, it is extremely important that they get it back again.' *Could* that have happened? Could the Arts Council have been restored to its former apolitical stance?

Subsequent events seemed to give much *less* cause, in fact, to believe in the principle, and the Arts Council's credibility with the arts world shrank to invisibility. The years after Sir Roy's departure were years of resignations of officers and of whole panels, of confused and confusing dicta from the Council, of an almost non-stop barrage of hostile publicity for the luckless officers in 105 Piccadilly. The reason was that places on the Council, and senior positions in the ranks of the officers (together with a number of RAA appointments) seemed to have been given on wholly political grounds. The Council curiously adopted a kind of half-baked Americanised notion of 'management', which led to the arts being discussed in terms of 'plant', 'capital', 'investment' and 'strategies'. A new breed of managers – who seemed by their language and manner to have been more ideally suited for manufacturing industry – discussed their 'market strategies', and 'regional plans' in a way that was earnest and more than a little comic, and which made it clear that one should not look for pleasure from the Arts, but market returns. The Council, under its new high-profile Chairman, Sir William Rees Mogg, capitulated completely to the presiding monetarist orthodoxy, producing a kind of Investment Brochure for the Arts ('Speaking to the government in the only language it understands', said one senior Arts Council officer, rather pathetically). The brochure however gave no hint that the Council now knew any other realm of argument.[36] It demonstrated, in every page, that the Council had not only abandoned a claim to 'speak for' the arts in Britain, but had fallen so far into the pit of political expediency, that never again could its wider credibility be restored.

Sir William Rees Mogg has indeed exhibited a curious glee over the Arts Council's closeness to government. The Council is now in his words not at arm's length from government but *the government's means of* shaping the Arts. His attachment to the present Prime Minister is blatant and his delight in her approval unconfined:

'I know I have Mrs Thatcher's confidence. She's delighted. She

thinks things have gone well in the arts, and I'm pleased because she's been very helpful and very interested.'

The feeling that the Arts Council has become a snug little Tory ministry is everywhere. Later in the same interview (*Guardian*, May 22nd 1986) he proudly asserts that he doesn't want to beat up Education and Health, but 'I can go into any arts centre in this country and be welcomed by the people there. Keith Joseph can't go into the schools.' In Sir William's roseate fantasies therefore he sits at the Cabinet table, alongside Sir Keith and the other monetarists whose successes in schools and hospitals have not had the universal acquiesence that Sir William believes that his efforts in the Arts have enjoyed – but colleagues nevertheless, confident of a job well done, basking in the warmth of the Prime Minister's approval.

This purblind gloating, which ignores the plight of the Council's officers who are left bobbing like corks in the storms of fury which it all unleashes, serves to underline the opinion of the opposition parties that the Council has bent so far to accommodate a particular political stance that never again could it work in its present form with a government of a different complexion. It is an arrogance which has buried the Arm's Length Principle, the independence of the Arts Council and the trust of artists all at once.

Footnotes

1. Hewison, *Under Siege*. (Weidenfeld and Nicolson, 1979)
2. Elder, *Travelling Players*, (Muller, 1939)
3. Guthrie *et al*, *Opera in English*. (Bodley Head, 1946)
4. Trewin, *Sybil Thorndyke*. (Rockliff, 1955)
5. Eliot, *Notes Towards the Definition of Culture*. (Faber, 1948).
6. Littlewood, 'A Laboratory of Fun', in Calder (Ed.) *The World in 1984* Volume II. (Pelican, 1964)
7. Clark, *Another Part of the Wood* (Murray, 1974)
8. *Stars in Battledress* continued for some time after the war, as, less predictably did several of the drag shows which toured troop camps in the war years. Best known was *Soldiers in Skirts*, which ran until the mid-fifties. The darling of sixties café society, Danny la Rue, worked in *Forces in Petticoats* at Margate, and later had his first stage speaking role in *Misleading Ladies*, another of the genre.
9. Fawkes, *Fighting for a Laugh*. (Macdonald and Jane's, 1978)

10. A 'benevolent deception', in the words of a well-known authority on law and the arts.

11. *The Arts Council: The First Ten Years* (ACGB, 1956)

12. Clark, *The Other Half*. (Murray, 1977)

13. In 1984/5 £30,597,000 went to the four 'nationals' – 29% of the total.

14. Randolph Churchill, *Irish Times*. February 28th 1946.

15. In *Covent Garden* (Exhibition Catalogue, V and A, October 1971).

16. The good citizens of Chesterfield must be particularly perplexed.

17. The Arts Council had extra monies at the time of the Festival of Britain. It subsidised, CEMA fashion, a number of *amateur* promotions.

18. Zoos were decreed educational at once. It must be a trait in the establishment mind, for London Zoo currently enjoys a subsidy of £2,000,000 from government.

19. Herbert, *No Fine on Fun*. (Methuen, 1957)

20. Dr Michael Hammet, of City University, points out that there are on any night always more people in Her Majesty's prisons than in the subsidised theatres, and suggests that it might be sensible to give the wretched soccer comparison a rest, and turn our attention to that fact instead.

21. *The Case Against Arts Cuts* (Observer, March 25th 1984)

22. Hewison, *In Anger*. (Weidenfeld and Nicholson, 1981). A trenchant assessment of the decade is in Allsop, *The Angry Decade* (Owen, 1958)

23. *The Aesthetic Aspect of Civil Engineering Design* (Institution of Civil Engineers, 1945)

24. One of the little ironies of history is that a concern for 'quantity and profitability' was a perfect description of the Arts Council's own professed aims in the early eighties.

25. In 1977 the Director of the remaining Arts Lab, set in the middle of Birmingham, told me he thought that an average audience of 15 was 'about right'. An audience survey commissioned in the previous year underlined the 'fringe' audience, far from being representative of the people, was more highly educated than an average West End gathering.

26. ACGB *Annual Report* 1969/70

27. ACGB *Experimental Projects* (Arts Bulletin, No.3 Winter 1971)

28. The New Activities Committee solemnly turned into the Experimental Projects Committee which despatched its findings direct to the Council, who then 'examined these hybrids with care'. It all disappeared in due course.

29. Lord Feversham, writing in *Experimental Projects*.

30. The present Arts Council still makes feeble attempts to use the argument that subsidy permits experiment and innovation. But any unbiased examination will suggest that experiment and innovation come in the visual arts as often from the commercial world as from the subsidised; much of the innovative drama since the fifties has been staged by commercial entrepreneurs – Bridges, Albery, White etc. And Sally Groves argues persuasively (*New Democrat*, Vol IV No.2) that it is the private sector, not the Arts Council, that provide the most adventurous commissions in new music.

31. ACGB *Annual Report* 1980/81
32. *Ibid*
33. ACGB *Organisation and Procedures* (1979). p.5. 'We have become aware through a great deal of the evidence submitted to us of a widespread sense of malaise and a low level of morale among many of the staff.'
34. *The Stage*. January 10th 1982
35. Burns, *Cultural Bureaucracy* (BBC 1964). Excerpts in McQuail (Ed.) *Sociology of Mass Communications*. (Penguin, 1972)
36. *The Arts; A Great British Success Story* (ACGB, 1985)

CHAPTER 4

THE CONSUMERISM OF THE LOCAL AUTHORITIES

'The arts, in any historical meaning of the word, will disappear. Already few people read books for pleasure; they 'use' them, or even 'view' them (books will have more and more pictures and less and less text). Poetry, already an arcane activity, will have totally disappeared. Fiction, even now a dwindling form of entertainment, will fade out and the only writers will be script writers for the television screen. Style, in any of the arts, will be regarded as an anachronism, like ornament in architecture. The stage may exist as a training-ground for actors, but no poets will write for it; plays will be produced by involving the actors in 'situations', for which they must improvise 'solutions'. The lighter forms of opera will survive because they are entertaining but composers like Beethoven, Wagner and Stravinski will be forgotten. It is not a cheerful prospect for the arts, though there will be more and more artists in the sense used by the entertainment industry. It will be a gay world. There will be lights everywhere except in the mind of man, and the fall of the last civilisation will not be heard above the incessant din.'

Sir Herbert Read, Atrophied Muscles and Empty Art, 1964

One of the uglier faces of the post-war Arts establishment has been its patronising attitude to the local authorities. We are led to believe that these dull provincial bodies are exclusively peopled by rednecked barbarians, keen on a bit of brutish sport, but ignorant of the finer things, and that it was only when the postwar Arts Council began to shine a light in the universal darkness, and bravely made 'approaches' to these distant herds that they began to see the value of the Arts. Now, so successful has been the civilising influence of the metropolitan bureaucrats, some of these bodies may even be taken into partnership with real Arts providers,

treated as equals, and trusted to help develop certain exciting new national 'strategies' to replace their own trivial and clumsy attempts to aid true Art.

The process has at each stage been clear enough. The postwar Arts establishment insisted, as CEMA had begun to insist in the war years, that until the coming of state subsidy there existed no real Arts world in Britain. 'You can count the museums and galleries in Britain on the fingers of one hand,' said Lord Keynes. (Actually, in pre-war Britain, but provided in the main by local authorities, there were more than 350). The Arts Council was there – in W.E. Williams's phrase – to 'build a new culture,' not to take account of the massive provision that existed for the old. The 2,600 village halls of pre-war Britain were to be replaced, for the higher purposes, by new 'Arts Centres'. The first example of such a cultural fortress, the Bridgwater Arts Centre, would, according to a 1947 essay by the Secretary-General of the Arts Council, 'serve the South West'.[1] The local authority library network, which was begun in 1845, and which was and is arguably the greatest achievement of British arts provision, but which is fatally flawed in establishment eyes by its accessibility and by its local authority control, nowhere featured in post-war plans for Britain's supposed renaissance, nor did the massive local authority promotion of Festivals, Carnivals, Wakes, Galas and Fairs which had survived the legislative culls of the late nineteenth century.

A second stage was the daring 'approach' (his term – the image of the intrepid explorer bravely approaching a wounded rhinoceros comes irresistably to mind) to the English Local Authorities by N.J. Abercrombie, who was first Secretary-General of the Arts Council and later its Chief Regional Adviser. He had first, been 'approached' by the new Secretary of the Association of Municipal Corporations, Sir James Swaffield, because Swaffield acknowledged 'my position was at the heart of what he knew was the least-developed part of his business.'[2] Abercrombie recognised that the local authorities were not absolutely ignorant of, nor totally hostile to, the arts, Boroughs tended to have a museum 'of sorts, with or without a (picture) gallery'; the Victorian tradition of philanthropy persisted 'in a few large towns' of aiding music; there were the libraries of course, but it was 'exceptional to find a town library in which local initiative is suffered to impress any distinctive 'cultural' stamp upon the range of its activities.[3] 'All these elements of the

Municipal scene had more than a half century of experience behind them, with a corresponding measure, in some cases, of conservatism and decay.' Plainly, the local authorities' interest in their citizens' cultural welfare was, until the Conference of the Municipal Associations in 1963, and until the Secretary-General of the Arts Council had mobilised them for enlightened action, a flickering flame and everywhere close to extinction.

'The whole of the first day of the Conference was devoted to 'Local Patronage of the Performing Arts'. It seemed successful at the time, and I have been told since by a senior member, I believe correctly, that it was a 'turning point'. Not in the sense of a reversal of direction, but as though a tide, which had then scarcely begun to show evidence of moving at all, was afterwards found to be swelling.'[4]

Thereafter – we are always assured that it was for the first time – some local authorities, by subtle coaxing from the Higher Enlightenment, began to take an active interest in the Arts, and indeed – the third stage of establishment patronage – may now sufficiently be trusted to enter into equal partnership with the Arts Council and its agencies.

Over simplification of the case though this may be, it is not an absolute distortion. The special redefinition of the Arts which the postwar Arts Council has come to adopt has meant that the long and complex work of our local authorities in promoting, financing, licensing (and often prohibiting) the arts has fallen outside the Council's field of vision. Because its particular notion of what constitutes the Arts is as it is, it cannot *see* the libraries, the museums, the civic galleries, the local authority leisure, arts and educational centres, local radio, the local authority-aided amateur music and drama, the poetry societies, the schools and colleges at work in the arts, the Fairs and Festivals and the Carnivals promoted and run by the local authorities, any more than it can *see* the huge commercial arts world. 'There is no worthwhile music north of the Trent', 'Nothing happens in Sunderland', 'For thirty years there was no arts activity in Eastbourne'. The judgements roll out glibly enough, assuming always that the Arts, the *real*Arts, are those subsidised metropolitan amusements whose 'standards' are maintained by general taxes, and whose communal worth is validated by the imprimateur of the Arts Council of Great Britain. The Council's occasional gestures towards

decentralisation show this clearly enough; metropolitan standards are passed to Regional Associations along with the 'development' money, so they may build 'new audiences' once again for Arts Council approved activities, 'to make a powerful argument for increased funding in the future from the government, local authorities and private sponsors' of the Arts.[5]

Any wider view however will show us that this view of Britain's cultural history is not merely mistaken, it is destructive of those very populist ambitions the Arts Council occasionally professes. Our local government bodies have a long and complicated history in arts provision, in arts licensing and in arts funding; they have played a central part not just in the provision of popular entertainment or the provision of facilities for amateur art activities, but in those popular activities which, in any cultural map, we tend to ignore because they are *too* broadly based for us to categorise and localise their significance. The local authorities too have played, and do play, a central part in the provision of the high arts, and it was indeed within the forums of local government that the battles of the late nineteenth century between the chaste Apollonians (who wished to use leisure for improvement only) and the Dionysians (who wanted to keep elements of the old revelry) were fought.

In the eighteenth century, the role of local government – varying as it did in nature between democratic survivals of the guild system in some older towns, and the more or less benevolent rule of small oligarchies in others – was in part permissive: licensing printers, approving building plans for theatres and museums, working with the visiting showmen in the annual fair. In part it was also promotional, building assembly rooms by civic subscription, promoting civic balls, concerts and civic ceremonial, and direct funding of a huge range of festivals, carnivals and other communal celebrations. Thus the Three Choirs Festival was begun in 1713, and civic initiatives created the Birmingham Festival in 1768 and the Norwich Festival in 1770. The Aldermen of Stratford upon Avon brought David Garrick to their town in 1769 for the first Shakespeare Festival.[6] The authorities at Birmingham, like many others, licensed and promoted wakes – street festivals which had their origins in celebration of the local church's Saint's day, but which had become secularised and coarsened with the years – such as Bell Wake in Navigation Street, and Chapel Wake on the north-eastern side of the town. Many eighteenth century

incorporated towns held official celebrations for the townspeople on November 5th whose features were a bonfire, music, firework displays and dancing: Guildford corporation, for example, paid for such an event, as did Lewes and Chelmsford. In Exeter the proceedings were a little more solemn; the Guildhall was illuminated and mayor and corporation led a signified street procession to the cathedral to give thanks for the deliverence of James 1st.[7]

The inns and coffee houses of the eighteenth century, built by businessmen with local government permission but otherwise little constrained by licence or local authority control, provide a vast communal resource complementing the Guildhalls, the corn exchanges, markets, assembly halls and town halls built by the J.Ps, the Aldermen and the merchants and owned directly by the authorities. Meetings, election addresses, sunday schools, plays, vestry meetings and exhibitions were as likely to be held in the inn as in the local guildhall or church. Concerts were *more* likely to be held in the inn than elsewhere – even when promoted by the local authorities – because so many had fine organs in their public rooms, left, in some cases, from the Puritan rule. Some ordinary charity schools even took place in the inn; the temperence movement did not gain a popular hold until the 1820s and no objection was voiced to children sitting with grown ups drinking their 'small beer'.

Until the coming of the railways the major function of the British inn was however as a transport centre. It was there travellers stayed overnight and in the inn yard that they mounted the stage coaches.[8] But there was always a secondary function, that of providing entertainment with the hospitality; plays in the inn yard, winter music, recitations and fireside stories, puppetry and magic lantern shows were all a part of the eighteenth century entertainment to be found at the local traveller's rest. From the middle of the nineteenth century however the communal entertainment becomes the predominant feature of the proliferating city pubs, and at the same time their licensing moves steadily under local government control. The 1839 Police Act required London's pubs to close at midnight on Saturdays and not reopen until 12.30 on a Sunday; in 1854 all pubs were required to close on Sunday afternoons. Sir George Grey's *Public House Closing Act* of 1864 specified weekday closing hours for London pubs, and in 1872 unrestricted weekday public house hours outside London were ended.

Even more important, *activities* within the pubs were brought increasingly under local authority control. From the eighteenth century music and dancing had been permitted within public houses and, until the 1870s, such houses had no need to apply for any kind of further authority to carry on their businesses. However, from that decade, a series of acts forced houses to apply annually for magistrate's licences in order to having singing and dancing on their (now 'licensed') premises. The increasing control over licensed premises gives us an important illustration of the way the battle between revelry and self-improvement in leisure tended to go in the nineteenth century.

The urban pubs, with their small 'pleasure gardens' round the back, and their song and supper rooms, thus provide a central focus in any picture of the nineteenth century arts. First, they are important by sheer weight of numbers. In 1896 Manchester had one pub for every 168 persons, Sheffield one for 176, while other figures are Birmingham 1,215, Liverpool 1,279, Leeds 1,345 and London 1,393. Second, they are important for the range of their cultural activities. Robert Lowery, for instance, recalls that in Newcastle during the 1830s:

'Every branch of knowledge had its public house where its disciples met. Each party in politics had their house of meeting – there was a house where the singers and musicians met – a house where the speculative and freethinking met – a house where the literate met – a house where the artists and painters met – also one where those who were men of science met!'[9]

In London, the range of entertainments at the *Eagle* in the City Road was legendary, ranging from dance to pantomime.[10] They also, like the *Star and Garter* near Kew Bridge organised regular balloon ascents as entertainment for their regulars. In the *Green Dragon*, in Fleet Street, the Public Executioner Marwood held regular court. Up in Bolton, the *Star* held over a thousand each night, flocking to see its menagerie, museum and picture gallery. There was a picture gallery too, and a library and reading room, in Charles Morton's London *Canterbury Hall* where music hall supposedly began its most characteristic phase of life, which soon led to the *Hope and Anchor* in Drury Lane becoming the headquarters of the music hall artists' benevolent society, and a clearing house for engagements. Many pubs were serious debating centres; the

Barley Mow off Fleet Street was one such, and Birmingham's *Hope and Anchor* another. The meetings of the Chartists, the noncomformists and other political groups in such surroundings puts the motives for the increasing legislation to control pubs and music halls in a different light. As Harrison observes, 'The cultural and political threat from pub culture lurked at the back of many a Victorian politican's mind.'[11]

The *Municipal Reform Act* of 1835 began the process of formalising local government, widening the franchise and increasing its responsibilities. The process was substantially complete by the *Local Government Act* of 1894, by which time there were county councils, county boroughs, urban and rural district councils and, in the rural districts only, parish councils. An act of 1888 had meanwhile faced the distinct problem of the capital by creating the special London County Council. The new councils took on the problems of civic planning and housing (though it was too late to do anything about the ugliness of Britain's unplanned industrial cities), sanitation, transport and roads, education – and matters of public safety and public order. Although legislation on safety seemed to be primarily directed towards places of work, concern for public safety was a cloak beneath which the authorities were enabled to license and control places of public entertainment and leisure.

This was particularly true in the case of the music halls – the one nineteenth century activity which might justly be called a working class art.[12] The growth of this urban entertainment was prodigious. In the 1860s it is calculated that there were at least 33 major halls in London, and 300 major halls outside it – 9 in Birmingham, 10 in Sheffield, 8 in Manchester and 8 in Leeds. The smaller, unlicensed venues in pubs and city cellars greatly outnumbered them: the publicans' newspaper, the *Era* claimed there were at that time more than 200 in London alone. It was the smaller music halls, the spittoons and penny gaffs, which were closed by the new safety and licensing laws and by the increased numbers of inspections made of their premises. The larger houses, which were built to the authorities' requirements, and which were managed not by the working classes themselves but on the whole by the conformist members of a capitalist middle class, were less harmed by the new restriction.[13]

In other realms the desire of the new authorities to succour wholesome and improving art and to curtail seditious amusements was even more apparent. The *Brighton Herald* summarised responsible civic feelings

when it surveyed the application of a Mr Trotter to run the town's Theatre Royal in 1814:

> 'The town has sufered, in too many instances, from the imprudent speculation of needy and unprincipled adventurers, and we are determined to support Mr Trotter in his venture, and equally resolute on all other occasions to oppose such persons as may attempt theatrical management, whose characters may be objectionable and promises renewal of those grievances as those, of which, at this time many feel that they have certainly a right to complain. On the present occasion, a petition, or appeal, has been framed to be presented to the Magistrates at the Quarterly Sessions at Lewes, in April, stating the inconvenience and pecuniary loss, etc. which the town has suffered from the causes above stated and recommending Mr Trotter to their notice as fully qualified to direct, with advantage to himself, and satisfaction to others, theatrical concerns in this place ... The Appeal is signed by the Churchwardens, Overseers, High Constable, and the principal inhabitants of the town.'[14]

The kind of admixture of commercialism and charity desired in any applicant for a licence was exemplified by Thomas Harwood in 1852 when he told the Select Committee on Public Houses that, 'it always struck me that the working classes could have a better description of recreation, supposing a person could *speculate sufficiently largely* and give the recreation at a low price.'

Bawdy entertainment, in the guise of the travelling showmen, and the kind of sedition that seemed dangerously intertwined with such working class arts as the music hall were both fettered and shut away by the new licensing operations of the local authorities. Family pleasures, and 'properly conducted' entertainments were however encouraged. The pantomime thrived under the new licensing arrangements, as did the cleaned-up middle class version of music hall, the variety theatre.[15] The dangerous pleasures of the fairground or the music hall were counteracted by the new civic museums, the reading rooms and the civic concert halls, all built and provided for by the new local authorities. Many spa towns and holiday resorts hired musicians to play regularly for visitors – some, like Folkestone and Buxton, being hauled over the coals by parliament for

spending too much on such things – and Bournemouth went even further and, in 1893, founded its own orchestra.

The provision of open land for recreation followed something of the same path. Some urban parkland was bequeathed, like Caesar's parks this side Tiber, to the general community; St. James's Park, Hyde Park, Green Park and Kensington Gardens together form such a gift, although it has to be said in fairness that Henry VIII took the land from the Church in the first place. Some was bought by the new urban authorities in the nineteenth century, as in north Birmingham, and run as a civic park – with tightly ordered pathways, 'keep off the lawn' notices, and closure at dusk. There were also commercial parks, largely sporting grounds operated under excise beer licences, and on them the authorities kept an increasingly vigilant eye from the 1870s. In all of them the civic bands played, occasionally galas and festivals were promoted, and around the turn of the century civic pageants and processions formed up on their grass. In some holiday towns and in the London County Council parks the summer programme arranged by the civic authorities – music, dance, exhibitions, puppetry, pierrot shows and magic displays – were impressively wide. On a seaside pier – the shoreline equivalent of the inner city park – one could at the turn of the century enjoy a broad range of civic entertainment, from Minstrel Shows and Children's Entertainers, through Punch and Judy booths to specially-written music in full orchestral recitals.[16] Holiday entertainers gained their own kind of local fame; the Adeler-Sutton Pierrots at Weymouth, Will Catlin at Scarborough, Allandale at Blackpool, Clifford Essex at Cowes.[17]

By the first world war, local authorities were employing in one way and another well over a thousand people engaged in the 'leisure industry' – librarians, museum curators, gallery directors, pier managers, musicians, art lecturers and their own licensing and promotion officials. It was still predominately a masculine industry, in spite of the stirring work of Emma Cons and Annie Horniman, and in spite of the efforts of the *Association for the Promotion of the Employment of Women*, which had been set up in 1858, and the *Actresses' Franchise League* (1908) with its Actresses' and Musicians' sections. Increasingly however the women's movements impinged upon the order of both the national and the local arts' events. Henry Irving's funeral in 1905 at Westminster Abbey was partially disrupted by chanting suffragettes, and the pride of the L.C.C.'s

recreational parkland, Hyde Park, attracted the biggest public gathering since the Great Exhibition when, on Midsummer Day 1908, thirty special trains helped to bring half a million people to a mass demonstration in favour of votes and fuller work opportunities for women.[18]

4.1 The Twentieth Century

Provision of, and licensing of venues for public recreations has throughout the twentieth century continued to be a central part of local authorities' work. As late as the 1950s, for instance, there were more than 500 dance halls still licensed for that purpose alone in Britain, while almost all of the 750 city and town halls were regularly used for 'Saturday hops'. It wasn't until the 1970s, when, typically enough, the Arts Council announced we were at the start of a 'dance explosion',[19] that the vastly popular world of ballroom dancing which at one time had regularly involved more than three million people, finally collapsed.

Even popular dancing set problems for the local authorities however. Their responsibilities continued to pull them in different directions; they were empowered to satisfy the ratepayers' reasonable wants, but also had duties to maintain public safety, good order and general health. The waltz caused trouble; was it a reasonable recreation or, as some said, an immoral and inflammatory activity? And that was nothing in comparison with the Argentine tango. Father Bernard Vaughan, a Jesuit much in the public eye, at once warned the nation against it, 'I have been too long with human nature not to know that, like a powder magazine, it had better be kept as far as possible fireproof.'[20] A correspondent to *The Times* in 1913 announced that such dances as the Turkey Trot were 'frankly symbolic of those primitive instincts of human nature which it is the aim of civilisation to suppress.' William Boosey, the music publisher, meanwhile wrote to the *Telegraph* complaining about the 'vulgar and decadent 'one step''.

Then followed another horrifying difficulty – jazz! 'What its effect will be, said the *Dancing Times* in 1917, 'time alone will show.' The 79-year old physician Sir Dyce Duckworth announced memorably in the *Evening News* in 1919 that he had not seen 'the Jazz' himself, but from what he had heard of it, 'it was not likely to be continued by decent people.' And so, in the nation's dance halls, notices saying 'No Tangoing' were succeeded by notices saying 'No Jazz', then in the twenties 'P.C.Q.'

(Please Charleston Quietly), through a whole sequence of anxious temporary prohibitions, ending with the last curt instruction in dance halls of the 1950s, 'No Jiving'. They took their places alongside a plethora of other local authority prohibitions, signals in public places of the authorities' difficulty in reconciling popular provision with popular control; 'No dogs', 'No smoking', 'No Jitterbugging', 'Keep off the Grass', 'No Ball Games', 'Please Wait Quietly', 'No Parking', 'No Whistling', 'No Food May be Taken Outside', 'No skateboarding', 'No cycling', 'No Transistor Radios', 'No Entrance'.

Of all its difficulties however, local government probably found the licensing of films for popular exhibition the most arduous, and in that realm alone local authorities have unequalled knowledge of the problems of arts administration. The British Board of Film Censors, which started its work on January 1st 1913, was a 'purely independent and impartial body, whose duty it will be to induce confidence in the minds of licensing authorities.'[21] Local authorities however, the licensing authorities in law, were nervous about the status of that body and wanted something tougher – though they did not wish to relinquish their ultimate powers as licensers. In the event a newly constituted Board was set up in 1916, with clearer powers. Soon County Councils began to make it a condition of granting licences to cinemas that the certificates issued by the British Board of Film Censors should be accepted, and that arrangement has broadly remained until the present day. Film Censorship is not under central government control; it is an independent activity, and local authorities, though generally accepting this, have the right to override the recommendation of the certificate as to who should see the film, for showings in their own licensed premises.

One may assume that in broad terms the Board's instincts were allied to those of the local authorities. However there have been occasions when local authorities have disagreed with the Board and indeed with each other. There were some who objected to *The Jazz Singer* (although it is their grounds for doing so which we would now find objectionable), and some authorities who refused to show 'X' films in their cinemas at all. Sex films caused different degrees of tribulation – *Last Tango in Paris* for example was a curious phenomenon, the presence of Marlon Brando in the cast apparently ensuring its respectability in some eyes, while its much-discussed buggery scene led to its being banned by others. The

result was that the citizens of Leeds had to travel to Bradford, and many midlanders to Birmingham if they wished to see the X-rated film.

Local authorities have however done much more than involve themselves in licensing the arts. They have taken a bigger part than is generally acknowledged in direct promotion and in direct purchasing within the arts economy. A number of County Councils for example have built up impressive picture collections over the years, sometimes regarding their purchases as an investment (which was largely the case with Somerset), sometimes regarding them as an educational resource, as in Leicestershire, and sometimes exhibiting them in local galleries. Municipal collections in county towns such as Lincoln or Chester are often of surprising range and interest.

From the beginning of the century local authorities have continued *directly* to promote a vast range of musical events, but drama has been forbidden. In 1925 that situation seemed about to be rectified, for the first draft of the *Public Health Bill* of that year sought to permit local authorities to spend up to twopence in the pound (or even a higher rate if it were approved by central government) on concerts *or other entertainments.* Had the bill gone through parliament in its intended form, local authorities could have directly promoted plays, and used rate money to do so. However, there was massive opposition from the commercial theatre managers, operating through their strongest professional body, the Society of West End Theatre Managers, and the clause was modified in its Lords reading to exclude stage plays and variety entertainments. Thus the local authorities reverted to the position of effectively being *forbidden* to run theatre companies.[2]

After the second world war their position was slightly modified. From 1948 they were permitted to spend up to sixpence in the pound on the arts, and that could include the drama. Some authorities spent it on maintenance of an existing theatre building – like Sunderland, the only authority at first to spend the maximum permitted sum, and who spent it on the Empire. In the 1950s some authorities began to consider the possibility of building *new* theatres from scratch and Coventry was first in the field, opening the Belgrade Theatre in 1958. Through the sixties and seventies some fifty new repertory theatres were built by local authorities, and some of the large old theatres in their cities were saved from destruction. A few authorities also followed Coventry's other lead and built new municipal art galleries.

The *Local Government Act 1972* made explicit the powers which the authorities were increasingly assuming. Section 145 stated that:

A local authority may do, or arrange for the doing of, or contribute towards the expenses of the doing of, anything (whether inside or outside their area) necessary or expedient for any of the following purposes, that is to say –

a. the provision of an entertainment of any nature or of facilities for dancing;

b. the provision of a theatre, concert hall, dance hall or other premises suitable for the giving of entertainments or the holding of dances;

c. the maintenance of a band or orchestra;

d. the development and improvement of the knowledge, understanding and practice of the arts and the crafts which serve the arts;

e. any purpose incidental to the matters aforesaid, including the provision of refreshments or programmes and the advertising of any entertainment given or dance or exhibition of the arts or crafts held by them.

The section goes on to make it clear that the authority may charge for admission on its own account, or may make such hiring arrangements as it sees fit to other promoting bodies working on its premises, who may charge in turn. The implication is that normally a theatre company will be set up as an independent limited company with charitable status, and that the local authority will then subsidise it, or that the local authority will simply hire a commercially-run company to perform on agreed terms in its theatre. That has normally been the case, although there are many examples, particularly in the field of musical theatre, of local authorities becoming involved in direct promotion.

This has however meant that overall, the local authorities' sponsorship of theatre has been less happy than their massive support of galleries, museums and music programmes. They have remained in uneasy coalition with the Arts Council and with a band of profit-seeking commercial providers who, recognising that their productions will not make money on an ordinary 'split' of box office income in the Arts Council-inspired small new civic auditoria, have demanded high 'guarantees' to bring in their touring plays, cheaply-staged musicals and tawdry pantomimes.

Local authorities have thus been caught in the middle in this one realm – theatres that they wre encouraged to build in certain ways for reasons of high Art are in fact too often filled with second-rate commercial tat, which costs far more than it ought in guarantees from the rates.

Meanwhile the large old theatres with their commercially-viable auditoria have too often been left to decay and demolition. There have been (with belated support in the seventies from the Arts Council) some efforts to save at least a few, to provide a skeletal circuit for the national dance and opera companies to perform in, but the majority have gone. And the public has, as in other areas, found that provision for the popular arts has been replaced by a much narrower provision, ostensibly for subsidised Art.

DECLINE IN SEAT NUMBERS IN PERFORMING ARTS VENUES IN
BRITAIN 1950–1980

	1950	*1980*
Birmingham	8,040	4,720
Glasgow	18,989	5,601
Liverpool	7,778	5,399
Leeds	5,350	2,837
Manchester	9,208	3,831
Sheffield	4,964	1,240
Gateshead	1,087	Nil
Huddersfield	2,000	Nil
Luton	2,569	256
Middlesborough	3,050	Nil
Northampton	2,333	650
Norwich	3,050	1,275
Oldham	3,530	1,010
Stockport	2,000	500
Wolverhampton	2,503	Nil

An important side-effect of this savage drop in capacity has been that local Amateur Operatic Societies (whose significance we mentioned earlier) have frequently found that in small and medium-sized towns there is nowhere for them to perform, for this drop in theatre seating has been accompanied by a massive and continuing drop in cinema provision, and latterly by the fact that those cinemas remaining have, in all but a few cases, been subdivided into miniscule 'speciality' houses. Many towns and some cities in Britain are thus left without a large-scale venue for drama, opera, dance or traditional pantomime, and nowhere for the amateur societies (who were often the most popular item on the year's programme) to present their work.

It is in the realms of amateur activity, as well as the small-scale alternative and community arts activities, that the 456 local authorities existing in England and Wales after the April 1974 reorganisation rest one of their most important recent claims to recognition. The sums may often appear small, but this is in part because the figures produced by the Chartered Institute of Public Finance and Accountancy ('after discussions with the Arts Council of Great Britain') register only direct subsidies to plain arts organisations – the massive *indirect* subsidy system, the direct and indirect aid to all kinds of amateur and community work given through the education and social services budgets, is nowhere evaluated.[23]

We have however had some indications of how generous this kind of support may be from the extensive publicity recently given to the direct spending in this field of the Greater London Council, set up in 1965 as replacement for the old London County Council, and the six metropolitan county authorities (Great Manchester, Merseyside, South Yorkshire, Tyne and Wear, West Midlands and West Yorkshire) established in 1974. The seven authorities were abolished, after considerable public turmoil, by the *Local Government Act 1985*, which divided their various functions between a ragged panoply of 32 London boroughs, the City of London, ILEA, sundry quangos such as the Thames Water Authority and the Arts Council, 36 metropolitan district councils, 19 newly-elected Joint Boards, one new London-wide statutory body for waste regulation, four statutory authorities plus a further three non-statutory joint authorities to dispose of London's waste, a statutory authority for waste disposal on Merseyside, and one for Greater Manchester (excluding Wigan). Seven residuary bodies were set up to deal with outstanding financial questions

in each metropolitan area, and, representing the boroughs and districts in each area, seven new co-ordinating committees.[24]

Spending on the arts, particularly community arts schemes and minority and alternative activities, grew dramatically in the last days of the GLC and indeed such expenditure was used as a propogandist argument for keeping the GLC alive.[24] In their last full year of activity for which reliable figures are available, the GLC spent £2,416,489 directly on amateur and community arts projects. The 189 allocations were for diverse activities – Community Bookshops, Film and Video Groups, Photography Groups, and Multi-Media Groups such as Walworth and Aylsbury Community Arts Trust who give equal weight to work in a whole range – drama, print, sound broadcasting, music and photography.

The propogandist argument for this[25] was unfortunately often couched in quantitative terms – the government, it was alleged, would leave this segment of the arts to die after abolition. The Arts Council joined in the public posturing, insisting that the extra monies given to them by government to deal with those parts of 'the' funding pattern for which they were to assume responsibility were insufficient. Inevitably the public debate focussed around the future of the prestigious large-scale organisations which the GLC or the other authorities had funded – Sadler's Wells, the Manchester Hallé, Liverpool Playhouse and the like – and the smaller enterprises were forgotten. And when the smoke began to clear it became clear that the additional money given to the Arts Council coupled with the generally willing adoption of some responsibilities by the boroughs would, in purely quantitative terms, close the gap, at least in the immediate short term – that is, as much money (from all sources) would be coming in to 'the' arts economy as before.

However, there had been a significant qualitative shift. The prestigious organisations were 'saved'; much small-scale, experimental, *amateur* and minority culture work died.[27] More important the overall organisational and political structure of the subsidised Arts world became more bureaucratic still, became, through the imposed political 'partnership' of Arts Council and the local authorities, ultimately more centralised in control, more organisation-centered, more politicised and incomparably *duller*. In spite of its professed recent belief that the Arts were to be found in 'village hall and university campus, in cathedral, in youth club and in another thousand different settings' there is no sign in the Council's

behaviour that it has begun to rethink the nature of the Arts world it has created, and no sign that its traditional stance to the local authorities of cultivated metropolitan superiority[26] is actually changing. The 'partnership' with the vastly underrated local authorities is a short term expediency to maintain the authority of the established Arts Council, and (a better reason, it might be thought) a means of maintaining favoured arts organisations. The Council and local authorities are not however natural bedfellows, if only for the reason that they each primarily operate according to different models of government subvention. The Arts Council's redefinition of the Arts is in part *designed* to be hostile to the work of local authorities, as it is hostile to any play of free market forces; all non-subsidised activities are denigrated. As Dr Alan Tomkins rightly remarks, 'Local government is the largest resource and funding source in the UK . . . It is not a 'backdrop' (the Arts Council's term) to the work of the Arts Council of Great Britain.'[28]

More than anything the sharp definitions of subsidised Art, popular art, amateur arts, community art and the rest focus public debate too narrowly upon politically confining concepts, and, by assuming that all questions of value (and 'standards') have to relate to those terms only, stop us from looking at other social forms which give value and significance to our lives, and which therefore might reasonably be assumed to have something in a wider sense to do with 'the arts'. The greatest significance of the local authorities' role has always been and is, not in the contribution they may choose to make (significant though this is in its own way) to the Arts organisations favoured by the metropolitan establishment, but in the indirect and direct contribution they make to our whole culture; the parks, the commons, the playgrounds, the market places, the licensed premises, the playing fields, the allotments, the conference centres. That provision, and the legal and financial infrastructure of local authority service, gives life to the myriad social forms in which most British people live. Subsidised Arts provision by contrast seems to assume, by its timings and its nature, that the Arts audience behaves in much the same way as it did in Victorian times; supper and the evening theatre trip for the family, while Mama will sometimes take her daughters of an afternoon for a promenade around the gallery. Yet we do not live in the kind of family clusters much Arts advertising assumes,[29] nor is our 'leisure' a limited commodity, utterly separate from 'work' and

something apart to be planned and cultivated by the discriminating, and 'wasted' by others. The old separation of 'work' and 'leisure' no longer holds good; the two realms intermingle and much of our time is spent in activities of quite different intensities which often merge the two – we are engaged in working holidays, on conferences, travel to and from jobs and meetings, in neighbourhood associations and community work, social service, voluntary work, on committees of the allotment association, sports club and social club, organising village fêtes and street parties, fund raising for charities, engaging in local politics, organising the pub darts team – the list of *dedicated* leisure activities will be different for each of us, but there will be few people who can plainly divide their functioning lives simply between 'leisure' and 'work'.

And in that area of dedicated leisure time, our local authorities make massive contribution – though one which will not show up at all if we simply focus on the question of direct funding for designated Arts organisations. To take one simple example of something never mentioned in descriptions of 'the' political economy of the Arts, that of conferences. Many local authorities (Birmingham, Brighton, Harrogate and Bournemouth among the most prominent) have invested in huge amenities which are termed conference centres, and which thus fall outside the description of Arts provision; yet the music, the dancing, the films, the exhibitions, the dramas that are presented within them each year would make an impressive list. Indeed just as conference centres impinge upon the arts, so do larger arts venues impinge upon the conference circuit by competing for lucrative conference bookings; the Nottingham Centre, St. David's Hall in Cardiff and Blackpool's Winter Gardens are three such. The 'conference economy' is huge. Birmingham for example is starting on a £106,000,000 convention complex in its city centre and the London Exhibition Venues Association (Earls Court, Olympia, Barbican and Wembley the largest venues involved) has already invested £250,000,000 in its venues and organisation. This economy, which is growing by 8 to 10 per cent each year, has a local authority base, and it is at least ten times the size of the subsidised Arts economy; expenditure on exhibition *advertising* alone last year was £191,000,000, greater than the total government grant to the Arts Council. Conferences, neither work nor leisure for much of the time, involve a fifth of the adult working population each year, and are a form of provision which has an effect upon our whole national

culture. Yet, as with so much else, our dominant definition of 'the Arts' ignores it, and ignores the local authorities' role in it.

Footnotes

1. Evans I. and Glasgow M., *The Arts in England* (Falcon, 1949)
2. N.J. Abercrombie, 'The Approach to English Local Authorities' in J. Pick (ed.) *The State and the Arts* (Offord, 1980)
3. This I particularly resent. The Denman Library in Retford was my home town library and was most certainly imbued with a distinctive 'cultural' stamp. The library was a centre for drama rehearsals, exhibitions, meetings, debates and an admirable place in which to find books.
4. Abercrombie, p.64
5. *Glory of the Garden* (ACGB, 1984)
6. Stockholm, *Garrick's Folly* (Methuen, 1964)
7. R.D. Storch 'Conflict, Solidarity and Public Order in Southern England, 1815 – 1900', in, Storch (ed.) *Popular Culture and Custom in Nineteenth Century England* (Croom Helm, 1982)
8. The railways followed the general practice, by building large bars in their stations, not recognising that rapidly transported passengers might be less thirsty.
9. M. Harrison, 'Pubs', in H. Dyos and M. Wolff, (Eds.) *The Victorian City; Images and Realities* (Routledge and Kegan Paul, 1977)
10. See F.Fleetwood, *Conquest; the Story of a Theatre Family* (Allen, 1953)
11. Harrison. *Op Cit*
12. As T.S. Eliot did.
13. The average capitalisation of London's major 33 halls was 10,000 and their average capacity 1,500. This and much else of value in P. Bailey, *Leisure and Class in Victorian England* (Croom Helm, 1978)
14. M.T. Odell, *Mr Trotter of Worthing and the Brighton Theatre* (Worthing, 1944)
15. The Moss Empires Music Hall syndicate was capitalised in 1900 with nearly £2,000,000.
16. I am grateful to Mr Gavin Henderson for much insight into piers.
17. A cheerful account is given by Pertwee, *Promenades and Pierrots* (Westbridge, 1979)
18. J. Holledge, *Innocent Flowers* (Virago, 1981)
19. That is, more people attended the *subsidised* dance programmes.
20. P. Fryer, *Mrs Grundy: Studies in English Prudery* (Dobson, 1963)
21. J. Trevelyan, *What the Censor Saw* (Joseph, 1973) Quoting the original terms of the 1913 Board.
22. Nevertheless, very many did, particularly the resort authorities.
23. A.H. Marshall, in his invaluable *Local Government and the Arts* (INLOGOV,

1974) remarked that 'a research project under way at the Arts Council at the time of writing should enable the local authorities' total effort to be evaluated, in addition to bringing to light the full scope of their very varied activities in this field.' Unfortunately, the effort has now been pared down so that sets of annual figures are produced 'after consultation with the Arts Council' which inevitably represent only a fraction of the full varied effort.

24. The aim was ostensibly, amongst other things, to reduce the bureaucracy, but, as with the 1974 reorganisation, the likely effect is to increase it. It was noticeable for instance that, although the government claimed that most of the GLC's functions would be handled by the boroughs, the London Residuary Body's first budget was two thirds that of the outgoing GLC; the full-time chairman of that body has a salary of £50,000 and the body will remain in existence until 1991.

25. See for example *A New Dark Age for the Arts in London* (GLC, 1984) Though stressing the GLC's contribution to London at £2,509,243 (revenue grant) it also quietly acknowledged that the boroughs were then *already* contributing £2,110,662 to arts organisations' revenue.

26. When I took up a post as 'Director of Arts Administration Studies' in 1976, which activity was predominately funded by the Arts Council, I was told not to take in local authority people because 'We don't want them learning our secrets'.

27. About 60 of the organisations formerly funded by the GLC did not receive 'replacement money' after abolition.

28. Dr. Tomkins' own essay in his *The State of the Art or the Art of the State?* (GLC, 1985) on 'Leisure Policy' cogently summarises the obstacles to local authorities with radical objectives.

29. The standard picture of the male breadwinner with housewife and two children is quite wrong. Such 'typical' breadwinners made up by 1979 a mere 5% of the labour force in Britain. Only a quarter of British households are made up of four or more people, and more than one family in ten has a lone parent, rarely male.

CHAPTER 5

THE ARTS ECONOMY

'I have always disliked the phrase 'the arts', it denotes to me furs, black ties and cocktail receptions, the patronage by the wealthy of work that is peripheral to their lives, or that fills them not with dread or awe or visionary joy but with self-satisfaction. 'The arts' have nothing to do with the loneliness of writers or painters working in their rooms year after year, or of actors putting together plays in lofts, or dancers tearing at their bodies to make special descriptions with the hope of beauty or transcendant truth. So, as a working writer, I distinguish myself from the arts community.'

E.L. Doctorow, Evidence to the U.S. House Appropriations Committee

Right-thinking people know there is only one Arts economy in Britain – the one delineated by Arts Council subsidies. Moreover that economy exists in its present state because the general public (who had no contact, it is understood, with art before Britain had such a Council) cannot be expected to support Art in its highest forms.[1] The government therefore must, from a judicious admixture of philanthropy and self-interest,[2] agree to ever-greater financial aid. The characteristic note, as ever, is sounded by Sir William Rees Mogg:

> 'The Arts Council grant is equal to the interest on the capital cost of the Trident programme. This is the relative priority the state gives to the enhancement of the human spirit.'[3]

The sweeping assurance that the enhancement of the human spirit, all of it, bears a simple causal relationship to the size of the government's grant-in-aid to the Arts Council is a central plank in the metropolitan arts establishment's platform. Another plank, no less warped, is that Britain 'gives less' to the Arts than other countries, and is therefore judged to be more uncaring and more philistine than, say, West Germany.

It is hardly worth the trouble of demonstrating the unsoundness of

both of these weary and endlessly reiterated tenets. The quality of our lives derives *sometimes* from activities generated within the subsidised Arts framework of course, but many people live lives of resounding quality without any contact at all with those things which concern the Arts Council, and few live lives whose quality and character is wholly dependant upon subsidised Art. As for the comparisons with other governments' enlightenment, if the judgement is to be made entirely upon the proportion of the GNP they give to the Arts, and if the mark is the size of that part of the Arts budget borne directly by the state, then we should turn our entire admiration to the Soviet Union, or learn from past successes such as Mussolini's Italy, where both proportions put Britain to comparative shame. Neither argument is worth pursuing however, for the whole platform rests upon a collapsing foundation. There is not just one Arts economy in Britain – even the different realms of the subsidised Arts work quite differently – and the subsidised Arts economy is a small part of the whole economy of the arts; and it is not, as it likes to claim, invariably at the generative core of the wider economy. Taking the wider definition of the arts – including the commercial, amateur, media and domestic realms of creative activity in addition to the workings of subsidised Arts organisations – we shall now note some characteristics of the wider economy, and then shall examine some of the claims repeatedly made for 'the' subsidised Arts economy, and show them to be only partially true.

The first characteristic of the arts economy we shall note is that, particularly since British homes have had electric lights in them, fewer creative pleasures have been enjoyed in designated public places and more enjoyed in the home. The development of, first, the national radio system and then the national television networks have meant that most drama and most music is now enjoyed domestically, and, to be fanciful, we can now say that in Britain almost every home 'is its own arts centre':

PERCENTAGE OF HOUSEHOLDS WITH AMENITIES IN BRITAIN

CENTRAL HEATING (Full or Part)	61.8%
REFRIGERATION	96.1%
TELEVISION SET	96.6%
RADIO	99.0%

In 1984 the British spent £1,128,000,000 on audio equipment, and £702,000,000 on records and tapes (a total, incidentally, a hundred times as great as the sum the Arts Council was enabled to spend on subsidising music in Britain's public places). The Council of Europe suggested that, domestically, each European watches the equivalent of two and a half full-length dramas a week. Other relevant figures for domestic spending are:

DOMESTIC LEISURE SPENDING IN BRITAIN (1984)

Weekly expenditure per household	
Books, newspapers, magazines	£2.42
Television, radio, musical instruments	£4.36
Materials for D.I.Y., repairs etc	£2.66

That average expenditure of more than nine pounds compares with a total of more than eight pounds spent weekly on meals and drinks outside the home, and an average of 20p per household spent on theatre and concert admissions.

In 1985 total domestic spending on leisure had risen to £47,488,000,000 of which the most significant features were:

EXPENDITURE ON LEISURE BY ITEM, (1985)

	£
Meals out	5,350,000,000
Alcoholic Drink	15,580,000,000
Holidays overseas	5,900,000,000
T.V., video etc.	5,970,000,000
Books, newspapers etc.	2,990,000,000
D.I.Y. and gardening	4,070,000,000
Other active hobbies and pastimes	3,670,000,000
Gambling	2,200,000,000
Commercial entertainment	1,230,000,000
Subsidised Dance, Opera and Drama (Est.)	40,000,000

Plainly, although the British spend a great deal on domestic pleasure, they spend more on leisure pursuits outside the home. Of this however only a very small amount, about .2% of the total, would appear to be directly spent on admissions to the subsidised Arts.

In view of this, it is hard to account for the widely publicised belief that 'the' subsidised Arts market could not bear higher admission charges, when its clientele is drawn predominately from high income groups who spend high sums on other pleasures. One in five members of the AB social group (who form the bulk of audiences for the subsidised Arts) manage to afford three or more holidays a year. Why could they not then afford the 'real' cost of sitting in the stalls for opera, the ballet or the symphony concert?

Must we assume, whatever the intrinsic merits of the two activities, that even the comparatively small audiences for subsidised Art are so out of tune with what expert opinion says they need, that they have to be bribed to enjoy their pleasures? Devotees of boxing, by contrast, do not ask for state subsidy to alleviate the social effects of the £25 they pay for ringside seats at big matches. Devotees of Bingo pay the 'real' costs of their entertainment in the 1500 remaining Bingo halls in Britain. Must we assume that if the Arts were to raise their top prices to reflect the 'real'

costs of the seats then the Arts devotees would not show a similar loyalty? Unless the fare has become very much less palatable, then it is hard to believe; in past times when the performing arts were wholly commercial, the percentage of the leisure pound spent on them by public choice was very much higher.

But the subsidised Arts, as we have suggested, are seen as inhabiting a curious territory midway between National Glory, General Welfare and Commercialism. Distinctions are smeared over; subsidy is seen as investment in National Glory, as a means of aiding the underprivileged to gain seats at the High Arts, as a means of rewarding the privileged for attending, and as a Placebo for dissenters, all at once.

Rather than repeat the well-known figures, we shall find it useful to add to the conventional picture of government support for the subsidised Arts indications of direct and indirect spending on a wider arts economy.

DIRECT GOVERNMENT SPENDING ATTRIBUTABLE TO THE ARTS 1984/5

Central Government

	£
The Arts (including Arts Council grant-in-aid and National Heritage Memorial Fund)	126,000,000
Museums and Galleries	97,000,000
Libraries	76,000,000

Local Authorities

Museums and Galleries	58,000,000
Libraries	375,000,000

These are the figures listed in the government publication *Social Trends 1986*, which then gives a figure for the *total* public expenditure on the arts, museums and libraries as £732,000,000

This figure is however misleading; the real direct public expenditure is somewhat higher. First, because the local authority spending given above does not include spending on the performing arts at all, and does not include certain other local authority payments to the arts, including contributions to regional and other arts associations. Second, because a number of other elements in the total local authority spending on leisure of £987,015,000 also bear directly upon the arts economy. These are not easy to summarise, but are set down here in as accurate a form as is possible:

OTHER LOCAL AUTHORITY SPENDING ON THE ARTS 1984/5 (England and Wales)

	£
Arts Centres, Halls used mainly for arts purposes	30,599,000
Theatres, performances, entertainment	36,474,000
Other leisure, recreation and cultural facilities	40,940,000
Grants and Contributions (including contributions to RAAs and other arts associations)	25,093,000
One twentieth of total leisure administrative costs in local authorities	7,265,000

Additionally, there are other direct government expenditures, which do not require us to shift far from the narrow definition of the term as we attribute them to the Arts. The Foreign Office, for example, funds the Arts through its annual grant-in-aid to the British Council (which accounts for about three quarters of the Council's income). The Council spends annually about £15,000,000 on the Arts. Without widening our vision very much therefore, we can see that the total direct spending by government at all levels on the Arts economy is around £900,000,000, eight times larger than the figure Sir William Rees Mogg finds the sole enhancer of the human spirit.

A wider sweep gathers in much more direct spending. The radio and television companies spend more than £220,000,000 directly on the arts – the B.B.C. spending three quarters of that sum – and, if one takes the view that television and radio *are* the arts, then the sum could be multiplied by at least ten. The Ministry of Defence spends £20,000,000 on military bands. Local authorities spend directly on the amateur arts also:

LOCAL AUTHORITY EXPENDITURE ON THE AMATEUR ARTS 1984/5 (England and Wales)

	£
Amateur Music	322,679
Amateur Drama	224,804
Amateur Opera and Dance	107,525
Amateur Film, Photography, Visual Arts	71,889
Other Amateur Arts Activities	726,563

Indirect local authority subsidy to amateurs amounts to much more than this £1,453,500 of direct aid. The last survey of amateur theatre suggested for instance that 44% of amateur groups in England received aid, 50% in Wales and 53% in Scotland; only about 33% received assistance however in the form of *direct* aid from the councils. It seems reasonable to assume therefore that indirect assistance from local authorities to amateur work amounts to at least half as much again as direct support.

We can therefore (excluding, for the moment, income to the arts from private and commercial sponsorship) begin to build a picture of the income for the *wider* British arts economy, in which the enlarged picture of government support is juxtaposed to income from consumer spending in various broad categories. The table is broad and indicative rather than definitive. It still does not include some government spending in Scotland,

Managing the Arts?

COMPARATIVE EXPENDITURE 1984

Government Spending

	£
Central government spending on the arts	299,000,000
Local authority spending on the arts (inc.Libraries)	573,371,000

Consumer Spending

Audio, Records and Tapes	1,830,000,000
Arts and Crafts	450,000,000
Books	650,000,000
D.I.Y.	2,302,000,000
Gambling	2,083,000,000
Cinema	124,000,000
Magazines	460,000,000
Newspapers	1,614,000,000
Photography	560,000,000
Musical instruments	223,000,000
Television	2,206,000,000
Video	1,445,000,000
Admissions to the subsidised Arts	38,500,000

spending on the arts from EEC and other international sources, indirect support of arts economies through MSC and other job-creation schemes, and (crucially) any acknowledgement of the massive indirect support enjoyed by the arts from the annual government support of the education system.

It would of course be absurd to claim that the experiences of watching video, reading novels, taking photographs, making a bookcase or listening to recorded music were all of exactly equal merit in some undifferentiated arts world to the experience conveyed by subsidised Arts organisations. It is however of much greater absurdity to claim that *only* those 'state-approved' subsidised Arts contain within them an enhancement of the human spirit, and that all the rest are mere ballast. That 'ballast' is, amongst much else, the public paying to see *Boys from the Black Stuff* and *Edge of Darkness*, paying to read William Golding and Roy Fuller, paying to listen to David Bowie and Spandau Ballet and Captain Beefheart, enjoying Jane Brown's photographs, reading Philip Larkin and Keith Waterhouse, laughing at Jennifer Saunders and Ken Dodd, being mystified by David Berglas, scandalised by Auberon Waugh, cauterised by Kingsley Amis, dissected by Penelope Lively and terrified by Peter Cushing. It would be very hard to say that there is nothing life-enhancing within the commercial arts market, as it would be hard to deny that there are some things within the subsidised sector which are enervating and drab.

Claims for the exclusive value of 'the' subsidised Arts *economy* continue however to be made, (as are claims for the exclusive value of the Arts). Those financial clichés which we shall now examine are all established favourites, and include:

The subsidised Arts provide venture capital for the wider commercial arts industries.

The subsidised Arts are a magnet for tourists, and therefore of wide economic benefit to the country.

The subsidised Arts are recognised as being at the core of our true national wealth, and naturally therefore should attract private and industrial sponsorship.

The subsidised Arts are shown by impact studies to have a wide economic impact in any community.

No money from gambling could (or should) aid the Arts in Britain.

5.1 Subsidised Arts as Venture Capital

The claim that the wider arts world and a whole realm of commercial ventures ultimately depend upon the subsidised Arts world has been made with increasing stridency in recent years, culminating in another coarse paragraph in the Arts Council's recent 'prospectus'[4]:

'Perhaps the least appreciated contribution of the publicly funded arts is the venture capital they provide for the wider entertainment, fashion and recording industries. The West End theatre, the revitalised British cinema, our unparalled broadcasting service, could not maintain their standards without them. Fine artists are helping to create a climate of opinion, taste and style which has a profound effect on the design of clothes, architecture, advertising etc. The recording industry benefits from the standards attained by our permanent orchestras and from the developing talents beginning to emerge in Black and Asian music.'

It is not at all clear what is being claimed here. Is it that our clothes, the advertising and the architecture of our cities are as good as they are because of the subsidised Arts, or is the writer claiming that somehow without the 'venture capital' the subsidised Arts have created these things would be even worse? Is it being claimed (it seems reasonable enough) that the taste and style exhibited in the appearance of the Arts Council's own Hayward Gallery has indirectly created a climate of opinion in which the other concrete monstrosities of our inner cities have seemed justifiable?

Normally the only hard pieces of evidence adduced for this pervasive influence are those carefully-managed transfers from the subsidised theatre into the commercial West End; 18 in the last year. There is some truth in this, although many have had misgivings about a system which allows the director of a subsidised theatre to be in cahoots with playwright and production company, so that in addition to the usual salary, he or she also gets a hefty commercial whack during the play's (or, more usually, musical's) run. Evidence from other areas is hard to come by. It is hard not to see other economic relationships as being inextricably

two-edged. For example, the subsidised Arts would seem to benefit as much from the B.B.C.'s support of writers, actors and musicians as 'our unparalled broadcasting service' benefits from them. The recording industry's support of musicians – as these words are written E.M.I. have given a £4,000,000 advance to Sigue Sigue Sputnik – would seem to benefit music at least as obviously as any benefit they receive from state subsidy.

Indeed in both quantitative and qualitative terms the 'venture capital' given to the wider entertainment, fashion and recording industries in Britain by the subsidised Arts is small compared to the effect of that given by the publicly-funded Education System. No group of subsidised Arts organisations has produced an effect upon design, fashion, music, film, architecture, the visual arts, writing and advertising of remotely the significance of that produced by the now-almost-defunct Colleges of Art. David Hockney, the Beatles, Bruce Oldfield, Bill Gibb, Robyn Denny, Ian Dury, Peter Blake, David Emmanuel, Ossie Clark, Mary Quant, Jo Calley, Sarah Jane Hoare, Ralph Koltai and Zandra Rhodes were not produced as 'venture capital' for any commercial world by the Arts subsidy system, but by the art colleges. That we have allowed the colleges to disappear into the abyss of an increasing mechanised higher education system, while piously defending much less productive chains of subsidised Arts organisations, may well be considered by historians of the future to have been a telling indictment of where our collective instincts lay.

Further evidence that the subsidy system does not directly give 'venture capital' to the wider Arts world, at least within the visual arts, comes from the recently completed Gulbenkian study into *The Economic Situation of the Visual Artist*. This is firmly corrective on the subject of grants:

'Arts Council grants and awards have often been misunderstood as a quantitively significant contribution to artists' incomes. Awards to artists are, in fact, no longer given by the Arts Council in England. As from 1981/2 all ACGB award schemes have been scrapped, the small amounts of money previously employed in awards being switched to other schemes – commissions, purchases etc. Smaller sums of grant aid are however still available in various forms. Larger awards are given by the Scottish Arts Council, and smaller awards and grants by the Welsh Arts Council and the English regional arts associations.'[5]

Later qualifying the subject further:

'What is important about Arts Councils and RAAs is not their direct but their *indirect* effects upon the economic situation of artists – the way they spend money in support of galleries, exhibitions, commissions and other support service. It has been commonplace of late to note that the policies and objectives of arts councils and RAA's, at least in the visual arts, are generally confused. There has been little clear sense of where they are going, what they are trying to achieve, or why money is spent in particular directions.'

Certainly the economic situation of the 1139 artists studied by the Foundation's Goldsmith College team would seem to support the view that the government investment in the artists' training was of very much more significance than the comparatively small direct effect of Arts subsidy. The picture is represented by the tables on the facing page. The artists chosen cannot be considered a wholly balanced sample – there are, for example, too few women in the group for that to be the case[8] – but the results are broadly indicative of a general outline.

Indeed the Arts Council's somewhat disingenuous claim that it is the government subsidy to the Arts which supplies 'venture capital' could well backfire. It is obvious that parts of the government's £12,000,000,000 investment in the education system are more obviously responsible for producing our 'fine artists'. The government however is sufficiently unimpressed by this to be cutting back financing of work in the arts and humanities in schools and colleges throughout the country.

5.2 The subsidised arts are a tourist magnet

Tourists do indeed cite Britain's cultural amenities as being one of the major attractions to them in visiting Britain. It is not predominately the subsidised Arts which are cited, but the heritage of old houses, castles and antiquated ceremonial, and, in theatre and music, the commercial realms of the West End and the Pop Music industry are as attractive as are subsidised houses. Nevertheless our subsidised theatres and galleries are a draw.

There is however a built-in belief that all such tourist interest is

The Gulbenkian Foundation Enquiry into the Economic Situation of the Visual Artist

Survey Areas

Career Type	PLACE A	PLACE B	PLACE C	PLACE D	PLACE E	PLACE F	PLACE G	PLACE H
Dual Career	89%	61%	86%	39%	69%	58%	66%	76%
Single Career	11%	39%	14%	61%	31%	42%	34%	24%
(Number)	(145)	(33)	(150)	(46)	(221)	(201)	(177)	(166)

PLACES: A = Wandsworth, B = Peterborough, C = Bristol, D = S. Lakeland, E = Birmingham, F = Tyne & Wear, G = Cardiff, H = Edinburgh

Age Groupings

Career Type	16–24	25–34	35–44	45–54	55–64	65+
Dual Career	50.1%	71.9%	83.1%	85.7%	62.6%	20.9%
Single Career	49.9%	28.1%	16.9%	14.3%	37.4%	79.1%
(Number)	(101)	(470)	(242)	(170)	(93)	(62)

Art School Training of age groups

Art School Training	16–24	25–34	35–44	45–54	55–64	65+
Full-time	92.3%	86.9%	73.8%	81.2%	61.8%	54.8%
Part-time	–	2.3%	9.3%	5.3%	27.8%	30.3%
None	7.7%	10.8%	16.9%	13.4%	10.4%	14.9%

Percentage of artists applying for, and receiving, grants

	Dual career	Single career	All
Grant recipients	27.6%	23.2%	26.3%
Unsuccessful applicants	16.0%	19.0%	16.9%
Others	56.4%	57.8%	56.8%
(Number)	(807)	(332)	(1139)

Average income from sales and commissions, by age and sex*

	16–24	25–34	35–44	45–54	55–64	65+
Male Artists	£230	£557	£802	£2,403	£1,196	£1,343
Female Artists	£272	£367	£236	£604	£1,381	£543
(Number)	(101)	(451)	(240)	(160)	(93)	(62)

* This table excludes 'Don't knows', refusers and two artists who earned more than £15,000 in the year of the survey.

ultimately profitable to Britain. This may have been so between 1968 and 1980 when Britain had a surplus on its travel account, overseas tourists spending more in this country than the British spent on holidays abroad. Since then however the picture has changed. In 1971 only seven million Britishers took holidays abroad: by 1984 it had more than doubled, to sixteen million; numbers of incoming tourists fluctuated, and showed no such steady rise. In 1981 there was a small loss on the travel account, and in 1982 11,600,000 visitors to Britain spent £3,184,000,000 while Britishers made 20,600,000 trips overseas and spent £3,650,000,000 – a deficit of £466,000,000. By 1984 the market value of Foreign Visitors to Britain had risen to £4,318,000,000, while the British were spending £5,380,000,000 on holidays abroad.

If we make the same assumption about our spending overseas as is made on the spending of Tourists, that about 3.5% of the total is attributable to cultural spending, then the net cultural spending loss to Britain in that year was £37,000,000. Or, to put it more polemically, a number of the privileged AB group whom we subsidise in their stalls at home, spend ever-larger sums on visiting Spanish castles, French galleries and German or Italian opera houses during their increasing numbers of overseas holidays. As we are fond of observing that our comparatively low seat prices attract overseas visitors, we might sometimes reflect on the leisure spending it liberates in home pockets.

5.3 The subsidised Arts attraction for Sponsors

Nobody seems to know just how much actually is currently given to the arts by British industry in the form of sponsorship. The government, which has made growth in private sector support a condition of continued government support for the Arts, continues to claim that it is growing steadily, and is now in excess of £20,000,000. Others[6] claim that the real sum is considerably lower.

Until the 1986 budget the only advantages to business in sponsoring the Arts in Britain were that it a) brought some prestige, and b) that some sums spent in this way could be taxed as advertising expenses. Companies could claim relief from corporation tax on the total amount of their covenanted payments, and on payments such as business sponsorship payments, or gifts, provided that they were seen as being wholly and

exclusively for trade purposes. Individuals were permitted to make donations to charities under deeds of covenant lasting more than three years, and were permitted relief from higher rate tax on covenanted payments up to a limit of £10,000 a year. All of this was by way of driving a further wedge between the subsidised Arts (comprising companies of charitable status) and the commercial arts, who could not offer such benefits to their supporters and indeed were often assumed (pop music, comics, films) to be *anti*-educational.

The Budget however acted to widen the field of activity. From April 1st 1986 companies were permitted to claim tax relief on ordinary gifts to a maximum of 3 per cent of the ordinary dividend paid by the company. The £10,000 limit on covenanted payments for private donors was removed. Most interestingly, the Chancellor proposed a new scheme to encourage individuals to make donations to charity through deductions from their wages and salaries. He proposed a scheme, to begin in 1987, by which employers could decide to aid charity and in which employee participation would be voluntary. In this scheme each employee may make a donation of up to £100 from his or her wage or salary, and the firm would send the monies collected to a (to be formed) Charity Agency for distribution.

It was not entirely clear how much the Chancellor expected his new concessions to realise. He said:

'Their cost to the Exchequer will depend on how generously companies and employees respond to this initiative. But my best estimate is that it could amount to as much as £70,000,000 in 1987/8'.

This is an estimate of the possible advantage to all Charities of course, and it would be unrealistic to expect the Arts to gain more than a quarter of this sum. The very highest estimate therefore is that the total sponsorship for the Arts in 1987/8 will be of the order of thirty five to forty million pounds. Even at such a level this sum would still be only about 5% of probable government spending on the arts (at all levels) and less than .01% of total consumer spending in leisure.

It is also important to recall how comparatively trivial such sums are within the business world. The following diagram shows the apportionment of the £17,400,000,000 which is spent annually by the business

world on entertainment and travel, a sum which almost balances out the £18,090,000,000 taken back by government from business in rates, advertising and corporation taxes.

Business Entertainment and Travel Costs in the U.K.
(1983/4 figures)

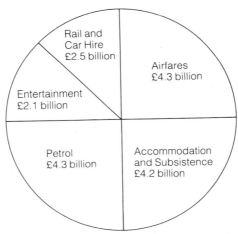

It is interesting to observe that even according to the most optimistic estimate of industrial sponsorship for the arts it amounts to little more than 2% of what businessmen presumably leave as tips.

5.4 Economic Impact of the Arts

There is a considerable literature devoted to the economic impact of arts organisations within urban areas. It is true that, as the most experienced researcher in this field Dr David Cwi says, planning arts venues can be a part of an entire urban leisure strategy.[7] Many of the impact studies so far undertaken in Britain however lack conviction. They are carried out during some heightened period of activity, for instance, and not unnaturally show that during a Festival or an All-Star Season additional

spending is generated in local hotel, restaurant and travel services. What is sometimes lacking is a sister study showing whether such expenditure is proportionately lower in the neighbouring towns from which participants in the cultural event have been drawn, and if therefore there is a kind of corresponding economic withdrawal in those areas. What other studies lack is a comparative study with other kinds of attraction; does the local arts festival have a greater economic impact than the local cricket festival, or the County Agricultural Show, for example.[8]

More than anything, we need to guard against the too-glib assumption that positive results from impact studies will necessarily help the overall health of the arts. If it is shown that arts organisations of a certain kind raise property values and bring high tourist spending into the area, it will lead to pressure to ensure that the arts organisation works (to revert to our earlier distinction in Chapter 1) in the Apollonian arts, plays for safety, and stays away from damaging controversy and risky experiment. For we are here talking about the economic impact of arts organisations, not the arts themselves. There the artist is a much less reliable economic lever. What did Bessie Smith do for Harlem? What did D.H. Lawrence do for Eastwood?

5.5 Gambling Income and the Arts

The Lotteries and Amusements Act 1976 permitted the regular running of lotteries in Britain to aid the arts. In this Britain was reviving a dead practice, for state lotteries had operated between 1569 and 1826, when they were declared unconstitutional; indeed, as we have already noted, the government supplemented its grant towards the purchase of the first collection in the British Museum in the 1750s by running a state lottery, which raised £300,000. Following the banning of lotteries in 1826 the prohibition had already been slightly eased for the arts by the *Arts Unions Act 1846*, which permitted voluntary arts association to run lotteries for 'distributing by chance works of art'.

The 1976 act permitted local authorities to run the new lotteries, providing that their schemes were registered with the national Gaming Board, and complied with the restrictions on frequency, prize money, the selling of tickets and their maximum permitted price. At first a number of arts organisations benefited from them – the Liverpool Everyman and the

111

Managing the Arts?

London Old Vic in particular – but a series of failures, of which a near-disastrous shortfall on expected income at the Sheffield Crucible of more than £100,000 was the most spectacular, has changed the climate. Very few local authorities are now claiming much success from lottery promotions in raising income for any kinds of worthwhile promotion, artistic or otherwise.

It is not immediately obvious why the outlook for such lotteries should be so dark, and why the decline should be viewed so fatalistically. For Britains spend increasing sums on the pleasures of gambling.

BRITAIN'S SPENDING ON GAMBLING 1979–1984

	£	% increase
1979	1,327,000,000	+ 13.6
1980	1,574,000,000	+ 18.6
1981	1,722,000,000	+ 9.4
1982	1,878,000,000	+ 9.1
1983	1,934,000,000	+ 3.0
1984	2,083,000,000	+ 7.7

State lotteries exist, and sometimes benefit the arts, in countries as diverse as Japan, the U.S.S.R., the Netherlands and West Germany. In some U.S. states, notably Nevada, arts and entertainment promotions are funded from gambling income. Most interesting of all is the Canadian experience. State lotteries were legalised there in 1970. In the first ten years revenue increased, from $34,200,000,000 in 1970/71 to $44,600,000,000 in 1979/80, and income from this source is a major element in the arts economies of a substantial part of Canada.

Commercial light entertainment in Britain is already mixed with the gambling economy. Bingo clubs (nearly £500,000,000 was staked in Britain's Bingo clubs in 1983/4; they are attended by more than 10% of

females, and 5% of males in the population) offer refreshments, singers, light comedians and on occasion 'speciality acts' in the bigger venues. Profits from fruit machines and pin tables in pubs help to pay for the Saturday night music or the bar disco in many of Britain's 76,000 licensed houses. In holiday camps and other holiday sites (which had a turnover of around £450,000,000 last year) light entertainment and 'a little flutter' are also intermixed; visiting 'turns' are asked to call the winning numbers or 'do the draw'. Britain's 12,000 betting shops have now been given permission to run live television and video on their premises and to serve refreshments, so we may expect there to be further intermingling of gambling and informal recreation. Indeed there is considerable, and growing, cooperation between commercial entertainment and gambling; it is a large market (94 per cent of adults in Britain gamble at some time or other, 39 per cent regularly). It would seem unduly pessimistic to think there can be *no* productive relationship between the gambling economy and the arts in Britain.

Changes in the lottery law might well be sufficient to accomplish a better partnership. A 1985 survey for example showed that a number of Councils were breaking that part of the law which says running costs of lotteries may not exceed 25% of ticket sales. And most of the 90 or so councils still running them feel constrained by prohibitions which mean that prizes may not exceed £4,500 nor ticket prices 50p. Certainly the early enthusiasm – which meant that three years after the 1976 act there were 5,000 lotteries being held in Britain, with income exceeding £32,000,000 – has dwindled. Local authority lottery income at present stands at only £5,000,000 a year (compared with £486,000,000 on the pools), and only a few authorities can now match the profitable operation at Plymouth, which has over the last eight years made a profit of £1,300,000. It is a general view that prize monies must be raised, permissible expense limits raised, and freedom given for leisure organisations to cooperation under fewer restrictions with their local authorities, for the activity once more to succeed.

In this as in so many areas what the arts seem to require is not centralised planning on their behalf so that 'the' arts economy is regulated by state boffins, but a series of relaxations from constraint to enable patrons, private businesses and indeed local authorities to make different kinds of accommodation for the health of different arts economies. And,

as we later suggest, if local authorities were free to develop local 'Artsbanks', or free to run larger scale lotteries to supplement rate resources, then freedoms given to local government to promote and build for the arts could be altogether more meaningful.

Footnotes

1. This may be thought to be a parody of the definition of arts support. However those who cannot do the supporting, are of course amongst the wealthiest in the community. it is interesting to note that taxation often works in the opposite direction and adds to the expense of the favoured leisure pursuits of the poor.
2. The subsidised Arts world nowadays has to simultaneously claim to be uncommercial by its nature, worthy by its general tone, and ultimately profitable by its prudence. Administrators looking for funding have to adopt the less pleasing aspects therefore of the personalities of Mary Poppins, Samuel Smiles and Long John Silver.
3. Rees-Mogg, *The Political Economy of Art*. (ACGB, 1985)
4. *A Great British Success Story* (ACGB, 1985)
5. Gulbenkian Report, *The Economic Situation of the Visual Artist* (1985). The report has not been widely published but may be read at the Arts Council, at City University's Department of Arts Policy and Management Resources Centre and at the Gulbenkian Foundation.
6. Mr Tony Banks M.P.
7. See Cwi, 'Public Support for the Arts: three arguments examined' in *Journal of Cultural Economics* 4 (1980)
8. The Policy Studies Institute in Britain is at present working on a major study of the impact of the arts in Britain. We may therefore expect these deficiencies to be remedied.

CHAPTER 6

THE BUREAUCRACY AND CONSPICUOUS CONSUMPTION

'It is paradoxical that despite the fascinating nature of administrative issues, public administrators – especially perhaps today – often feel frustrated and caught in a narrow round of limited tasks and frequent consultations. Part of the explanation is organisational. But part is intellectual – a lack of time and opportunity to look freshly at the environment of facts, theories and opinions with which the administrator (often unconsciously) is encircled.

Peter Self, Bureaucracy or Management?

'I have to say,' mused the Earl of Gowrie gloomily during the 1985 House of Lords Debate on the Arts, 'that I sometimes feel less a Minister for the Arts than the Minister for those who administer the performing arts. Inevitably, these sop up most of the monies available all over the country.'

The ambivalence, coming from a man who had been an English Don and a secretary to a great twentieth century poet, is tantalising. Why *inevitably*? Did Gowrie believe that it was inevitably in the nature of things that the subsidised performing arts soak up much of the available money, or was it inevitable given the nature of the bureaucrats involved? And to whom did *these* refer? The performing arts, or the administrative bureaucracy, the administrators themselves? There is truth in each possible interpretation, but, unpopular though its utterance may make an Arts Minister, the most telling truth wrapped in this enigmatic paragraph is that government money 'for the arts' spawns and feeds a growing bureaucracy which together with its allied armies of arts technocrats, threatens not to catalyse the wider British arts world, but to throttle it. It

is, in the widest sense, 'those who administer' who sop up the monies available.

It is of course a curiosity that a government which has, repeatedly and loudly, rested its political case upon the need to cut down state bureaucracy and the need to cut government spending, should have in practice failed to do much to prevent the spread of bureaucracy. But throughout the century, and particularly in the last three decades, government spending and government bureaucracies have alike steadily swollen. In 1910 only 6d. in every pound was spent by government; in 1980 it was 60p. in the pound. In 1910 government employed only 55,000 people; in 1980 it was 735,000. The 'White Collar Workers' were the area of most impressive recent growth:

WHITE COLLAR WORKERS EMPLOYED BY GOVERNMENT

1950	433,000
1960	380,000
1970	493,000
1980	560,000

Local authorities have likewise greatly enlarged their manpower employed, and their aggregate expenditure over the same period:

EMPLOYMENT AND SPENDING BY LOCAL AUTHORITIES

	Manpower employed	£ Expenditure
1950	1,420,000	1,600,000,000
1960	1,709,000	2,730,000,000
1970	2,387,000	7,920,000,000
1980	2,900,000	30,000,000,000

In the lifetime of Mrs Thatcher's government local authority expenditure has first risen and then dropped back from its 1983/4 peak of 33 billion, but *central* government costs and expenditure have steadily risen, from 112 billion in 1979/80 through 118 billion in 1982/3 to 121 billion in 1985/6. (And, just as total government expenditure has risen, so has government subvention to the arts – in spite of all talk of 'cuts' – actually risen overall during the life of the present government, although that has helped the heritage arts more than living artists, and bureaucrats more than both).

In that context therefore the growth in Arts Council operating costs is not remarkable. The growth could be held to be adequately accounted for by the increase in size of the annual grant-in-aid to be administered (although that does not necessarily make the work more complex or demanding) and by substantially increased salaries. Again, we take 1980 as a base:

OPERATING COSTS OF THE ARTS COUNCIL OF GREAT BRITAIN

	In England	In Scotland	In Wales
1950	77,368	8,138	–
1960	125,709	15,156	12,026
1970	420,092	83,188	66,110
1980	2,231,751	401,170	339,410

However the money remaining does not in some cases go directly to the client, but in England may now be passed on to the 12 Regional Arts Associations (who did not exist in 1950), or in Wales to the small Arts Associations. In 1980 approximately 10% of the Arts Council's total grant-in-aid was passed to its Regional Associations.

A fair estimate of the average RAA operating costs attributable to the received Arts Council grant is difficult to make. R.A.A.s have income from several sources, and it is not easy to weight their operating costs against the various kinds of activity these various grants help to fund.

Moreover there is a great difference in operating costs between Associations, in part reflecting the differences in size, population density and kind that each organisation covers. However, a considered figure, taking all of these factors into account, is 10.5%. In broad terms therefore, before it reaches the producing clients, the total government grant of £63,000,000 has been reduced by at least £3,300,000.

However, the major operating costs have yet to be met. These are the administrative costs of the client organisations themselves. In 1980 the Arts Council gave four typical examples of the expenditure patterns of its performing arts clients, from which we deduce how much would be spent

ARTS COUNCIL GRANT TO REGIONAL ARTS ASSOCIATIONS 1980

Eastern Arts Association	419,398
East Midlands Arts Association	428,033
Greater London Arts Association	652,301
Lincolnshire and Humberside Arts	335,893
Merseyside Arts Association	338,147
Northern Arts	1,088,960
North West Arts	578,474
Southern Arts Association	525,050
South East Arts Association	318,807
South West Arts	535,794
West Midlands Arts	696,735
Yorkshire Arts Association	444,425
TOTAL	£6,362,017

on administration by clients were each example entirely typical of its category.

	Amount given in grant aid to this category	% Admin Costs	Admin Costs	% Performers' Salaries	Performers' Salaries
Regional Drama Company	£6,432,185	31%	£1,993,977	36%	£2,315,587
Regional Symphony Orchestra	£2,180,000	12%	£261,600	70%	£1,526,000'
Touring Drama Company	£2,170,703	11%	£238,777	22%	£477,555
Touring Opera Company	£2,325,670	19%	£441,877	37%	£860,498

Independent calculations suggest that if there is such a meaningful thing as an average administrative cost for regional or touring organisations, it is in the region of 18–20%. The same kind of calculation suggests that average *technical* costs, including technicians' salaries, for these companies is 30–32%.

Plainly the variation between the different categories, and between organisations within each category, is so great as to render any notion of an average expenditure a mere academic convenience. However, it is useful to bear in mind that, in the broadest terms, about 5% of the government grant in aid is absorbed in operating costs by the Councils themselves, and the clients in the performing arts will probably spend about a half of it on administrative *and* technical costs. Moreover, in the visual arts, virtually the *whole* of government grant in aid passed on to galleries by the Arts Council is spent on administrative and technical servicing of exhibitions. The size of the Arts Council's subvention to the visual arts (including, in this case, other kinds of grant aid) may be gleaned from the table on the following page.

APPORTIONMENT OF ARTS COUNCIL GRANT IN AID 1980/1985

£ thousands	National Companies	Regional Arts Associations	Art	Drama	Music	Dance	Liter-ature	Other	TOTAL
1979/80	18,723	6,362	3,625	12,674	9,105	1,846	1,307	9,483	63,125
1984/85	30,597	12,857	5,290	17,788	19,918	4,541	1,916	11,839	104,746

The national companies – the Royal Opera House, the National Theatre, the Royal Shakespeare Company and the English National Opera Company – vary a great deal in the amount they expend on administrative and technical costs. The National Theatre's employee costs amount to about 65% of the total. About 11% of total cost was expended in running the National Theatre's five production workshops, 13% on stage manning costs, 18.3% on building services and 10.5% on administrative and other supervisory costs. Because the National has a quite different responsibility for the costs of the building it inhabits, a direct comparison with the RSC is not possible. That company spends 35% of expenditure on 'Theatre Operations', and apportions 5.25% of expenditure to 'administration'. The Royal Opera House, different again, spends 33% of its total on 'other costs' such as front-of-house and public-ity and advertising, and 12% to general costs, including administration.

It is not possible to indicate therefore with any precision how much of the government's grant in aid to the Arts Council goes in total to the administrative and technical costs of placing the arts before their public. Neither would it be possible – 'administrative' and 'technical' covering so many different kinds of activity in different areas – to say with accuracy how much of the £410,000,000 spent in 1984/5 by the Local Authorities on the arts, museums and libraries went on administrative and technical matters. It can however be safely surmised that, after it has passed through the various administrative and bureaucratic layers, less than half of government grant in aid for the 'Arts' now actually reaches the artists. If the public really does believe, as is sometimes said, that government grants to the Arts puts money into the pockets of wierdoes and crazed self-proclaimed geniuses, then they suffer under a misconception. Money

for 'the Arts' substantially goes to a growing bureaucratic system, and a growing arts technocracy. The proportion going to artists, and certainly to the kind of avant garde experimenters that occasionally make news in the popular press, is steadily shrinking.

This is of course covered in part by the fact that the British Arts Council is predominately organisation-centered. The present Secretary-General underlines this:

> 'What do I see today from my privileged view of the arts? *On the whole, well-run administrations* serving imaginative and exciting artistic enterprises . . . However, this small but highly successful part of Great Britain Inc. is once again under threat through lack of investment . . .' (*My italics*)[1]

And it is further hidden by the habit we observed in Chapter 1, using the word 'Art' to cover *all* the processes from the creative inception, through its presentation and diffusion. The fact remains however – a point we shall make with greater emphasis later in the chapter when dealing with the Baumol and Bowen theory of cost disease in the arts[2] – that however we may choose to smear over what we actually mean by 'the arts', *artists* (creators and performers) get proportionately less and less of expenditure, while additional technical, administrative and consultative skills are throught necessary to bring Art before the public, so those people get more and more.

A simple illustration of this perversity lies in theatre sound. In the days of the King's men, and in the days of Henry Irving's Lyceum company, there was of course no sound technology in theatres and consequently no sound experts were employed. Some amplification was used in pre-war variety theatres and in some musical shows, but it was rarely employed in the straight theatre. Now quite often theatres have extraordinarily sophisticated sound technology. And, in defiance of the general economic rule which suggests that using advanced technology means fewer people are employed, the installation of sound systems has in the theatre led to *more* technicians being employed, and a growing market for 'consultants' in this, as in so many arts areas.

A second example of the general trend might be taken from the nature of the grant-awarding system. Ostensibly, organisations are assessed

according to their 'standards' of artistic excellence, from which supposedly their financial needs derive. However, this assessment has in fact always to take place *prior* to the creation of a show (without the guarantee against loss or challenge grant or whatever, the company cannot contract to present its intended programme). The 'assessment' of an organisation's quality cannot therefore wholly concentrate upon its art (which is not yet created), but must concern itself with the wider objectives it sets itself, and the standards within them which it reaches. *Those standards which can be quantitatively assessed are as we have already noted primarily managerial and technical.*[3] The objectives set will tend to lie not directly in the realm of the arts, but in those areas of greatest concern to the funding bodies. An organisation relying on British Arts Council funding will now have an 'education policy' and if it is large enough, an Education Officer, for education is a current 'concern' of the Council's. An organisation relying upon funding from a particular Foundation might well have a series of discrete social policies, one relying on funding from an urban local authority will have an 'ethnic arts' policy and probably have an 'Ethnic Arts Officer' on the staff. Those organisations with regular dealings with the British Council might well find it prudent to have a 'Sponsorship Officer', and certainly a policy on fund-raising and sponsorship. Each new piece of faddish 'planning' involves the creation of two realms of 'experts'; one layer in the funding bodies to do the 'assessing' and one layer within the client organisations to make presentations in the form in which they can be assessed. Each new fad tends to favour the large organisations, for they have sufficient flexibility to appoint staff to 'respond' to these new 'strategies'.

This bureaucratisation derives from the tendency we noticed in Chapter 3 – arts councils inexorably replace critics with experts. It derives too from the general haziness about what 'art' actually is, and from the sister feeling that it is better to 'assess' client organisations in areas of social welfare in which there are clear ground rules for experts to work by. At heart however, it is because the system is in a state of funk. As Richard Hoggart said of the Arts Council itself:

'If anything the Council suffers from uneasy, ill-digested, reactive populism. It falls over backwards to assure itself of its own democratic leanings by offsetting a grant to a traditional art with

one to an experimental, a London grant with a provincial. It doesn't like debate about principles.'[4]

The developed system can rarely recognise *art*, but it can recognise compliant bureaucracies, good accounting practice, well-phrased education policies, well-used technical resources, currently fashionable marketing practices, and well-run offices. That reinforces a bureaucracy which fuels the characteristics of the British post-war 'art world': more bureaucrats and technicians producing less work over a narrower range, to fewer people, but at a higher technical 'standard'. The characteristic images of Art in our time are impeccably-lit exhibitions in near-empty galleries, beautiful new concert halls half-filled, and expensive sound systems over-amplifying actors' voices to rows of empty provincial seats.

Sheffield provides us with a model which illustrates all the trends we have so far mentioned in this chapter. In 1950 it had four theatres, one of which, the Palace, Attercliffe was beginning to slide down the descending spiral that led to the death of 'variety' entertainment; it was beginning to book the inevitable tatty bills and soon, the 'nude posing' shows of cheapskate managements. Its closure was followed by the closure and eventual demolition of the Empire (which collapsed with the Empire chain) and then by Beaumont's Lyceum theatre 'going dark' for long periods. Through the sixties and seventies however the Council, in cooperation with the Arts Council, was seeing its function as the creation of a new Art theatre, the Sheffield Crucible, which replaced the old Playhouse. The new theatre was built, with unintentional irony, next to the boarded-up-Lyceum. There were some moves to retain the beautiful old Lyceum as a popular theatrical venue however. Actor and comedian Jimmy Jewel tells the story:

'In 1978 I heard that the old Lyceum, Sheffield, was running Bingo. I had played there many times, so when two boys from a group called Friends of the Lyceum came to see me I agreed to go with them to talk to the town clerk and several of the town councillors.

We met at the Town Hall and talked about ways in which we might re-open the theatre. The owner wanted eighty thousand pounds for it and another forty or fifty thousand would be needed to refurbish it. I went away and came back with a plan which would enable us to keep it open all the year round. I suggested the Council

Managing the Arts?

SHEFFIELD'S THEATRES

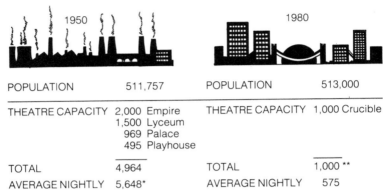

POPULATION	511,757	POPULATION	513,000
THEATRE CAPACITY	2,000 Empire	THEATRE CAPACITY	1,000 Crucible
	1,500 Lyceum		
	969 Palace		
	495 Playhouse		
TOTAL	4,964	TOTAL	1,000 **
AVERAGE NIGHTLY	5,648*	AVERAGE NIGHTLY	575

* Three of the theatres in 1950 frequently operated a twice-nightly programme.
This figure is an estimated 75% of capacity.

COMPARISON OF THE OLD PLAYHOUSE'S ECONOMY WITH THAT OF
THE CRUCIBLE THEATRE

	1950		*1980*
Average No. of Actors	18		18
		(with Young People's	9
		Theatre Co.)	
Average No. of Other Staff	20		130
Total Operating Costs	£24,950		£785,138
Total Subsidy	Nil		£423,891
Earned Income	£28,100		£314,294
Earned Income as percentage			
of costs	112.6%		40%
PLAYS PRESENTED	23	(in Main House)	9

** The Crucible has also an attached Studio Theatre seating 240.

124

should buy it. Then I would take it on a peppercorn rent for a fixed number of years. There would be a ten week pantomime season, then from February to May we would put on the Royal Ballet, the big opera companies, six weeks of amateur companies and two weeks variety. From the middle of May until the middle of September there would be lavish productions with an ice floor and a watershow. In September it would become a legitimate theatre again, with opera and plays until the pantomime season.

The councillors didn't want to know. They turned the plan down flat. In 1980 I went back to the Lyceum. It was standing only because it is a listed building, but I was looking at a wreck. The circle ceilings had collapsed and there were gaping holes in the roof and walls. Rats scuttled everywhere. It was like a horror story. It seems sinful to allow such a place to fall to pieces. I came away from Sheffield feeling terribly depressed.'[5]

The Council have not felt able to support schemes for such a popular art venue, although their support for the Crucible theatre has been, in financial terms, generous. A fuller scrutiny of the economics of the Crucible theatre, in 1980, and a comparison with the economics of the old Playhouse it replaced, which was operating within a theatre provision which allowed 1% of Sheffield's population to go to the theatre every night, is highly revealing. It is now true that only about 0.1% of Sheffield's population may on any night visit their highly subsidised new theatre. It is also true that there is a far narrower choice (in 1950 the citizens of Sheffield could choose during the year between 3 pantomimes, more than 50 plays, more than 60 variety bills, and a range of opera and dance), and that the administrative and technical staff costs have grown vastly.

The Arts Council decided in the early eighties that Sheffield was a theatrical centre of excellence and greatly increased its grant to the Crucible. However, had it been less fortunate and been forced to curtail its operations, it is likely that we should have observed another aspect of arts bureaucracy. Just as in times of growth the bureaucrats multiply in employment at a faster rate than do artists, so in times of cutback do bureaucrats (and technicians) suffer less drastically. Here, for example, are the reductions made by the National Theatre over a six month period in 1985, when cuts in funding led to the temporary closure of the Cottesloe theatre, and full-time staff were reduced from 550 to 476.

Managing the Arts?

REDUCTIONS IN NATIONAL THEATRE STAFFING 1985

	No. of staff	Percentage
Administrative staff	− 11	− 2%
Technical staff	− 16	− 2.9%
Engineering maintenance staff	− 17	− 3.1 %
Actors	− 30	− 5.45%

Of the 74 staff dismissed, 35 related to the closure of the Cottesloe theatre but, typically enough, actors did worse than technicians and administrators.

It would be reasonable to say at this point that the arts bureaucracy is no worse than that of other fields, in which increased employment of bureaucrats is not accompanied by an improvement in the levels of service or levels of production and sales. In the allied field of education for example there were in 1965 456,000 teachers and 398,000 non-teaching staff; by 1980 those numbers had leapt to 693,000 teachers employed and a staggering 717,000 non-teachers (an increase of 80%) with no very obvious improvement in the service offered. In the health service between 1961 and 1979 the total employed rose by 900,000 (administrative and clerical staff rising by 50%) while the numbers of available hospital beds fell by 11% in the same period.[5] In a quite different area the life of the Milk Marketing Board has coexisted with a fall of 22% in the public demand for milk.

It could even be said that in the modern state bureaucracy is necessary, and there is no point in complaining about it. Weber comes close to this view:

'However much people may complain about the 'evils of bureaucracy', it would be sheer illusion to think for a moment that continuous administrative work can be carried out in any field except by means of officials working in offices. The whole pattern of everyday life is cut out to fit this framework. For bureaucratic

administration is, other things being equal, always, from a formal, technical point of view, the most rational type. For the needs of mass administration today, it is completely indispensable. The choice is only that between bureaucracy and dilettantism in the field of administration.

The primary source of the superiority of bureaucratic administration lies in the role of technical knowledge which, through the development of modern technology and business methods in the production of goods has become completely indispensible.'[6]

Given the 'development of modern technology' we must, apparently choose between a necessary bureaucracy, and the (implied) absurdity of dilletantism. Certainly we have acted as if modern technology *must* be used in the presentation of Art (even though our arts establishment deny that pure Art can exist within the technological media) and we often act as if one artistic bureaucracy is superior to another on the basis of its efficient use of technology and business methods. At certain pinnacles of the contemporary Arts, in performance art and most particularly in music theatre, what is celebrated *is* essentially the bureaucracy and the supportive technology. Thus in *Cats*, in *Les Miserables*, in *Starlight Express* or in *Time* the twin attractions are how much it all cost (and what political battles had to be fought in smoke-filled offices) and the dazzling technological display. *Time*, the £4,000,000 epic, has lasers and computerised scenery, a 14-foot high head of Sir Laurence Olivier which 'speaks' his recorded voice, and a plot which is pure baloney. As such it is entirely representative of its genre, and may in due course expect a publicly-funded revival.

However, it could be suggested that a good deal of the fashionable technology arts organisations buy is only necessary for their Art because they say it is. We have enjoyed the visual arts, music and effective theatre in the past with very little of it; much larger auditoria than we have were filled without the 'necessity' of computerising the box office, orchestras were heard without the electronically-operated baffle boards of modern concert halls, pictures gave pleasure before there were video presentations in the gallery foyer telling you of the artist's domestic circumstances and current neuroses, plays were seen without the multiplying rows of lamps now deemed necessary to light a stage. It may be that the arts represent

one area in which the dilettante *is* sometimes preferable to a bureaucracy (particularly to one simultaneously trying to imitate the welfare services and the management of productive industry), and an area in which the raw excitement of a genuine artist matters more than 'standards' of technical and organisational support.[7]

6.1 The Cost Disease and Conspicuous Consumption

In 1964 Baumol and Bowen postulated that the performing arts suffered, by their nature, from a 'cost disease', which meant that the cost of live performance of staging plays, operas, rock concerts or whatever, will, because of the labour-intensive nature of the performing arts, rise at a rate persistently faster than that of a typical manufactured good. As Hilda Baumol and W.J. Baumol observed in 1985, 'since the cost disease was described in 1964, arts administrators throughout the world have been using the model to back up their requests for increases in government support for the arts.'[8]

Some qualifications to this theory should be made before we proceed. First, Baumol and Bowen compared the performing arts with a typical manufactured good, not with other services. Second, their generalisations were based upon orchestral costs in the U.S., and not, until recently, upon theatre in the U.S. Third, it was not assumed that the model always worked in all circumstances; it was described as a manifestation of the *relative* lag in productivity growth in performance, and from the first the authors noted that it did *not* work in periods of inflation.[9] In a word, much of the usage of this model in Britain has been based upon inadequate knowledge of its limitations, and it has been assumed, wrongly, that it necessarily applies to a country like Britain which since 1964 has been in an inflationary spiral.

However it has undeniably entered the folk lore of the presiding arts bureaucracy that the arts are, *by their nature*, bound to be labour-intensive. Professor Walter Newlyn's summary is that 'a science-based industrial revolution has made possible reduction in the man-hours required for all material products.' But, *Hamlet* apparently requires as many man-hours to perform as when it was written, so 'it follows that the performing arts must become relatively more costly over time unless the wages of performers are reduced or subsidies increased in real terms.'[10]

128

The argument is familiar enough. The same kinds of qualifications have to be made however. The comparison made is with *goods*, not services. And, again, the generalisation is made from one, dubious, kind of example.

The example implies that actors' wages, like those of players in an orchestra, represent the major cost of performance of plays, and that therefore 'the performing arts' can all be lumped together. But this is not so. They were the major cost in Shakespeare's company. However, the actors' wages represented only about 33% of total costs in the Lyceum company at the end of the nineteenth century. In the Royal Shakespeare Company actors' salaries represent about 30% of total expenditure. In arts council touring companies actors' wages will represent between 22 and 27% of total costs, and in some commercial productions they are between 12 and 15% of the total expenditure. Over time, actors' salaries represent a lower proportion of expenditure in almost all cases, but, equally consistently, *administrative and technical wages show steady increase.*

The Baumols' own figures[11] bring tangential but useful corroboration from the regional theatre in the U.S. The figures given here were derived from 22 such organisations over the last decade:

THE 'COST DISEASE' IN U.S. THEATRE

Percentage distribution of expenses	1974	1978	1983	% difference
Artistic salaries	26.9	28.9	24.6	− 9
Administrative salaries	13.7	15.7	18.9	+38
Technical salaries	11.4	13.4	14.8	+30
Non-salary expenditure	47.9	42.3	41.8	−13

Again the offstage wages have risen proportionately quite steeply; the proportion of expenditure going on the actors is less. This may of course be because fewer actors have been employed (directors favouring one set pieces with small costs) but it is hard to see why technical salaries have

risen so high, and hard to see why more administrative costs are incurred in dealing with fewer actors and simpler productions.

The phrase 'conspicuous consumption' was first used by Thorstein Veblen in 1899 to describe a pattern of expenditure which was used to display that the spender was above basic economic restraints. It has been used to describe patterns of spending in all kinds of fields used to impress particular power groups. I have used it elsewhere to describe some of Irving's spending habits when he sought to impress Victorian society that his theatre existed in the highest realms of the new 'improving' art[12] It could now be applied to some private views for arts exhibitions, where the expenditure is less to help the art reach its public, still less to sell it, than to impress particular social groups. It applies to many art catalogues, many posters and some programmes for arts events.

In a new application, it may also be applicable to the functions of much of the British arts bureaucracy and the allied technocracy in arts organisations. Time and manpower are both profusely spent in meetings, in preparation of submissions for grant aid, and in processing them within the funding organisation. In some cases a majority of an arts bureaucrat's time is spent on such work.[13] Moreover, the interaction between the smaller arts organisations, who must now seek multiple funding from an increasing number of possible sources, and the various bureaucracies with whom he must deal, becomes more complicated each year. The diagram opposite is simplified, but suggests something of the multiplying complexity of the small unit's present relationships with funding bodies.

This means that, although there must be a great deal of expenditure of time and money by such small organisations to fit the different requirements of the various (linked) funding bodies, they cannot refine their administrative functions. Those at the top of the large organisations, and at the top of the funding bodies, can however do so. In such a system entrepreneurial flair on lower levels or in smaller organisations will be difficult to exhibit, and will in any case look like incompetence or disruptive behaviour. More usually, promotion will go to 'organisation' men and women, who comes to rely upon the panel and the committee and the group to define existence. As Whyte said:

'Where the immersion of the individual used to be cause for grumbling and a feeling of independence lost, the organisation man

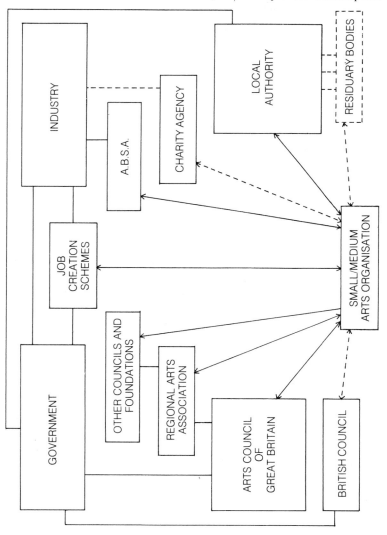

of today is now welcoming it. He is not attempting to cut down the trend and to cut down the deference paid to the group; he is working to increase it, and with the help of some branches of the social sciences he is erecting what is almost a secular religion.'[14]

It may be however that the arts, however defined, cannot be created, effectively understood or brought before the public by groups and committees at all. It may be, and we shall discuss one aspect of this in the following chapter, that only individuals can make art, and only individuals can promote it to the best effect.

Footnotes

1. *Arts Council of Great Britain. Annual Report. 1984/5*
2. Under 'The Cost Disease and Conspicuous Consumption', below.
3. When asked why they used expensive real hair for wigs at the National Theatre, a member of the staff showing visitors around answered haughtily, 'Because we are the National Theatre, and have to keep standards up for the profession.' (We have since 1950 lost half of the then-available theatre seats in this country, and at any time at least three fifths of the profession are out of work).
4. *Sunday Times* 15th May 1983.
5. Jimmy Jewel *Three Times Lucky* (Enigma Books 1982)
6. M. Weber 'Legitimate Authority and Bureaucracy' in *The Theory of Social and Economic Organisation* Trans. A. Henderson and T. Parsons. (Free Press, 1947)
7. As in Peter Brook's rough theatre, Nola Rae in Senegal, or Max Wall anywhere.
8. 'The future of the Theatre and the Cost Disease of the Arts' in M. Hendon. J. Richardson and W. Hendon (Eds.) *Bach and the Box* (Association for Cultural Economics, 1985)
9. *Ibid* p.8
10. Letter to *The Times*, 1980. Quoted by H. Baldry, *The Case for the Arts* (Secker and Warburg, 1981)
11. *Ibid* p.16
12. 'Henry Irving and the art of Conspicuous Consumption', in J. Pick, *The West End, Mismanagement and Snobbery* (Offord, 1983)
13. The B.P.-sponsored Research into the nature of Arts Administration at City University suggests that middle and senior arts administrators spend on average about a third of their working week in formal meetings and about two thirds of the remaining time in various informal meetings and dialogues.
14. William H. Whyte, *The Organisation Man* (Pelican, 1960)

CHAPTER 7

THE COMMERCIAL MANAGERS

'We do find many aspects of working with some government-fed organisations frustrating and unsatisfactory. Most are grossly over-staffed, maintain luxury offices with unnecessary appointments which more often than not are abused, and too often the real workers one does occasionally find in these organisations are tied down with a stuffy committee of supposedly well-educated board members who have no idea what show-biz, entertainment and 'the working arts' are all about. And to that extent we see ourselves, rightly or wrongly, as playing the 'Devil's Advocate' to some of these organisations – the antagonists, the hustlers, the stimulants, the very necessary injectors of theatrical addiction.'

Michael Edgley, The Role of the Commercial Entrepreneur in the Arts of the Eighties

From the Winter of 1923/4 to the outbreak of the second world war, the Royal Opera House Covent Garden was leased out of season and run as a dance hall by the Bertram Mills organisation. Their financial success was instantaneous, and for sixteen years Londoners danced during the Winter to bands which, previously, 'had been reserved for the very rich', Jack Howard, Debroy Somers, Jack Hylton and Herman Darewski among them. The half crown admission (12½p) yielded good profits to the lessees, and the generous rents paid 'played some part in keeping grand opera alive during the pre-war years, which were perhaps the most difficult in its history.'[1]

The commercial success has many of the positive characteristics we might observe in the work of commercial arts mogul – although it was a part only of the huge entertainment organisation which Mills controlled. Such a commercial organisation is conceived and executed on a

large-scale. It is run with an efficient line management, which tasks are clearly delegated:

> 'Nobody was ever a better man to work for than Bertram Mills. He did not believe in overloading people with instructions and in practice this meant that, having been given a job, we were expected to use our heads and get on with it.'

There is an absence of unnecessary bureaucracy. The whole enterprise is usually informed by the belief that large-scale provision enables the best artists' work to be enjoyed by large numbers of people – the faith that, *if no untoward social restraints are imposed*, most people will, in any sphere, respond to the best. The enterprise thus brought hitherto exclusive society bands to a venue with the strongest associations of social snobbiness, but they attracted a kind of broadly-based attendance that has never been found for subsidised opera.

Mills and his sons (who worked alongside him before the war and assumed the whole leadership of the organisation after it) took the same principles with them into the circus world. Each year Europe was scoured for the best acts, who were then hired either for the winter Olympia circus or for the summer tenting show. Olympia seated 7,000; seats in the tent numbered some 5,000 (Mills did not permit his seating to grow more; although he believed in the large-scale he recognised there was a sensible limit to it).

The tenting tour would usually cover some forty towns in the pre-war years, and rather fewer (because of the circus' great popularity it made longer 'stays') after the war. The prices were always kept low, even in the difficult tours in the forties:

> 'If we had been greedy we could have increased prices overnight between one town and the next, but even though we had to recoup our war-time losses our reputation was worth more than any immediate gain, so prices remained unchanged.'

The organisation made over a million and a quarter in profits from their high-quality circuses, but never budged from the low price policy; in its last year, in 1965/6, the cheapest seats at Olympia were 6/- (30p) and the most expensive stalls 22/6. Cyril Bertram Mills gives an interesting account of the finances of those last years at Olympia:

'The Grand Hall of Olympia is little more than an ugly shell when a tenant enters it. In our case for every £1,000 spent in producing our annual circus about 30% went in building the seating and the stables, decorating them, shutting out the daylight from the glass roof with a sort of red and green bunting 'big top' and generally turning the shell into a comfortable circus building, warm and free from draughts in mid-winter.

For the rest, about 20% was spent on advertising and publicity, about 14% on rent and rates, some 15% on wages and overheads, about 5% on light and heating and only about 14% on artistes' salaries; animal food and odds and ends accounted for about 2%. It will therefore be seen that I had no need to limit the amount spent on artistes' salaries for the simple reason that we needed the best talent available and were willing to pay whatever it cost. An extra one or two thousand pounds could easily be paid for by an extra twenty or thirty patrons at every performance. To fill 7,000 seats twice or three times a day during the first three weeks was easy, but to have full or very well attended matinees when the school holidays were over was a different matter, and to do good business during the last days of the season we needed to draw on potential patrons who had been unable to buy tickets during the high season and they had to be convinced that we had a programme really worth seeing.'

In broad terms the Mills circus broke even before the war if it sold 50% of its seats, but at its close the break-even point was not reached until 75% of seats were sold. The last Olympia circus the Mills ran made a modest profit of £25,000, against the £211,000 profit the show made in its first post-war season.[2]

In everything Mills writes about the family management there is a sense, common to the best commerical entrepreneurs, of a personal contract with the general public. Typically, the organisation was personalised by its bosses, who maintained a high profile, and offered a personal guarantee that the public would not be shortchanged. They spoke with absolute authority for their organisation, and 'gave their name' to the quality of its presentations. (In this the manager of a non-commercial organisation, run by a board, would appear to be at a

disadvantage. It is hard to promote the character of an organisation in the person of the manager, or director, when that person is a temporary employee; much easier for the commercial entrepreneur who has built the organisation according to his personal lights, and who can speak for it without reference to any bureaucracy. The public's contract is then with a single person; a highly visible embodiment of excitement, quality and value).

Showmen, in their different ways, instinctively promote their own (or assumed) characters as embodying their organisations, and as being, in a sense, a part of the show. They are 'larger than life' but highly accessible; colourful, but down-to-earth and honest. Thus, the Mills prominently featured in all copy about their circus. Of their rivals, Billy Smart would be driven into town in the back of a huge open American car, wearing a ten gallon hat and smoking an impossibly large cigar, Chipperfields would lead a massive circus parade of 'over 200' animals and a host of performers from each town's railway station to the circus site the day before they opened. The tradition of 'selling' the character of the boss along with the show in a circus parade is as old as showmanship, C.B. Cochran (no slouch himself in personal publicity) recalls watching Lord George Sanger's circus parade in Lewes, when the showman arrived in the town more than a century ago:

'I vividly recall even now my first sight, from a first floor window, of a great and gracious lady, Mrs George Sanger, garbed as Britannia, with a lion at her feet, seated on a very high gold chariot which was carved with white angels, some holding garlands of flowers, others balancing overflowing horns of plenty, and, wherever there was room for them, the more affable gods and goddesses of mythology stood out in bold relief. The chariot was a huge and imposing affair, and it was the centre-piece of the procession which made a formal entry into the town; it was drawn by many horses, three – or was it four? – abreast, at whose head walked liveried grooms; in another car a band of musicians played brassy tunes, mostly patriotic; a clown walked on very high stilts outside Britannia, leaving her from time to time to peer into first floor windows while other clowns capered in the streets.

First in the procession came the elephants, moving ponderously,

their trunks swaying from side to side in search of buns held out by adventurous small boys. Then came the cages with the wild beasts; there was a roaring of lions and a snarling of tigers, and in one cage there would be a vividly attired trainer, lounging in what seemed to be dire peril. On each side of these exciting cages rode richly dressed cavaliers and their ladies, on steeds which were not ordinary horses but had about them the unmistakable magic of the ring. You felt that at any moment they might break into some sort of equine quadrille.

And then came the great 'Lord George', his very self, sitting, as was perfectly right and proper, in an imposing open carriage, somewhat resembling that used by Queen Victoria herself on state occasions, drawn by six pairs of horses, with outriders and postilions. It was a brave sight.'[3]

Character and flamboyance are given to their enterprises in our own century by showmen as diverse as Alfred Hitchcock, Richard de Marco, Gerry Cottle, and (recently and spectacularly) Bob Geldof. The events they promote are coloured and charged by their personalities. They do not pander to some drab notion of public taste (unlike the great rump of second-class commercial managers) but trust that the public's taste is attuned to their best instincts. As Cochran said:

'I produce plays or entertainments because I like them, not because I think they are what the public wants. Whenever I have departed from this rule I have invariably failed.'

Failure is not blamed upon public apathy, or upon the cloddishness of the popular mind. It is a risk to be taken that sometimes the instincts of the showmen and the general taste will not coincide; the important thing is that generally they are synchronised. Cochran had a number of failures, but his overall success rate was high:

'The series of Pavilion revues realised an average profit of £15,000 on the London runs. I actually lost money on one, and another just got the investment back. All the others showed handsome profits.'

Indeed he was able, in mid-career, to arrange an insurance with Lloyds against loss of profit on new productions.[4]

Far from pandering to some base common denominator, the best commercial showmen will often exhibit an unexpected desire to elevate, even to preach at, the general public. The kind of qualities one associates with Lord Reith in his running of the B.B.C. in its early years, are also to be found in wholly commercial operators such as Lord Rank, or, more obviously, Sidney Bernstein. Caroline Moorhead's admirable biography of Bernstein[5] has given us a picture of a zesty, litigious, far-sighted entrepreneur whose concern for the general welfare was considerable. It was Bernstein who opened his vast city cinemas in the mornings during the 1930s, at very low prices of admission, so the unemployed might use them as comfortable refuges from the streets. At the outbreak of the second world war he gave further dramatic evidence of his concern for the promotion of the higher public interest:

> 'Sidney was at his desk in Golden Square one day when John Betjeman called to see him with a message from Sir Kenneth Clark, the Surveyor of the King's pictures. Clark had been told that he would shortly be put in charge of the Films Section at the Ministry of Information and wanted to ask Sidney's advice. 'What,' said Betjeman, 'should the government be doing about film and propaganda?' It was a satisfying moment for Sidney. He reached down, opened a drawer in his desk and drew out a prepared typed document: British Film Production and Propoganda by Film'. He had occupied some of the days before war was declared by mapping out his thoughts on how films could be used in case of war.'[6]

Bernstein was later Adviser to the Ministry of Information, but, predictably enough, found the accumulating bureaucracy of that wartime government body irksome; 'anything I have been able to do has taken more effort and time then was necessary because of the laborious explanations to people who do not understand films, and strangely enough, are not really interested in them.' The commercial manager almost invariably finds accommodation to the habitual methods of bureaucrats tiresome and baffling, and there is, in the reaction to the commercial figure by the higher echelons of the British cultural bureaucracy, a large admixture of snobbishness. Practical experience and entrepreneurial flair tend to be resented and downplayed. Kenneth Clark

gives a clear view of such snobbery and prejudice at work in Britain in the fifties:

'When we were about to appoint the commercial television company later known as ATV, I invited its principals to come to my room and meet some members of my Board. They were Prince Littler, Val Parnell and Lew Grade. Prince Littler was very quiet and practical, and my Board swallowed him without difficulty. Val Parnell was everything they expected show biz to be like. But Lew aroused their latent snobbery, and they all protested to me about his inclusion. 'He's the best of the bunch,' I said, and the subject was dropped.

We wanted our first three companies to represent, as far as possible, different aspects of 'communicating with the public'. We therefore chose a theatrical group (Prince Littler and Co.), a newspaper group of which the principal shareholder was the *Daily Mail*, and a film company, Granada, which had special ties with the North of England. This last gave me some trouble, as its boss, Sidney Bernstein, had, like most intellectuals of the thirties, formed affiliations with the Communist party, and I was asked to exclude his company. I said I would only do so if it could be shown by M.I.5 that he was still a signed-on member of the party. I had already found out from him that he was not. There was a good deal of protest and pressure from government circles, but they realised that for me to resign at this early stage would have been a serious blow to the infant ITA, and they let the appointment pass.'[7]

7.1 High Risk and low taste?

It is inevitable that we soon have to leave the traditional fields of nineteenth century showmanship and begin to take examples from television, for we soon confront the Arts establishment's familiar barrier against the media. That consists of a blurring of any distinction between the basest operation of commercialism and all forms of mass production which might be termed 'media': anything replicated for popular consumption and pleasure becomes by this view something foisted on to the public, or answering base and vulgar *wants* - instead of the deep

inarticulated needs that arts bureaucrats are so good at detecting in our 'communities'. The 'media' – paperback books, magazines, radio, but particularly television and the recording industry – are, according to the familiar argument, by their nature removing all discrimination and choice from the consumer, and condemning the public to a supine and passive acceptance of whatever shoddy goods the media moguls choose to sell them.

> 'Demand is generalised and diffuse – for entertainment, for thrills, for vicarious sadness, for laughs; it can be satisfied by programmes of different types and different qualities; and only after those programmes have been offered is there any demand (specifically) for them. Supply comes first in this business and creates its own demand.'[8]

Yet what is being suggested here is surely no different in kind from supply and demand of other forms of contemporary art? The painter, poet and composer do not compose their works because a specific demand for such material has been identified by market researchers. The work, when created, contains within itself the rules by which it is to be understood and enjoyed, but they are also the supplier's rules rather than the prospective customer's. The demand that now exists for the works of David Hockney or Michael Tippet did not exist prior to the artists' creation of their paintings and music.

Once created and once comprehended and enjoyed, a work of art will of course have a known market – a public taste will be said to exist which appreciates Barbara Hepworth's sculptures, the plays of Sean O'Casey or the music of Elgar. The work can be enhanced by critical debate, can be reinterpreted or revalued; it can enter the canons of our heritage in art. Here again, one asks in what way that necessarily differs from work transmitted through the media; why is it only in television, as Dr. Himmelweit says that, 'taste is the product of the producer rather than television entertainment the response of the producer to the public's taste'?[9] Taste is surely produced over time, in television as elsewhere. We have witnessed the growth of a 'market', and a discernable public taste for much that is good in television, and good television is not infrequently repeated and subjected to critical reassessment like other art constructs – *Hancock's Half Hour*, Humphrey Burton's *Ring Cycle*, the first episodes

of Granada's *Coronation Street*, the list of good repeats can be extensive. It might even be said that television moguls know rather more about public reaction to their constructs than do Arts bureaucrats about theirs, for their researches into public reaction are very much wider in scale and deeper in nature. They conduct research into the appreciation[10] of their productions as well as research into their consumption. By contrast a gallery director knows only (if lucky) how many people have visited an exhibition, and the theatre director knows only how many people have chosen to pay to come in. Unlike the television producer they know very little about what people chose to do instead, or what reservations they had about the work, and why in particular they enjoyed it.

A part of the barrier against the media is erected by the Arts establishment upon the belief that by their nature the media cannot satisfy as completely as can the direct experience of the art. In certain realms of art that is true; no electronic image can convey the delicate form of a Cezanne or the vigour of a Van Gogh painting, and even an excellent reproduction is limp beside the original. In other realms the television and radio cannot, however hard they may try, convey the feeling that you are *there*; the buzz of the foyers is missing, and the gathering sense of excitement before the conductor takes his place. But on the other hand we cannot pretend that the sound within the actual concert hall is necessarily better than the sound reproduced in some homes; if the satisfaction derives from hearing the music, rather from the social rituals which surround its playing, then it is sometimes possible that the satisfaction derived from a record or a broadcast is greater. There is thus no *compelling* reason to insist that the subsidised Arts, say, will inevitably produce a richer and more satisfying experience than participation in mass entertainments and media satisfactions. It may be, as Kammen suggests, that subsidised Art, popular art and the media face a common problem:

> 'One might assert that the most serious scarcity in our time – and one at the very core of that contemporary malaise so frequently mentioned – is a *scarcity of satisfactions*.'[11]

Or it may be, as is being suggested here, that they face a common *opportunity*. The antipathy between the subsidised Arts and the media world gets in the way of sensible co-operation. In the words of the novelist and broadcaster Melvyn Bragg:

'Examples and inadequacies could be multiplied. There are those active in one or other or the arts who find this comforting. The *arriviste* stands baffled outside the gates of the old culture, and its lack of success reassures the established forms. A strong and persistent snobbery and elitism – undeniable and surely tedious to instance – reinforces those with a sense of complacency: it is right and proper, so it goes, that the vulgar mob rule of television should be repulsed. The arts are a special preserve and best kept that way.

Those of us who practice the arts and also work in television find the impenetrability of the arts, their reluctance to join in the teleflow, both impressive and daunting: that smug, ungenerous and fundamentally insensitive elitism is deeply depressing . . .'[12]

He elaborates the point with an example from practical finance:

'A note in parenthesis. Many of the large companies are subsidised out of taxpayers' money. The general public pays a further fee for its television. There is clearly some demand for the work of those companies to be available to a wide public. The obvious solution is to put them on tape for the television screen via the networks or video. Educationalists and enthusiasts guarantee audiences large enough to give a sense of fair return for thos initial subsidies and licenses. Yet the expense of taking a production from any of the subsidised companies is quite extraordinarily high – even by television's costly standards – and is becoming prohibitive... It is a disgrace that the very high fees being demanded by companies whose money comes from the taxpayer should prevent recordings being made that would, at the very least, let the taxpayer see where his money was going.'

Bragg, no less than Kenneth Clark when he created the notable television series on *Civilisation*, finds a rooted hostility to the role of the populariser which, when it is combined with the ever-latent antagonism towards the media, leads at best to 'goodwill and inertia', and at worst to a viciously charged elitism, which can manifest itself both in an extreme protectionism toward the 'Arts world', and an ugly hostility towards media intruders in it.

Yet Bragg is both a populariser in the way Clark was in his television

work, one who renders the high arts accessible, *and* a populariser in another sense – popular artists are taken seriously. He has the quality of *recognising* popular art, and of evaluating it by other than sociological or statistical means; his 'South Bank' programme on Paul McCartney, for example, did not offer the usual stunning list of the musician's sales figures, or attempt the kind of usual gawking expose of McCartney's private life, but treated him as an interesting composer of light music. The media, no less than the Arts world, has its own tendency to treat popular artists campily, and visitors from the Arts world with undue reverence, but Bragg is one of a small band of contemporary British figures who avoid that trap.

So we return to the point at which we began. The best commercial managers do not set out to find the lowest, the most vulgar and the most simple common denominator of popular taste, and then exploit a supine mass. They have a highly-tuned sense of what is popular and good, and that is recognised instantaneously, by a kind of showman's instinct. They do not work well within bureaucracies, but (usually) alone. They then shape their organisations by decisive leadership, usually obsessed with visions of large scale success; their decisions appear eclectic, incautious, even random to their followers. They often succeed, but failure does not usually diminish their faith in their own populist instincts.

And, more than their colleagues in the subsidised Arts or local authority arts provision, they are attuned to the immediacy of popular fashion. Managers in the media, in the pop world, in the world of fashion design and interior decoration all talk of what is 'in', 'of the moment', 'hot', 'coming up' 'out there' and a host of other phrases, themselves as transitory as the fashions they refer to. And one harsh view is that they do not so much detect the taste of the moment as create it. The school of criticism associated with Denys Thompson[13] is less harsh, but its adherents are strongly inclined to allot great and sinister power to the entrepreneurs in the media and the so-called popular arts. It is as if they were capable of more or less choosing anyone from the street and making them, by a little judicious cooking of the promotional books, a star – or as if *any* kind of random habit could be profitably promoted as a 'fashion' or 'the latest craze'.

The reality is different. For every hula hoop or skateboard craze, there are a dozen expensive flops, and a hundred that do not ever see the light of

day.[14] For every Keith Richards there are fifty Joe Dolces[15] and a thousand unknowns. Far from choosing the product and then manipulating the market to take it, the successful commercial managers carry with them a complex reactive knowledge of the currents and waves of popular fashion and, often with great speed, recognise contemporary high talent – however unlikely the setting. Impresario Kit Lambert describes how he discovered the central figures in 'The Who', in the *Railway Tavern* in Harrow:

> 'I paid my few shillings and went into the back. On a stage made entirely of beer crates and with a ceiling so low you could stick a guitar through it without even trying, and lit by a single light bulb, were The High Numbers. Roger (Daltrey), with his teeth crossed at the front, moving from foot to foot like a zombie. John (Entwistle) immobile, looking like a stationary blob. (Pete) Townshend like a lanky bean-pole. Behind them Keith Moon sitting on a bicycle saddle, with his ridiculous eyes in his round moon face, bashing away for dear life, sending them all up and ogling the audience. They were all quarrelling among themselves between numbers. Yet there was an evil excitement about it all and instantly I knew they would become world superstars.'[16]

Brian Epstein's first sighting of the Beatles was not dissimilar, though his reaction was less impetuous:

> 'I arrived at the greasy steps leading to the vast cellar and descended gingerly past a surging crowd of beat fans to a desk where a large man sat examining membership cards. He knew my name and he nodded to an opening in the wall which led into the central of three tunnels which make up the rambling Cavern.
>
> Inside the club it was as black as a deep grave, dark and damp and smelly and I regretted my decision to come... I started to talk to one of the girls. 'Hey' she hissed, 'The Beatles're going on now.' And there on a platform at the end of the cellar's middle tunnel stood the four boys. Then I eased myself towards the stage, past rapt young faces and jigging bodies and for the first time I saw the Beatles properly.
>
> They were not very tidy and not very clean. But they were tidier

and cleaner than anyone else who performed at that lunchtime session or, for that matter, at most of the sessions I later attended. I had never seen anything like the Beatles on any stage. They smoked as they played and they ate and talked and pretended to hit each other. They turned their backs on the audience and shouted at them and laughed at private jokes.

I stayed in the Cavern and heard the second half of the programme and found myself liking the Beatles more and more. There was some indefinable charm there. They were extremely amusing and in a rough 'take it or leave it' way very attractive.

Never in my life had I thought of managing an artiste or representing one, or being in any way involved in behind-the scenes presentation, and I will never know what made me say to this eccentric group of boys that I thought a further meeting might be helpful to them and to me.'[17]

The commercial managers usually have the additional attribute of attracting money to their projects. Their judgement is often seen as a commercial asset. Stockbrokers will advise clients to invest in Robert Stigwood's enterprises,[18] and when Andrew Lloyd Webber's Really Useful Theatre Company was floated, it was capitalised at £9,000,000.

Yet business is asked to aid the *subsidised* Arts as a charitable enterprise and our system forces a great divide between commercial managers and the managers in the subsidised sector, and whereas Stigwood can make vast profits from *Jesus Christ Superstar*, raise £2,000,000 for *Tommy*, and capitalise *Grease* in many more millions, the subsidised Arts manager has been left operating a system in which a loss must be planned, where money accidentally made in profit has not easily been permitted to pass into the following financial year, and in which the only posture is that of being a *worthy cause*. Yet if, as a wild instance, we were to capitalise a 'Royal Shakespeare Company' in the same way Mr Lloyd Webber capitalised his theatre organisation, the response could be at least as great.

The distinction between the skills of the better administrators working within the subsidised system, and the skills of the better commercial entrepreneurs, is less in their innate abilities or in the qualities of the work they produce, than in the managerial and financial contexts in which they respectively operate. And the schism seems to be harmful to both sides. It

seems ludicrous that (say) Graham Greene, Suzy Quatro, Rowan Atkinson, Francis Bacon and Doris Lessing might be categorised as commercial artists, and David Puttnam, Richard Waddington, Craig Raine and Barry Stead as commercial arts entrepreneurs when one recalls the denigratory view the subsidised Arts world has always taken of purely commercial realms. *These* are the people who in the words of the 1965 white paper are assumed to be primarily concerned 'with quantity and profitability', or who, in W.E. Williams's earlier phrase, must surely be 'interested in business and not in art'. Absurd surely, as it would be absurd to think that people of the calibre of David Brierley and Bill Wilkinson, Ed Berman, Charles Osborne or Anthony Field might be adrift in the realms of higher management or financial entrepreneurship because of their connections with the 'pure' subsidised segment of the Arts market. The gulf between the non-profit-making charitable world and its jealously-guarded values, and the hard-nosed 'real' world of arts commerce, and its pugnatiously asserted values, is made ridiculously large.

Footnotes

1. Cyril Bertram Mills, *Bertram Mills Circus*. (Ashgrove Press, 1983)
2. A sum roughly equal to the total Arts Council grant in its first year.
3. Charles B. Cochran, *Showman Looks On*. (Dent, 1945)
4. Charles B. Cochran, *Cock A Doodle Doo*. (Dent, 1941)
5. Caroline Moorhead, *Sidney Bernstein*. (Jonathan Cape, 1984)
6. *Ibid* p.113
7. Kenneth Clark, *The Other Half* (Murray, 1977)
8. *The Journal of Social Issues* No.2 (U.S.)
9. H. Himmelweit, *Television and the Child*. (Oxford, 1958)
10. The A.I., or Appreciation Index, is a well-established tool in television audience research. 'Television's research into audience reaction (as distinct from size) always discovers a great, even fervent, sense of gratitude for the transmitted arts, despite all limitations.' (Melvyn Bragg).
11. M. Kammen, 'From Scarcity to Abundance – Scarcity?' in K. Boulding, (Ed), *From Abundance to Scarcity* (Ohio, 1978)
12. Melvyn Bragg, 'Open Space for Arts' in B. Wenham (Ed.). *The Third Age of Broadcasting* (Faber, 1982)
13. D. Thompson, *Discrimination and Popular Culture* (Pelican, 1964).
14. Remember Exercise Wheels, Pet Rocks, Moon Sweets?
15. Mr Dolce made it, very briefly, to No 1. in the Hit Parade with a horrible song called 'Shut Uppa Ya Face', and has not been heard of since. Mr Richards's

more enduring talents are described together with those of the other Rolling Stones, in D. Dalton, *The Rolling Stones; The First Twenty Years* (Thames and Hudson, 1981)

16. In conversation with Tony Palmer.
17. Brian Epstein, *A Cellarful of Noise* (Souvenir Press, 1964)

CHAPTER 8

MODELS FOR GOVERNMENT SUBVENTION

'The . . . regime exists for purposes that are not served by art, and the support of art is not among the powers that were given to the Federal government. None of the arts agencies under study has a defined purpose in any proper sense of the word, let alone one arrived at with knowledge and deliberation. What passes for purpose with each of them is a set of vague and conflicting statements of good intentions based on gross misconceptions of the nature of art and of the amount and character of the public demand for it – the precipitate, so to speak, of competitive struggles among interest groups and of adaptations by administrators endeavouring to maintain and advance their organisation in the face of changing circumstances.'

Edward C. Banfield, The Democratic Muse

Sometimes it is still said, as if this is a cause for great self congratulation, that in most western democracies the Arts are 'above politics' and that there is 'broad agreement between politicians of all parties' about how to deal with them. Yet the only sense in which it is true that there is broad agreement is that all governments assent to the same flabby platitudes – Art is a good thing and we should keep our national heritage intact, kind of thing. Strategies between successive governments in fact vary dramatically, and the variation of practices even of one government over time will often show that it adopts different principles for different purposes. The nature of intervention in the arts market will also vary between a national government and the regional or local governments, and this complexity is further compounded by differences over desirable strategies which may exist between governments and their neo-governmental funding agencies. All of these warring bodies will agree that people ought to have access to

149

the Arts, that the heritage should be treasured and that the Arts are important, but that does not mean that their conflicting actions and fluctuating cultural strategies are 'above politics'. The reverse is nearer the truth. Empty phrase-making is hiding a theatre of action which, though confused. is assuredly highly political.

The confusion is widely noted, but commentators will often write as if it exists only because politics has somehow crept in to the pure world of arts funding, and that as soon as it can be purged of political taint the government subvention system will work again. Thus the admirably trenchant Mavor Moore described some of Canada Council's difficulties in the early eighties.[1] In the *Wall Street Journal* Edwin Wilson noted (August 28th 1981) that the U.S. arts world was in a state of confusion, but made the British assumption that a nation's concern for art is measured only by the enthusiasm with which it creates and supports a neo-governmental funding body.

> 'We came quite late to the realisation that there may be something to the arts. A mere 15 years ago the National Endowment for the Arts (NEA) was founded along with the National Endowment for the Humanities (NEH). Most state arts councils are even younger.

And this has led to the kind of Fallacy of Administrative Innocence which suggests that all wrongs will be righted if the funding agencies of government are 1. taken over by pure Art lovers or pure businessmen and out of the hands of slimy politicians, and 2. given more money by these same politicians. Thus the outgoing National Concert Hall chairman in Ireland, Fred O'Donovan, remarked briskly that the Arts scene in Ireland in 1985 was 'a total shambles', that the confusions in aims and practices between different government and other agencies were 'not just a waste of financial resources' but a disgrace, then adding that the correct solution was to recruit a team of 'professionals' who would be 'without axes to grind' and who would form a semi-state body that would devise a cohesive and co-ordinated policy.[2]

There may be nothing wrong with the ideal of desiring there to be a cohesive and co-ordinated policy, providing that the policy-makers acknowledge all those areas of the arts in which no direct intervention is desirable, recognise that any arts policy must in part be reactive rather than prescriptive (a central failure of the British system has been that it has

forced the Arts Council into making prior announcements about how much excellent composing, play production or dance choreography there will be in each financial year), and do not apportion the highest value only to those organisations over which they have direct control. What is however wrong is any pretence that even people without axes to grind could do this *apolitically*. The definition of Art for such purposes is in part a political decision. The recognition of needs or wants associated with that Art involves political decisions. Satisfying chosen wants or needs from the inevitably limited resources involves the creation of priorities, a further and even more obvious political act. *All* systems are political.

The times when observers have suggested that systems of government subvention in Britain, Canada, Ireland, the United States or indeed in any of our European partners *were* working cohesively and when policies were co-ordinated were times when the prevailing systems of government subvention, or parts of those systems, broadly matched the more vocal arts constituencies' political ambitions. Such tranquil times, in Britain at any rate, did not mean that our Arts Council had any one coherent set of principles. It funded some organisations because they contributed to national glory, and others because they wished to overthrow such establishment bastions. It funded tiny performing Arts venues and savaged others because their attendances were too small. It primly announced it didn't support amateurs but carried on for some years supporting the National Youth Theatre, which was amateur. But its actions over some short periods, confused and contradictory though they were, met the major rhetoricians' demands, and kept them satisfied in meetings and panel discussions, playing the funding game the 1976 Redcliffe Maud Report characterised as 'He who shouts loudest gets most.' But when, for whatever reason, the different expectations which have been aroused can no longer be met, as has happened in many western democracies and in many countries within the Commonwealth over the last decade, and when the contradictions and confusions within the system are therefore starkly exposed, then it is too readily assumed that 'politics' has crept into the chaste Arts world – whereas the truth is that more limited resources mean that some political accommodations can no longer be sustained, and what remains appears (as it is) political, partial and inadequate.

It is therefore useful to separate out the various different models

according to which governments (of all kinds) act when they intervene in the arts world. Interventions can of course be positive (making legal concessions, supporting educational systems, giving subventions, building and lending expertise) or negative (legal and fiscal prohibitions, censorship, or other controls) but they will often be undertaken according to one or other of the following models. As we shall also see, governments may, and often with little sense that they are making such a shift, directly move, or cause their funding agencies to move, from one model to another. Sometimes this causes no difficulty, for the different aims and practices are reconcilable. Sometimes it creates irreconcilable tensions, as we shall observe later in the chapter.

a. The Glory Model

This is, according to Professor Hampshire,[3] the only valid reason for government subvention in the arts. Governments support those constructs and activities which embody the richest and most sophisticated aspects of the culture, for such a national investment contributes to the national glory. The National Gallery, the National Dance Company, the National Opera impress visiting ambassadors and are themselves ambassadors; they make a glorious mark upon history. We thus think of 5th century B.C. Athens as a place of supreme civilisation, because of the glory of its dramas (and forget the 14,000 slaves working in hideous conditions underground[4]). We think well of the civilisation of Louis XIV, dazzled by the glory of Versailles, and forget the starving peasants outside its walls.

All kinds of governments act according to the glory model. Stalin promoted the grandeurs of the Bolshoi, and his successors sent Red Army Choirs and Folk Dance troupes around the world to impress their neighbours with the glories of Soviet life. Impoverished countries such as Zanzibar will nevertheless give priority to a National Dance Company. The French President, M. Mitterand, has caused to be built at the Bastille a second great opera house, at a cost of £200,000,000, which, when it opens in 1989 will promote the glories of French *haute culture* through the next century. These companies and these buildings – at the supreme level the two are inextricable luminaries of the national glory – are the modern wonders of the world.

In Britain great achievements are national, outstanding achievements are Royal. In this country therefore we have an extraordinary pattern of twin-starred glory – the Royal Academy and the National Gallery, the Royal Symphony Orchestra and the English National Orchestra, the Royal Opera House and the English National Opera. Thus the British Royal Family, formidable patrons of the visual arts, give their patent and approval to certain streams of national artistic glory, and enhance it (as with Prince Charles's work on behalf of the Royal Opera House) with their practical support.[5]

As in most European countries however, the supreme glory is the one art form that has no claim to be indigenous to Britain. The opera, as we have already seen, is in a curious way the *raison d'être* of the post war Arts Council, and is seen as the lodestar of our national culture. Threatened with the continuation of a general tax upon the opera house in 1978, the Royal Opera House supremo Sir John Tooley announced that it would mean 'spiritual death' for the whole country! The arts establishment is of like mind. The subsidy the state pays per seat occupied in the Royal Opera House is now in excess of £20. The importance the state attaches therefore to this particular glory may be crudely gauged from a comparison such as the following:

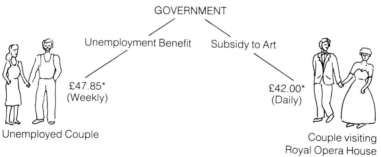

GOVERNMENT

Unemployment Benefit Subsidy to Art

£47.85*
(Weekly)

£42.00*
(Daily)

Unemployed Couple

Couple visiting
Royal Opera House

* June 1986 Figures

Or indeed – as apologists for the subsidised Arts world are fond of saying that arts subsidy 'equals' the hull of a trident, or the tail fin of Concorde or whatever – one might point out in order to subsidise each

cultivated Londoner's visit to the Opera House, the government expenditure 'equals' the tax gained from the sale of more than seventy pints of the workers' beer.

b. The Placebo Model

Times of crisis bring forth from worried governments a second invocation – arts as placebo, a stifling of or cure for some pressing problem. Governments may do this inefficiently – as with Marie Antoinette's misguided ideas about diverting her rioting subjects – or more sensibly, as with some of the U.S. Federal Schemes for arts-led activity between the wars as placebo for the ills of unemployment. They may do it in annual bursts – as with aid for the Caribbean Carnivals – or continuously, as with the Urban Council's entertainment programmes in the parks of Hong Kong. It is however a frequent motive of governments in subventing the arts. Programmes offered for this reason are not overly demanding; they are not surrounded with the kind of portentious puffing that glory Arts products are, and they are usually presented simply and with little social carry-on. They give a group of people what they are supposed to want, and governments usually imagine that such a gesture brings social harmony and calm.

Television services are usually perceived by some government interests (and some hostile critics) as being placebos, and there is often trouble when programmes are 'controversial', 'explicit' or 'disturbing'; it is even seen as a kind of unethical usage of a basically soporific medium if it sets out to alarm and discomfort its viewers. National Festivals sometimes have this character, and those people who claim that 'the Arts' could help solve the problems of our inner cities plainly see the Arts as being a placebo for a wide range of social and physical problems.

c. The Educational Model

In its most extreme form – that found in totalitarian regimes – this model makes allies of the state education service and the state system of arts subvention, forbids all opposition, and promotes the Arts as an adjunct to the state propoganda system. All education in the Arts is then a centralised induction system which aims to provide an appreciative audience for the state-approved Arts, and leaves no room for critical dissent. The system is

at its most extreme accompanied by a rigorous system of state censorship, coercive in nature, and universally applied.

The purest example may be found in the pre-war Third Reich in Germany, where unacceptable views presented in any art form were punishable by death. The state however promoted 5 state theatres, 25 provincial theatres, 105 town state theatres and 34 community theatres. The country was divided into 32 districts, 800 sub-districts and had 18,000 regional arts offices with 8,000 regional arts officers – all promoting the dramas which the state deemed to be good and which the schools taught how to appreciate. In music the most extreme example might have been Fascist Italy, where Mussolini's Cars of Thespis took opera and music to every village through the *Dopo Levoro* movement. Fine music was presented at prices which ranged from ½p to 2p, but, again, it was allied to a rigid censorship system and a stifling of critical faculties in the state schools. A more recent example in the visual arts would be the censorship which existed under the Greek Colonels in the sixties and early seventies, when bemused visitors would be taken under conditions of great secrecy to see clandestine exhibitions of contemporary painting and sculpture; meanwhile state-approved art was vigorously promoted when it could be allied to propogandist purposes.

We have earlier observed how in Britain the growth of state education – which, as the energetic head of the school inspectorate James Phillips Kay observed in the nineteenth century, 'must be concerned with more than mechanical training' – went hand in hand with the increasing suffocation of mere entertainment.[6] In general however, since that time, the state system of subvention and the state education system have grown apart. There has been the notion in British schools and universities that a sense of critical discrimination is fostered as a core of a liberal education, and that 'arts education' does not exist to provide audiences for state-approved Art. However, we might notice with some disquiet (though no very great surprise, if the essentially narrow and patrician character we have given the Arts Council is anywhere near the truth) that in recent times, when it has seen 'education' as one of its concerns, the Arts Council has seemed to see education as an activity indistinguishable from marketing (see Appendix – The Arts Council and Education).

It also viewed the development of the Creative and Performing Arts degrees that are validated by C.N.A.A. with grave disquiet, making the

apparent assumption that their only function could be to train people for the subsidised Arts world, and sternly announcing that there was no room for them. Early evidence suggests that they were wrong; the graduates from such courses have an excellent record in finding employment in a range of educational, social and media positions, and have not impinged much upon sacred 'professional' preserves. (An interesting development is that Dance seemed to become 'subsidy-worthy' after it had, through the work of the Polytechnics and C.N.A.A., become 'degree-worthy').

d. The Reward Model

The arts may be promoted as a reward to an aristocratic, meritocratic or other group seen to be deserving of them. This was the reason Mr Brezhnev gave for the sumptuous new theatre the authorities built in the 'hero city' of Riga in the U.S.S.R.; it was a 'reward' for the courage and hard work of the local citizens.[7] Reward may also be in the form of an inducement, and new towns or even developing countries will often build arts venues to help to attract industry or investors, and to reward them for their support.

In Britain there is an extreme form of this model, which suggests that the Arts system must function as a response to, and reward for, the activities of influential technocrats. This group is assumed to consist of people with a wholly 'new consciousness', of which (it is implied) we should take great notice. This line of thought began with the late Sir Charles Snow, who announced that the 'new men' of the scientific age would not have much to do with 'the old culture'.[8] The new group is given a broader and more recent definition by Sir William Rees Mogg:

'The class structure of the late twentieth century is coming to be dominated by a large, affluent and technically qualified middle class, whose work is either directly involved in communications or conditioned by electronic systems.

The development and strengthening of the power of this new class is apparent in all advanced countries, and is significant even in poorer and more backward ones such as those of the socialist bloc. We must not make the mistake of thinking that the laws of economic and social change stop short at the Berlin Wall. This modern middle class has no traditional upper class roots and few, if

any, upper class aspirations. It sees the relics of an aristocratic past for what they are, handsome relics; it does not, like the upwardly mobile Victorian class, pretend to a pseudo-aristocratic life style; it is not wedded to silver, mahogany and dinner jackets.

The history of the arts has been punctuated with periods of the rapid expansion of a new middle class; they have been most favourable to artistic development . . . The electronic middle class, if one may so describe them, are already providing a similar expansion of the late twentieth century audience for the arts.'[9]

The Arts however must meet the expectations of this pervasive 'new consciousness' and reward their affluence and technical qualifications. Thus 'twentieth century modernism' is the 'art of its grandfather's generation'. Artists must move out of the 'post-Fabian Guardian consciousness of genteel academic English collectivism', must cease to be 'trapped in a dated and provincial set of attitudes'[10] and must establish a relationship with this new electronic middle class, and 'share the new consciousness'. This argument, by isolating one supposed segment of society and announcing that it is a 'new audience' (even though artists have apparently to be trained afresh to share its language and values) masks a value judgement which is based upon the reward model. This technologically-minded group is presumed to be *deserving*, and the Arts are to be reshaped as tangible reward for their virtues.

e. The Service Model

Both totalitarian and democratic governments may, for different reasons, have policies which permit presentation of the arts to be in such forms as render them generally accessible. No state legislation can equalise the creative talents of its citizens, and render them all poets, painters and musicians of equal ability, but legislation can both create systems in which all citizens can equally participate in creative activities, according to their wishes, and systems which give all people a reasonable chance of enjoying the arts.

The service model may be operated with considerable coercive powers by the authorities, as in Athens in the fifth century B.C., when theatre-going was, at the time of the civic festivals, compulsory. It may be offered without legal coercion however, as in Newfoundland's touring

circuit systems, which aim to give all citizens a roughly equal opportunity to see stage shows in a region where travel to a central urban area is often difficult. In the second case, where there is no direct coercion, the distinction between making the arts available and making them genuinely accessible is important. The fact that all citizens have presentations close by, and cheaply available, does not render the arts equally accessible; all kinds of intangible social and educational barriers may still remain.

In Britain significant parts of the wider arts world operate according to service models. Some of the arts teaching in our education service is compulsory, and there is an element of coercion in the way our children are 'taught to appreciate' Shakespeare and Milton.[11] Another element, the national Library Service, operates without coercion – rather more like the Health Service, which aims to be universally accessible, though its ministrations may not be equally sought by all citizens, and there is no compulsion to use it. The Library Service does not operate according to a Glory Model and does not usually seek to maintain centres of excellence in reading, but is a general service. The 600,000,000 borrowings that are made annually from its 5,500 outlets incude a very great deal of material which critical opinion would hold to be enervating and puerile, but this form of the service model does not make a prior judgement (usually) as to public 'needs' but aims to satisfy a range of their wants.

There is of course a critical view which holds that a relatively undifferentiated service *inevitably* leads to lowering of standards and that a service which reacts to popular demand as well as following its own judgements and trying to be proactive, must be tainted, and must lead to a general debasement. Evidence from the British television service hardly supports this view – both the work of the B.B.C. in its 'battle for the ratings' and the work of the commercial Channel 4 suggest that the opposite may be true. And one barometer of reading habits – the new titles published – does not indicate that the ready availability of Ethel M. Dell and Jeffrey Archer in our public libraries has turned us into mindless zombies devouring nothing but cheap fiction.

f. The Compensatory Model

According to this model, the state, its designated quasi-governmental bodies or local governments may sometimes choose to promote an

NEW BOOK TITLES ISSUED BY CATEGORY

	1971	1981	1984
Children's Books	1,553	2,438	3,628
Fiction	2,134	2,910	3,132
Political Science	1,919	2,896	3,076
Medical Science	1,008	2,341	2,778
Education Textbooks	2,385	2,576	2,767
Religion and Theology	775	1,089	1,534
Art and Architecture	1,037	1,423	1,530
History	980	1,085	1,269
Biography	716	941	1,264
Law and Public Administration	586	1,095	1,238
Sports, games and pastimes	575	937	1,146
Natural Sciences	814	1,044	1,017
Poetry and Drama	981	704	911
Chemistry and Physics	888	567	584

activity that was formerly supported by another agency, now defunct, or may choose to maintain activities which once flourished in different circumstances but which would now, unless aided, disappear. Thus the West German authorities choose to maintain opera houses that once were sustained by the patronage of princes, and at the other end of the

spectrum the folk arts program of the U.S. National Endowment for the Arts seeks to support traditional folk activities that would otherwise, in the swirl and eddy of social change, probably disappear. Recipients of the 1984 National Heritage Fellowships included a 'Coiled Grass Basket Maker', an island story teller, a 'Knotted Bedspread Maker', a black tap dancer, an Irish fiddler and an Eskimo craftsman.

In Britain it sometimes used to be said that the state had 'taken over' from private patronage, but this is a misleading notion. All the arts in Britain have at various times had substantial periods when they have sustained themselves in the market place without any form of patronage. There are however elements of compensation in the work of arts centres (in part compensating for the widespread loss of village halls and other communal centres and activities provided by the church) and of community groups (who sometimes seek to compensate for the loss of traditional neighbourhood activities) and in the building programmes of local authorities (where leisure centres, galleries and theatres may be built to compensate for the loss of facilities formerly provided by local aristocracy or commercial entrepreneurs).

g. The Commercial Model

The final model for state subvention must be carefully distinguished from ordinary commercial activity in arts markets. This is the model by which governments may choose to treat the arts as goods, commercial *products* which are to be invested in because they bring tangible profit. Governments in this respect may behave like private speculators, and may hoard pictures, tapestries, jewellery and other treasures not for their beauty, or with any intention of displaying them for public enjoyment, but simply for their appreciating commercial value.[12] Less extreme are instances of government subvention in which an activity is set up by subsidy in the hope that it will ultimately be profitable in a wider sense – some grants given to craftsmen in European countries to set up and develop their own businesses would come into this category. At a lower level still, governments are sometimes urged to give financial aid to arts organisations because, even though they may not be directly profitable, their wider impact brings profitable business to the neighbourhood. Finally, at the most basic level, it is sometimes argued that governments

can still think about their subvention in the arts market as a commercial activity because cost-benefit analysis, which puts figures to the intangible social benefits arts activities supposedly engender, shows they are, in a wider sense, profitable.

The commercial model has, until recently, rarely played any part in British debates about subvention in the arts market. This was for an obvious reason. The prime argument was always that *the Arts, by their nature, were unprofitable* and needed subsidy to 'bridge the gap' left by the excess of their necessary expenditure over the maximum the public could be expected to pay. Latterly, in recognition of the fact that governments have been increasingly disinclined to support 'lame ducks', and a feeling that in any case too great a reliance upon public charity breeds over-dependence, the Arts establishment has tried to meld the commercial arts world with the subsidised Arts world, pretending that the grant support system is in some way an 'investment' in the whole arts economy. This obviously weakens the older argument for subsidy, by suggesting that the arts are *not* by their nature uncommercial. So a curious twinning has been created. For a period it has been suggested that arts organisations should supplement their government grant (given, for so long, because the arts cannot hope to be a profitable investment) with industrial support and commercial sponsorship (argued for on the opposite grounds, that the arts *are* a profitable investment).

These seven models have two immediate uses. First, they give a new language in which to describe government subsidy, more precise than the vague platitude that governments simply 'aid the arts'. By the use of these models their purposes become clearer. Second, and following from this, it becomes more apparent how a cohesive cultural policy may be formed, for some of these models *may not be simultaneously pursued*, and only confusion (of a kind readily apparent to us when we look at the chaos of much modern policy-making) will ensue.

It is, for example, difficult to promote the arts according to the service model, *and* according to the commercial model at the same time; *the arts cannot simultaneously be regarded as both goods and services*. Likewise it is difficult both to provide arts facilities according to a reward model, and at the same time according to a compensatory model; each suggests different priorities, conflicting methodologies, and a contrasting under-standing of needs. Although there is no cut and dried certainty about it, it

is even possible to suggest (as in the following diagram) those areas which are likely to be areas of conflict when government agencies assume two contrasting models for their behaviour.

AREAS OF LIKELY CONFLICT IN MODELS FOR GOVERNMENT SUBVENTION

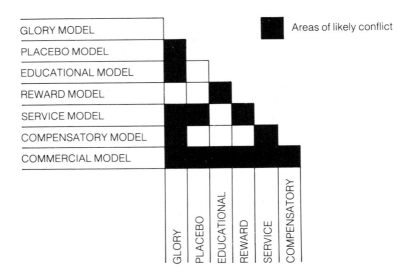

Thus the arts which are promoted according to the glory model, for example, cannot – if their aim is recognised excellence – simultaneously be promoted according to the commercial model. Nor is compromise easy to find. There will inevitably be arguments over excellence and popularity, over profitability and critical acclaim, and over a hundred other inbuilt conflicts. Almost every action taken (for example) by a National Theatre, which is both government supported for the national glory but yet has to find a degree of commercial viability, will result in conflict. Each item on the programme will throw up the conflict between excellence and

commercial profitability, every discussion on ticket prices will throw up the problem of whether to offer easy access to all or whether to ask the well-to-do to pay a commercial rate, every show the Director produces outside the subsidised realm will pose the question as to how far he or she is justified in using a subsidised service base to make a personal commercial profit. The aims are conflicting; the criteria for success are inextricably confused; the management strategies are in mutual opposition.

And such conflicts are not merely economic difficulties. Each of the models described above involves a different political strategy, so each has its own ethical and moral assumptions. To confuse (say) the service model and the placebo model is to create not just an economic, but a *moral* conflict. And such inbuilt moral conflicts have, in Britain, too often been hidden by the smeary attempt to make 'the arts' appear to be a homogeneous whole, instead of a universe of different kinds of construct, and by the attempt to make it appear that 'the arts' are 'above politics'. Inevitably, the Arts Council is at the centre of this obfuscation, for it continues to pretend to speak for 'the arts', as if that is a coherent body which it converses with or controls, and continues to act as if it is an apolitical agent. The truth is rather that over the years it has at various times added strategies to its armoury which follow each of these models. It acts therefore from a variety of motives, accumulated at various times, and is a complex political body, hiding its twisted entrails beneath a skin of apparently bland and unexceptionable platitude.

The Council however has *never* formally renounced any one of these motives, and the 'criteria' for its support thus become ever more numerous, as do the bureaucrats required to apply them. Thus, in 1983, the British Arts Council's criteria for judgement numbered fourteen, here baldly summarised:

a. quality of artistic product, and input to an overall programme.
b. actual and potential creative strength.
c. the extent to which stated aims and objects are realised.
d. full use of facilities and wide provision to the community.
e. education policies in relationship to the artistic programme.
f. employment and other opportunities extended to members of ethnic minority groups.

g. overall value for money, including any success in extending audiences through other media.
h. box office and attendance returns.
i. company's success in raising local authority and other additional support.
j. efficiency in using resources and accuracy and control in budgeting.
k. the urgency and nature of any fundamental financial problems.
l. the adequacy and security of tenure of premises.
m. the balance of provision between London and other regions.
n. the Council's existing declared policies, particularly the emphasis it places on full-time professional work.

Those criteria were not set out in any order or priority, nor, it was understood, did each criterion have to be considered in each case. As these criteria are (we have suggested) mutually contradictory, it was indeed impractical to consider them all in each case. It was inevitable that a hidden agenda must operate which determined which criteria were applied to which applicant.

Partly in recognition of the fact that the Council had gathered to its keel different aims and priorities at different times on its voyage, and that these contradictory dicta stuck to it like barnacles, the Arts Council produced in 1984 its much-heralded reformulation of its policies, *Glory of the Garden*. The continuation of the horticultural metaphor in the title was not propitious, and the document itself, though announcing that it contained a new 'strategy' for the eighties, was a sad disappointment. Such proposals that it made for change were slight, and were long-winded continuations of the kinds of 'policies' which successive Secretary-Generals had announced desirable for the previous thirty seven years – longer term planning in aims and objectives for the well-established clients, responsivity to new work, and a slight further shift in the transfer of state aid to 'the regions'. The document announced sensibly enough that the Council was stuck in a groove, but it made no attempt to examine the nature of the groove or the reason for its continued adherence to it. There was no questioning of the fact that the definition of 'the Arts' had become so narrow and so bureaucratised, no fundamental challenging of the assumption that the Arts are helped and favoured by state support of the Arts Council kind, and no reconsideration of the notion that the Arts,

the real Arts, only exist when the Council approves of them, has 'taken initiatives' and is controlling them through the subsidy system. The document was thus full of weary pieties which could well have been written at any time during the previous three decades.

'It has for some time been the Council's policy to develop the arts in the regions', the document announced, having portentiously informed the world that the Council was 'making a start towards redressing certain historical imbalances in funding which favour some art forms at the expense of others.' The equation of 'funding' with 'development' is everywhere – the notion that creation and presentation of art can be smeared together, and transferred to the 'regions' by a centralised apportionment of state funds, is all hidden under a bland and dangerous new term in the Council's lexography, *'development'*. Although any actual comparison of the Arts Council's modest role in the overall British arts market with the role played by the Soviet Ministry of Culture is bound to be ludicrously imbalanced, it says something for the Council's extraordinary desire to affect a total control of the arts market that they use a word, 'development', which is central to *Soviet* cultural planning. Their awaited 'devolution' of power to the Regional Arts Associations also became, through their passing on of 'development' plans and 'development' money, very different from the transfer of critical authority for which some of the RAAs had hoped; it became instead a form of decentralisation, in which, as in the U.S.S.R., the 'regional centres' are in fact provincial offices of the central authority, passing on predetermined sums to designated clients according to a centrally-determined system.

The Glory of the Garden was nothing very new. It took no account of the nature of the wider arts world (The 'priority areas' were announced as Art, Dance, Drama, Music and 'Education'), and took no pains to re-examine the language in which these questions could be discussed. It continued to blur the distinction between Critics and Experts, and its own new breed of experts spoke with a self-important authority (Arts Council memoranda became National Plans for Art) but with no comprehension at all of how the arts might be evaluated in other than modish political or economic terms. It recognised none of the pervasive contradictions within its own thinking, affecting to believe that it was a matter only of talking the fashionable commercial language of 'fundamental reviews' and 'hard new looks' to convince the world that serious thought was in progress and

that the national culture could safely be left to the Arts bureaucrats. They understood in Mrs Thatcher's Britain what were the creative 'needs' of the new technocrats, and they understood the hitherto stifled 'needs' of folk outside London (who found that their provinces were now referred to as 'regions', and that they were being *developed. . .*)

The document is full of comments on urban and rural Britain which were, to put it kindly, of stunning banality, and the whole 'development strategy' was of a size ridiculously out of proportion to the urban and rural cultures and the social problems to which it sought to give answers. Here, defending the *Glory of the Garden* 'strategy' from the scorn and outrage which its publication generally attracted, is the ubiquitous Sir William Rees Mogg:

> 'I sympathise with the National Theatre, housed in that great concrete dreadnought on the South Bank, an expensive but unfortunately, not a watertight ship. But I sympathise a lot more with the Everyman theatre in Liverpool, *on the edge of the worst area of social suffering and deprivation in England.* The National Theatre gets £6.7 million from the Arts Council; the Everyman, *even after development,* will get less than £250,000.'[13] (*My italics*)

The implied equations here are of a numbing crudity. The authority with which Liverpool (Liverpool of its two great football clubs, the Beatles, the Scaffold, Carla Lane, its Garden Festival, its magnificent Museums development, its writers' theatre, its great cathedrals, its folk clubs and its pub poets, its Walker Art Gallery, its great scouse comics and its nervy local radio stations) is assumed to suffer the worst cultural deprivation in England suggests an unusual degree of authority in the speaker. The assumption moreover that the 'development' of which the Arts Council speaks has any bearing at all upon the developments in housing, health and education which are plainly wanted is extraordinary. The implication is that *social* justice is somehow met by the Council's (no doubt welcome) desire to give the Everyman organisation a larger grant; an inequality in wealth and opportunity somehow redressed by the gesture. But the gesture is inadequate not because the Council didn't give *enough* - if the Council gave £6.7 million to the Everyman it would have only a marginal effect upon the rich and thriving culture of that city, and would have little effect upon the actual physical deprivations of its citizens

– it is inadequate because it is given as a token, a part of an ill-considered 'strategy', for confused reasons, and (however highflown in ambition the public aims seem to be) as a pawn in what is a bureaucratic game.

The confusion within the Council is clear enough – the outside management experts who pronounced upon the Council's internal workings in 1984/5 rightly isolated lack of clear policy and confusion over role as the first areas of concern in the organisational arrangements – but our concern here must be to notice that this leads in turn to a further blandness of public language (and the increased adoption of internal codes of language between Council officers and their contacts), an increased bureaucratisation as each conflicting aspect of the 'strategy' has appointees arguing for it, and pushing for the appointment of similar specialists in clients, and most obvious of all, leads to the Council expending a great deal of energy upon its own survival. *The Glory of the Garden* is perhaps to be condemned most of all for its willingness to throw any fashionable management notion, any principle currently in favour and any modish buzz words into a scrambled argument which some would read as less an argument for the arts than a plea that the Arts *Council* must at all costs continue.

Footnotes

1. Mr Moore, formerly of Canada Council, has become a trenchant critic of the system.
2. *The Stage* April 17th 1986.
3. Professor Hampshire put the view with great force in his review of Baldry's *The Case for the Arts*, in *The Times Educational Supplement* February 26th 1982.
4. Kitto, *The Greeks* (Penguin, 1974)
5. An extreme view is that the Royal Family are themselves, in their public lives, with the attendant state ceremonial, the major contemporary British art.
6. A good account of Kay-Shuttleworth's character, and with Arnold's work with the school inspectorate (and hence the location of the developing school system within the debate on *Culture and Anarchy*) is in Honan, *Matthew Arnold, A Life* (Weidenfeld and Nicholson, 1981).
7. Leonid Brezhnev, *Address to the Citizens of Riga* (Prospect, Moscow. 1979)
8. C.P. Snow, *The Two Cultures*, 1963.
9. Sir William Rees Mogg, *The Political Economy of Art.* (ACGB, 1985)
10. 'Dated and provincial' is in Arts Council newspeak the perjorative form of 'the

heritage of the regions', which is by contrast an admirable thing.
11. Some remembered acts of coercion may have a different basis. See Professor Hudson's *Contrary Imaginations* (Pelican, 1974)
12. Values and prices in the visual arts world are lucidly discussed in Moody, *The Art Market* (Comedia, 1986)
13. Sir William Rees Mogg. *Op cit.*

CHAPTER 9

AN ARTS POLICY?

The ordinary criteria of just and equable distribution of taxpayers' money will not be satisfied in subsidising the arts.

If equity cannot be achieved in this particular distribution from public funds, what important ends can be achieved and what criteria or principles can be applied?

Professor Stuart Hampshire

'Our major arts institutions, such as the Arts Council,' said Dr David Owen in 1986, 'are all campaigning to save themselves from what they term a 'crisis' in the arts. The 'crisis' is not in the arts, however, but in the system by which these institutions are subsidised by the state – a very different matter. It is the current structure of finance that needs changing.'[1]

Dr Owen was voicing an opinion which has found a wider acceptance amongst politicians (and arts publics) in Britain and elsewhere in the English-speaking world, particularly in the last year. It is recognised generally that the 'British system' of financing the Arts through an organisation 'at arm's length' from government has now many more disadvantages than positive advantages. It is divisive, making a separation between 'Art' and other creative pastimes which is based more upon institutionalised practice, available funds and political expediency than upon genuine critical judgement. It atrophies the muscles of the arts markets and does not stimulate them. It spawns unproductive and arrogant bureaucracies, and leads us to substitute their ingrown political cant for the live and nervy language of genuine arts appreciation. It rewards unpopular art and commercial failure disproportionately, and draws organisations which sport such traits into a grid which neo-governmental agencies can readily use as a system of control, by their ultimate power to give or withold money. Its structure means it is

organisation-centered, and the determined maintenance of increasingly-bureaucratised organisations has come to be synonymous with the maintenance of 'the Arts'.

The post-war British system above all is to be condemned because it forces us to live a series of embarrassing lies – that the subsidised Arts sector is 'the' arts economy, that additional funds for that small segment is somehow an 'investment' in the whole arts scene, that all the higher values of the Arts are to be found in subsidised 'centres of excellence', and that this highly-vocal, highly politicised activity is somehow carrying out the whole of a great range of (contradictory) arts-related activities; sustaining the best, spreading the arts as service, giving a voice to minority groups, satisfying peoples' wants and educating them to know their supposed needs. The claims for the subsidised Arts world in Britain become ever larger as its audience shrinks and its bureaucracy swells, until one has a nightmare vision of the whole structure being reduced to a chain of tightly-guarded Georgian dwellings, into which secretive armies of Arts bureaucrats daily shuffle, a network which swallows up most of the available funds in its own running costs and gives the rest to other organisations who exist largely to have meetings with it, and from which issues from time to time a new 'strategy' for the coming decades; 'Fertilizing the Pansies', 'Gro-bags for the Regions', 'Pruning and Shredding', and, to maintain continuity with the past, every ten years or so a report on the problems of the four London Orchestras.

The recognition that the British system, with its 'arm's length' notions of keeping politicians away from the Arts, has instead led to a politicisation of Arts practices, is worldwide. Relations between governments and Councils have worldwide been strained. Broadly speaking, as Councils have forfeited their claims to be concerned with proper critical evaluation, and have thus been perceived as political agencies, they have lost the confidence of the wider arts world; their attempts to take the opposite stance, and to confront governments on policy matters as if they represent the entirety of the arts world are perceived by the governments in their turn as sham. The tribulations of the Canada Council, National Endowment for the Arts, Australia Council and the British Arts Council are thus remarkably similar. There is a loss of faith in the neo-governmental organisations' abilities to attain any of the objectives they claim to be within their competence, a lack of belief that they do really

'represent' the arts, and above all a lack of faith in the kind of assessment/grant-aiding cycle which has been at the heart of the financial systems.

Not unnaturally there has been from the Right of the Conservative Party in Britain a feeling that it would therefore be much more sensible to have no system of aid, subsidy or subvention in the arts at all, and that people and arts organisations would be better left to the open market, with some personal taxation and organisational taxes removed. This was put in modified form but with admirable clarity by Sir William Rees Mogg:

'I am not sure I would not prefer cutting out taxes on the arts to raising subsidy in real terms. VAT on theatre, dance, music, even paintings and sculptures sold in galleries, is an absurdity. Money goes to the treasury, on to the office of arts and libraries, on to the Arts Council and back to the theatre that paid it – after three sets of administrative overheads on the way. I do not think that knowledge ought to be taxed, or education. I would prefer to reduce our clients' dependence on the Arts Council by cutting taxes on art rather than by increasing subsidy.'[2]

A more familiar Conservative argument has been that state subsidy should be supplemented by private support, and that the present financial support system should be weakened, but not demolished or replaced. This received its prime formulation in a Bow Group pamphlet by Colin Brough, *As You Like It* which offered the well-worn (and as we have seen, innaccurate) historical justification for 'Patronage':

'For centuries the arts have been supported by individuals who knew what art they liked and had enough money to 'pay the piper and call the tune'. These patrons have generally belonged to the governing establishment of the day, be they the Royal Family, the Church or, since the Industrial Revolution, the business community. Frequently their influence inspired, and their wealth financed, much of our artistic heritage. Now their power and affluence have been eroded by social reforms and taxation, leaving a vacuum in the pattern of traditional support for the arts.'[3]

The pamphlet continues by making suggestions for a series of legal and fiscal changes, some of which have been introduced by the present

Conservative government, to make charitable donations easier for industry. However it rests still upon the myth that 'the arts' have always been patronised and subsidised by one means or another, and ignores the awkward fact that for more than two centuries a considerable part of the arts world – the greater part – has been commerically viable, and that (as with sport) in most areas enough people have wanted to participate in it to pay for it to be so. There is more than a hint, here and elsewhere, that what is being proposed is a kind of arts control system for the private sector parallel to the control system which runs on government money. The pamphlet regards such a system as 'complementary' to the Arts Council (p.4), and an 'alternative' (p.5). It makes it clear that the prime motive is to engender 'good will' towards the companies (p.5 ff), and that we must therefore expect the Apollonian arts (Chapter 1) to be promoted rather than the darker, challenging forms of artistic creation.

It is significant that only in the middle-to-left sectors of the Conservative Party does one find any direct support for the Arts Council subsidy/support system remaining more or less as it is. To Conservative eyes the present set-up appears to be satisfactory enough; a degree of control to prevent the system engendering overmuch radical thought, but the government interest far too small to raise spectres of Art being nationalised. 'In my view,' Lord Gowrie said to me in 1984, 'we still have the best system in the world.'

Since 1977, when the Labour Party published a detailed manifesto, *The Arts and the People*, it has been Labour party policy to change the system quite drastically. At that time, the proposal was that a 'reformed' Council, with elected members, would take its place within a Ministry of the Arts, Entertainment and Communications alongside three new bodies, as follows:

Ministry of The Arts, Entertainment and Communications

| Reformed Arts Council (Formerly under DES) | Museums and Galleries Council (Taking responsibilities from DES) | British Film Authority (Responsibilities from Dept. of Trade) | Communications Council (From Dept. of Trade and Home Office) |

The Arts Council would have panels which were elected or which were representative of various segments of the arts market. The creation of the Ministry would be allied to the introduction of legislation to give Britain's local authorities the *statutory* obligation to initiate, develop and support arts and entertainment facilities in their areas (a 0.5p minimum rate was recommended as the baseline for such statutory spending).

These proposals were designed to aid a kind of welfare model of arts support, which in the words of the document, had as its first four objectives:

a. to make the arts available and relevant to all people in this country;
b. to increase the quality and diversity of the arts with greater emphasis on those based in communities;
c. to increase public finance for the arts;
d. to ensure that the content of the arts is not controlled by government and that artists are free to produce their works without external constraints.

The clumsiness of expression could be (and was) demolished with ease. How do you leave artists free while predetermining that their works must be made 'relevant' to all people? How do you increase public finance, define more sharply the purposes of art, and yet increase the *diversity* of what is done? And what is the difference between quality art which is 'based' in communities and quality art which is not? Was Wordsworth, wandering lonely as a cloud, outside the permitted remit? Conversely, does that mean that the Bloomsbury Group were politically sound?[4]

More seriously, the document made an interesting and valuable distinction between the financial and managerial functions of the reformed Arts Council, and the function of a forum in which the arts could be openly discussed in which open critical judgements might be made and which could, when necessary, 'speak for' aspects of the wider arts world. This body was described as a 'National Conference for the Arts and Entertainment,' comprising 'elected representatives from local authorities, Regional Arts Associations, arts and entertainment trade unions, subsidised arts management and other relevant bodies such as consumer groups and individual artists.' The commercial managements were not represented. However the conference was to be charged with

'determining a national policy for a reformed arts council'. Indeed the proposed structure raised immediate questions over whether one kind of bureaucracy was not likely to be replaced by another; one could see endless political debates 'determining' policy on all fronts, and working out how to make the newly-freed artists relevant to all citizens, and becoming so occupied in their new task that they did not notice that fiscal and legal powers had largely remained in a non-elected Ministry bureaucracy above them.

A *national* forum with elected members is in any case quite a difficult proposition. To be fairly representative of all the various levels of activity within the different art forms it must be so big that it could not *debate* such detailed questions as a national 'arts policy', and would have to delegate its powers to an inner group, and then vote, or exchange polemical points on such a coarse level that the result would vitiate the detailed care expended in setting up democratic consultation. National forums for the various arts might be more feasible, gathering together the myriad national organisations that exist for every aspect of the arts in Britain, from folk song to theatre-in-education. However, in more recent discussion documents the Labour party seems to have dropped the idea, and to have concentrated instead upon proposals for abolishing the Arts Council as now constituted and replacing it with a kind of federal system of Regional Arts Associations, all represented on a national 'representative' Council. Meanwhile local authorities are now to be required:

a. to undertake a process of consultation with all interested bodies (including trade unions, community councils, etc) and

b. to publish their proposals.

This looks like a replacement of the mandatory requirements to give financial support to the arts which were proposed in the party's 1977 document.

The Labour party debate is, like the Conservative party's, open to the objection that it makes little serious attempt to discuss what the arts might actually comprise. It is all about systems of distribution and control, implying that it is well enough understood what the parameters of Art are. At core, although it wishes to be rid of the Arts Council, it nevertheless accepts unquestioningly the Arts Council categories of Art, from arguing

for the opera to announcing that 'ethnic arts' and 'community arts' are important. The fashionable political categories are unthinkingly accepted – no doubt if the Arts Council had adopted different slogans it would equally obediently announce that Arts for the Elderly, or Rural Arts (or whatever) were paramount concerns.

However present thinking in the SDP is even more striking evidence of how a hasty glance at recent polemics within the Arts establishment offers a poor basis for making a policy. Their current discussion documents announce darkly that, 'We have received much evidence as a group suggesting that the SDP should abolish the Arts Council', but adding that 'unless reform is implemented that goes to the root of the Council's present difficulties rather than to their outward form, any new instrument created to replace the Arts Council is likely to suffer from precisely the same defects.'

We have of course argued throughout this book that the managerial and political crises in the Arts exist because of the way the Arts Council has developed its functions, and the bogus language that it has gradually adopted to describe its political functioning is destructive of the arts markets, and bruising to our critical capacities. *The Arts Council is the root of the problem.* Astonishingly however, and in spite of the massive evidence to the contrary, the SDP has chosen to believe that the 'root' of the problem is that the present system is not primed with enough state aid:

'Ironically the crisis arises not through the failure of arts institutions but through their very success. For the reasons we have already stated, the demand for increased access to the arts by many to whom access has been limited has never been greater.'

That – unless one accepts wholesale the particular and narrowing definition of the Arts promulgated by the London Arts establishment over the last thirty years – is a profoundly distorting fantasy. From that, further fantasies inevitably follow:

'It is an access which the arts institutions have the will but not the means to supply. This imbalance of demand and supply is at the root of most present controversy in the arts, creating tensions between the funding agencies of government and their clients, amidst the clients between the historically more prosperous

national companies and newly emerging companies in the regions, between those clients capable of attracting private funding and those less well placed to do so. There are simply insufficient funds in the system from all sources: box office, sponsorship, private giving and public funding.'

The apparent wholesale acceptance of 'the system' is in fact at odds with the party's innovative and interesting notions for re-forming the financial operations of many segments of the arts market. In their present thinking, the party's strategists begin to confront some of the wider questions of the urban environment, and the questions of incorporating cultural development into the day-to-day functioning of local government planners:

'Our first measure, which we term development planning benefit, would permit local authorities to reach agreements with private developers whereby, as a condition of planning consent, they would agree to contribute, in cash or in kind, for the purposes of cultural development, a sum equivalent to 2½% of total development cost, capable of being set against corporation tax. Where a cultural institution acts as a land developer itself, local authorities would be permitted to designate a rating zone within the immediate vicinity in which increased rate yields arising from development would accrue directly to the institution.'

That proposal (a commonplace instrument of law for local cultural development in the United States, as the party acknowledges) is allied to the suggestion that in development schemes which exceed £1,000,000 in cost, a mandatory 1% of costs should be given over to the commissioning of works of art in public spaces.

More innovative still is a new scheme to provide real 'venture capital' for the arts. This is a proposal known as 'Artsbank'[5] This would be a new body with two distinct investment portfolios – one as a quasi-merchant bank, raising guarantees from the City and providing fully repayable capital and development loans to profit-generating cultural businesses, and the other as a public enterprise board, government-funded, providing venture capital for developments which were expected to be sustained in part by continued public sector revenue funding. In its second function Artsbank would be working in an area already accepted as legitimate for

national and local government both in urban economic development (The Greater London Enterprise Board) and rural-economic development (the Development Commission). Interestingly, the SDP acknowledges that large parts of 'the arts industry' are already profitable and suggests (without going into detail as to how this might be achieved) that a cross-subsidy could transfer arts profits to venture capital for new organisations.

It was generally agreed that in the late seventies quite the best evaluation of the problems of ordering government intervention within the arts markets came from John Elsom, with his pamphlet *Change or Choice*. Mr Elsom has now generated further wide-ranging consultation within the Liberal Party and has produced a document of great merit. It begins where all policy-making must, with a recognition that we have blinkered ourselves by an insistence that an arts policy must concern itself primarily with the difficulties of the subsidised Arts alone:

'No British government has yet managed to understand the significance of the arts for Britain. This is not just a matter of philistinism, but of plain definition. What are commonly called 'the arts' amount to a small stretch of a much wider field.'

He elaborates the theme with a telling example from Britain's highly profitable record industry which is, in the establishment definition, not a part of 'the Arts' at all:

'In 1984, the British record industry sold tapes and discs to the value of £1.6 billion, or more than a quarter of the world's sales. It achieved a 34% penetration of the US market; and royalties accruing to the British-based companies from abroad have been estimated at £313 million. The industry however has yet to recover from the widespread commercial piracy of the late 1970s; and the international protection of copyright agreements, where they effectively exist, remains a major concern of the record companies, as it does of the publishing houses and the video producers.

But it is not the concern of the Office of Arts and Libraries, a small department which has been shifted around under different British governments. The Arts Minister is responsible for only a limited sector of the arts, with parts of the theatre, for example, but

not the film industry. Other matters concerning the arts (including Copyright) have been scattered around other ministries with little understanding as to how they may relate with one another. It is as if some bureaucrat had isolated a small area of market gardening, such as the growing of asparagus under glass, and decided to call it Agriculture.'

Elsom goes on to insist that this narrow focus poisons the language of arts debate. In this he is again perfectly right. The metaphors we use in discussing 'the Arts' relegate arts activities and art constructs to being minority pastimes, with secret properties understood only by a privileged few. More damagingly, the usual language of public debate about the Arts blurs any distinction between critical assessment, political manipulation and managerial control within the Arts world.

The Liberal Party proposals are therefore much broader in scope than are those of other parties, and are concerned with promoting a degree of liberation (by the removal of some of the legal restrictions upon local authorities, and some of the financial restrictions upon the use of government funds) as well as with controls. The first outline of the party's aims once more removes the emphasis from the 'need' to 'increase funding' for 'the' Arts economy, and takes a wider view of arts markets:

'In government, our first task would be to strengthen the infrastructure to the arts – by which we mean such matters as improving the Services to the arts which local authorities can provide; researching and installing the new technology appropriate to broad – and narrow-casting in the 1990s; strengthening the Regional Arts Associations and establishing a new Arts Development Board which would take on some of the existing functions of the Arts Council of Great Britain, which would be abolished; securing a sounder financial basis to the arts in Britain, which would include making some arts institutions independent of pressure from both national and local government through the establishment of endowment funds; improving the legal protection of artists' work and encouraging a greater internationalism of outlook. We would encourage the growth of community arts, through the establishment of community arts trusts; and seek to

foster a new concern for our heritage and for improved aesthetics in town planning.'

The manifesto goes on to propose a new Ministry, designed to cover Arts, Communications and Heritage. It proposes also a National Arts Development Board, which would be 'a forum for the discussion of national arts policy' and would give some short-term 'priming' grants. The details here suggest however that the new Board might be rather less of a public forum than is desirable. Its composition (two thirds of its members appointed by the RAAs and one third by the Minister) suggests that it could become instead a semi-secret bureaucracy concerned with the reconciliation of conflicting political and financial claims on government by the regions, rather than with the open discussion of art.

Finally, the document is notable for the emphasis which it places upon an enhanced role for the British Council, whose value is contrasted with the 'autocratic and run-down bureaucracy we have at the moment in the Arts Council of Great Britain'. That would be removed from the control of Foreign and Commonwealth Office and placed within the new Ministry, together with the B.B.C. and the Visiting Arts Unit. It proposes also a Museums and Heritage Council within the new Ministry, which would remove the care of sites and archeological remains which need protection from the control of the Department of the Environment.

All party proposals are open to the criticism that they conceive of 'an arts policy' as being concerned primarily with proper control of organisations, buildings and finances. The relationship of artists and art to these tangible concepts tends to be implied, but rarely directly confronted. It is assumed that if we can arrange for a just and equable distribution of arts organisations, arts buildings and arts funds then, somehow, all will be well. Political manifestos have to make the assumption that the arts are either goods or services (for there are no other categories in which politicians may discuss their notions of production and distribution), but in fact, finally, the arts are neither of these things.

The great danger is that even those party documents which acknowledge that our present barren bureaucracy has caused us to be shackled by an equally barren political language, propose not the abolition of all bureaucracies, but other forms of it, with (one fears) other kinds of organisational language. 'I understand that this is a meeting of writers to organise resistance to Fascism,' said Pasternak in 1935.

> 'I have only one thing to say to you: Do not organise. Organisation
> is the death of art. . . . In 1789, 1848, 1917, writers were not
> organised for or against anything. Do not, I implore you, do not
> organise.'[6]

Any system therefore, will be a system for the organisations, buildings
and finances which seem to bear upon the arts. It will be incomplete, for
the relationship between those entities and the writing of a poem, or the
making of an art work or the composition of a song, and the relationship
between them and the joy that each of those creations may bring, is
unknown and unknowable. The art of a nation may well be created
outside all of the constructs it has set up to engender and contain it. And,
as the state system, however broad and however democratic, will
engender its own language and system of thought, and as that thought
becomes the System, it is always likely that the arts will be created outside
the mesh of the language System too. It is a pious thought that state
organisations can be set up to 'respond' to new ideas and genuine artistic
innovation, but organisations inevitably develop their own systems of
thought, their own mesh of language, through which the genuinely new
will tend to slip undetected.

While recognising therefore that our present system is bankrupt, we
must not seek to *replace* it simply with a 'better' one. We must
acknowledge repeatedly that the various legal and fiscal faces of an arts
policy are effective only within certain realms of the arts; within physical
realms, such as the provision of arts buildings, and within organistional
and fiscal realms. We do not have, cannot have, an *all-embracing* System,
and if we again pretend (after getting shot of the Arts Council and
'replacing' it with a Ministry, for example) that we have one, we shall
again substitute the language of the prevailing Arts System for art itself,
and replace creation and joy in art with the sterile exchanges of Arts
politics. An arts policy must not be just a compound of *systems*, but must
have at its centre a system of thought which permits genuine critical
reaction to shape our thinking. *At the centre of an arts policy there must be
critical, open, public debate.*

That central and continuous debate must acknowledge the existence of
a variety of organisations which should seek to support a much broader
range of arts activities than at present exist, but should seek to prevent the

bureaucratic language of any one of the organisations dominating the general language. It should lead to government (however organised for the arts) seeking to remove distorting restrictions as often as it seeks direct intervention. To put it more plainly, the central requirement of an 'arts policy' is that it should recognise that the arts cannot be legislated for in the sense that we can legislate for roads or railways. All our systems which bear upon the arts markets must be subject to constant adaptation and change, and, above all, the values and the critical assessment of the arts must not derive from the bureaucratic jargon of Systems. The systems should be shaped and given *their* values as a result of the functioning of a broad, and distinct, critical evaluation.

9.1 Aspects of planning

The responsibility for critical debate, for a serious new evaluation of the quality of our lives, does not lie directly with government. If we agree that we need to dismantle the present system and to demolish the diseased language of current British Arts politics, then we should be negating that (very necessary) action if we set up in its stead a single government-inspired Forum for discussing the arts. The necessary critical debate (which will take time) which begins the continuous wider assessment of all the joys and challenges involved in being British must be carried on in and between our schools, colleges and universities, in our churches and parish halls, in pubs and council chambers. It must be genuinely open and universal. It will show itself in its language – the ways (which will be different for each of our wider range of art forms) in which we discuss the preservation of our fine houses, the beauty of our gardens, our painters, our poets, our hymns and our comedians. The responsibility of government is to remove the barriers to open debate which have been erected – to restore to their rightful place in our education system teaching in the arts and humanities, to create conditions in which the journals of serious debate can flourish[7] – and to ensure that the arts systems are responsive to that voice.

'Provision' in the arts must not be based upon any one of three partial views. It must not simply be determined by a bureaucratic assessment of 'needs' – whether based upon population density, distribution of wealth, previous manifestations of demand or an 'expert' view of what people

'really' should be provided with. Nor must it be determined solely by what artists provide. Those systems which buy the products of state-trained artists 'for the nation' have in general nothing but warehouses full of rotting pictures or unread novels to show for their pains. Nor must it be solely a matter settled by a consumer-centered system of 'wants'. Our systems must, where necessary, provide for organisations their buildings, and state financial support, as a result of critical debate which is open, untethered to any one institution, which takes account of all the various perceived 'needs' and wants of artists and people, and which restores the critic (academic and public) to a rightful central place in the discussion.

We need to make once more the distinction (recently blurred) between the financial and managerial judgements of experts and the judgements of arts criticism. Some *systems* can be changed without fresh critical debate, for they are managerial. Our pretence that we were critically assessing the work of the Royal Shakespeare Company or the Royal Opera House in determining their annual grant was patently ridiculous, for example. They, and a majority of Arts Council clients, are organisations which should be supported directly from government for the purposes (Chapter 8 above) of national Glory, and, if sufficient funds can be found, there would seem to be great merit in removing some layers of the distracting bureaucracy necessary to deal with *annual* assessments and grants-in-aid, and funding them according to the Liberal Party's endowment scheme, which will give them a reasonable security over a period. This would of course mean that they would not be 'at arm's length' from governments but would, like the national galleries if they too were brought into a national endowment scheme, be free of the *annual* tinkering by bureaucrats. A part of any policy which sought to broaden the notion of the arts once more would have to be the addition to this group of other types of endowed organisations – of circuses, recording studios, ice rinks, garden centres, carnival organisations, bookshop chains and arts schools.

There is an argument, at least in the immediate future, for having regional 'arts organisations', but the geographical areas they serve need to be re-defined (at present they are controlling areas marked out during the last war for the purposes of civil defence), the range of arts with which they are concerned needs to be broadened, and their functions more clearly defined, so they do not – as offspring of the discontinued Arts

Council – retain the confusions of the parent body. They too must be responsive to critical debate, and not affect a private monopoly of critical judgement. They must operate firstly according to the Service Model (above) in partnership with the local authorities, with the media and with local commercial arts organisations.[8] Second they must operate according to the Compensatory Model in ensuring both that their region is not disadvantaged unduly by its comparative poverty, its lack of certain buildings or other tangible shortcomings and, conversely, must ensure that particular strengths and characters are enhanced and are not (as happens too often in the present system) fitted into some centrally-determined national framework.

With our local authorities we need to remove the shameful misuse of language which suggests that they are only just 'getting into' the arts, and recognise that the range of concerns which a local authority in Britain has – from education to the provision and licensing of public places – massively affect the arts, and that the need is less for local government to 'develop' new arts policies and tack them uneasily on to their other concerns, than for them to recognise that their existing wide concern for the quality of life, for general health and wellbeing, for enlightenment through education means that they are already, inevitably, concerned with the arts. Planning for cultural development needs to take account of the need to remove some of the present restrictions on local authorities (on their right to run performing arts groups directly, or license performances late at night), and needs to disentangle them from the effects of the snobbish and cliquish exhortations of the metropolitan establishment, which have usually implied that the setting up of a subsidised gallery is the proper concern of the Arts world, but that the whole urban environment is not.[9]

There is considerable merit, as we have earlier noted, in the creation of an 'Artsbank'. There is however a danger that if there is one national organisation that it will operate essentially for the larger, more visible schemes, that it will become organisation-centered, at best a kind of supplement to national endowments in the arts, and at worse an establishment organisation, promulgating establishment values. It may therefore be worth consideration for there to be a nationwide scatter of *local* 'Artbanks', allied to local authorities and connected with the local authority investment schemes.

So much planning however must be of a different kind. The responsibility of an Arts Ministry (if we are to have one) must be, paradoxically, to give itself as few responsibilities as possible, to recognise that so far as possible its purpose (as with the Ministry of Health) must be to remove the obstacles in the way of the open enjoyment of the commodity in its title, rather than in any pretence that it is concerned with the direct production and distribution of it all. Governments need to remove censorships, need to reformulate bad laws (such as that on copyright) and constantly attend to a host of difficulties which obstruct artists, or which get in the way of artists finding their audiences. They need to listen (As the Ministry of Health listens to doctors and surgeons rather than to the medical opinions of bureaucrats) to the voices of artists and critics and to the voice of open public debate and not to the furtively debated strategies of state 'officers'.

Finally, would-be planners must recognise that all systems are fallible in operation, partial in their effects and are liable to breed the corruption of constricting bureaucratic systems of thought. They become dangerous however when the systems are allied to a political prejudgement about the kinds of art which will be 'created' 'supported' and 'promoted'. We may hope that ethnic minorities will produce good art, that it will find audiences and that it will give great joy, but we cannot legislate for it to happen. Nor can we create rural arts, folk arts, industrial arts or street art by legislation; we can only set up systems which do not *dis*courage their life, and which recognise them when they appear. If we try to act otherwise we shall set up Systems and an arts language which (as now) apportions artistic values according to a political and social prejudgement, and which will almost certainly ignore the genuine new art of our time.

We should thus exchange one tired and wasteful bureaucracy for another, for we should have substituted a political axiom for the open critical debate which should once more inform our thinking about the arts and about the way we live. That would mean that we in Britain had learned nothing from the successes and eventual failure of 'the' Arts Council system, and had simply passed back any concern for the arts to a different set of anxious politicans and possessive bureaucrats.

9.2 The British Experience

The British experience of creating an Arts Council and seeing it operate

through thirty five years and more has created a curious paradox. It has, largely in semi-secret, and drawing heavily upon employees and associates trained within a particular kind of British liberalism and with a particularly British notion of public service, achieved many accommodations that have enabled arts organisations to grow and prosper. As it has grown in size however, and as its work has therefore more fully entered the public domain, it has raised expectations that it cannot satisfy, not merely in terms of giving money to the arts, but in terms of being able to act as a genuine forum for critical debate. Particularly in the last decade, when the strains upon it have been very great, it has moreover seemed to exhibit more and more those very malaises from which it was supposed to protect us. It has not protected the arts from the intrusions of party politics, and it has itself been perceived as being a body more political, more secretive and more bureaucratised than the dread corridors of Westminster against which it was supposed to be a shield. Supported once for its impartiality, it has allowed itself to become so clearly an agency of the government of the day that the Chairman of the Council openly boasts that his work has the Prime Minister's direct interest and approval. Once sustained for its expertise and its specialised skill it has repeatedly, in recent years, addressed itself to ill-defined issues and discussed them at a conceptual level which would be unacceptable in an undergraduate essay.

There is a widespread feeling – shared in some cases by present Arts Council employees – that the Arts Council, and with it the whole post-war system of deficit-funding of the arts, is past its time. The temptation therefore is to replace the worn-out system with a new one. There is however nothing which suggests that this is the only way forward.

So many of the problems of the last decades have arisen because we were trying to gather what is a world of myriad complexity into one (small and pretentious) one-dimensional 'system'. We started to speak of 'the' arts economy, started to use terms culled from management which implied that it could all be described in one crass vocabulary – 'investment', 'development of the regions', 'efficiency', 'returns', meeting the 'needs' of the consumer, and the rest – and pretended that because it was all dependant upon a system, art could be rationalised, and turned into a matter of 'meeting objectives' and ten year plans. The 'system'

became the arts, and thus, as we settle upon doing away with the Arts Council, too often we do not ask how we can help the arts, and help artists, but how we can 'replace' the Arts Council system. And we assume that a policy must be at heart a set of systems, a rationalisation of the infrastructure, a clearly-designated state bureaucracy that is, perhaps, more rational, bigger, more democratic, or more efficient than was the Council.

And of course we assume, because the system replaces the arts, and because the *system* is important, the arts must be represented in Cabinet, must have a Ministry, must have ambassadors and Regional Officers and Production Meetings and every other kind of titled body that systems demand. But it is not necessarily so.

Any Arts Policy which is going to address itself to the arts, and not the arts bureaucracy, must begin by recognising two things. First, that 'the' arts world is vaster than anything conceived of in Arts Council strategies. Second that 'the' arts world is made up of dozens, hundreds, nay thousands of proper arts worlds with their own cultures, their own knowledge, their own financial systems. Any government, any Ministry, must aim primarily to remove the monopoly of high value which at present only special, privileged, Art enjoys. This is not merely a matter of creating committees which are democratic in nature – useful though that sometimes is – but a matter of freeing concern for the arts, *all* of the arts, from the musty clutches of secret experts. We do not need to puzzle over the maintenance of arts organisations so much as we need to find a way to restore to the British a sense of participation within their common cultures – participation in their whole environment, their education, their recreation and their domestic and public creative pleasures. That is to be done less by tagging on 'lecture rooms' and 'education officers' to existing arts organisations, than by re-forming structures of genuine broad communal participation, and in listening to people (and artists) rather than in organising them, and marketing them, and selling them to tourists.

Most things worth doing in life do not have a Member of the Cabinet representing them, nor do they have rigid organisational systems. It may well be that the British experience suggests more deregulation of 'the arts world' is desirable, and suggests that a 'Policy' should aim to develop as *few* national systems, and as *few* intrusive controls as possible. It would require courage, but an argument for the creation of a Ministry under an

enlightened government is that it would be powerful enough to *remove* control of the media, commercial and state art from undesirably possessive or greedy hands. Courage would then be needed to face the result, which is that a freed artists' community will speak as often in Dionysian form as in Apollonian, and will sometimes bite the hand that has let them off the chain. It would seem to be a risk worth taking. More radical voices in the arts would be more in keeping with much of Britain's history than the poor cowed whispers of so much that we have produced as subsidised Art.

Footnotes

1. Dr David Owen, SDP Arts Seminar, February 16, 1986.
2. Sir William Rees Mogg, *The Political Economy of Art* ACGB Lecture March 11, 1985. Sir William went on to say, in one of the best parts of the lecture that he would also (recalling the furore over W.E. Williams's former attitude to his 'chicks') welcome tax cuts for the unsubsidised arts.
3. Brough, *As You Like It* (Bow Group, undated)
4. If sound for the Labour Party then presumably not so for the present Arts Council regime, who would find them too metropolitan-centered (London already has sufficient poetry and pamphlets) and would disperse them to the regions. Conversely Wordsworth and the other romantic poets might be considered too lake-centered, and would have been instructed by the Arts Council to meet the needs of the underprivileged South.
5. The party acknowledges that the idea is not new. It has been most lucidly propounded in this country by Keith Diggle, whose *Guide to Arts Marketing* (Rhinegold, 1984) contains a great detail of incidental material on the way arts economies work that is of value.
6. Quoted in Brian Lee, *Poetry and the System* (Brymill, 1983). On the question of language in the arts see also Protherough, *Sir Keith Joseph and the Language of Education* (Journal of Arts Policy and Management, Vol 2, No.3)
7. It has to be said that one of the Arts Council's least endearing characteristics has been the energy with which it has stifled, or sought to stifle, opposition. The Literature Report (which demonstrated the questionable links between the Council's panel members and grant recipients) was, like Sir Alan Peacock's report on Inflation in the Arts, never published. A *Panorama* programme, critical of the Council, was mysteriously withdrawn and never shown. Editors of small magazines receive unsolicited 'corrections' from the Arts Council when they have published pieces critical of Council policy. This is allied to the habit of publishing 'consultative documents' which turn out to be near-final formulations of central policy.

8. There is a dolorous willingness to use the latest tag phrases in creating 'arts policies.' The Labour Party has decided to call the reorganised RAAS, Regional Arts *Development* Associations.
9. Briefly, the Arts Council once acknowledged that the look of the places in which we live *was* their concern. In the Annual Report 1950/51, acknowledging the work in raising public sensitivity of R.I.B.A., the Georgian Group and the National Trust, the Council announced that it would 'welcome any inexorbitant proposals for encouraging popular interest in architecture:' There are no visible signs that this brief interest was sustained.

APPENDIX A

THE ARTS COUNCIL AND EDUCATION

When I say that my first reaction upon seeing the cover of the 1981 'consultative document' *The Arts Council and Education* was one of mild surprise I hope that I shall not be misunderstood. I am not for the moment speaking of its contents. It simply seemed surprising that such a document existed at all. The Arts Council had after all been in existence for thirty five years, and during those years it had operated in part as an educational agency. This was not the result of any policy decision. It had operated as an educational agency because you cannot promote the public showing of art without, in the broadest sense of the term, also promoting some kind of educational experience.

So what could such a slim document possibly say that would be of serious interest? It could not hope, in twenty four typed pages, to say anything of any consequence about any of the disciplines in which the relation of education to art might normally be discussed. It could not contain any new insights into that relationship which could interest social historians, philosophers, psychiatrists or even serious educationalists. There was not the space – and in any case in outward form it was 'consultative'. The suspicion grew therefore that this was political – what younger arts officers earnestly call (as they struggle to say something intelligible) a 'reformulation'. We were not to suppose that any kind of major issue was being dealt with. The Arts Council was not going to come out *against* education, nor was it – in one of those megalomaniac flushes that dangerously affect little quangos in warmer weather – going to march overnight and occupy the primary schools. This 'reformulation' was, one presumed, a kind of political signal, giving notice to grant applicants that

it might be expedient to tag 'education' on to one of the descriptions of their work, but in essence one presumed that it was merely going to restate the obvious, that education and art concern each other in a host of theoretical and practical dimensions. As I do not know anyone who is ever likely to dispute this, I put the document aside.

However a number of folk whose opinions I value took the trouble over the next weeks to tell me how bad, in their opinion, the piece was. It was vacuous; empty, yet dogmatic; insulting to teachers; insulting to other arts organisations that had something more sophisticated as an arts policy. I was intrigued to learn that it had caused such a reaction, and (suspecting that any document which manages to bewilder and annoy so many people might be more provoking than I had thought) I read it.

In general the document was not quite as I had suspected, and in one important respect, it was quite different. Not quite as I had suspected, because I had not expected that so shallow, wilfully ignorant and feeble a document could possibly be written in a tone so smug and so self congratulatory. The important respect in which it differed from my expectations I shall come to in a moment.

The wilful ignorance first. There is, readily available upon the library shelves, a century of writing about the relationship of education and art. On those shelves are consultative documents dealing with that subtle and difficult relationship which have provoked decades of analysis and work. There are reports which emerge from such consultations – not just reports of the arts education of the meritocracy, but reports of the education of less advantaged groups in the arts. One need go no further back than the 1963 *Newsom Report*, for example, to find discussed at length questions of the music, writing, literary education, craft work, art work, drama work, links with the professional theatre, television and film studies of those of average and below average ability in our schools. But not only does the 'consultative document' ignore Newsom, it ignores *all* the vast literature upon its subject.

Now of course its authors may argue that they are talking about the Arts Council's links with education, and not about *those* links between education and art. Yet if that is so, why is there such a terrifying sense that the authors believe themselves to be saying something profound and novel, when it has all so obviously been done before? It is not merely that the authors painfully explain what is meant by 'education through art'

without reference to the different things this has meant in the Western educational tradition since Aristotle first discussed it, but that the suggestions for 'initiatives' are made without any reference at all to those hundreds of places in which, again and again, these things have been done (and done better) – the Cambridgeshire of Morris, Leicestershire under Mason, Longland's Derbyshire. The State Schools – Banbury, Intake, Bosworth, dozens of them that anyone trained in the field, still more who has been active in the field, knows well; the Public Schools – Dartington, Bedales, Summerhill, Atlantic College – whose work in the development of creativity in the young is known worldwide amongst educationalists. All are ignored, but some of their ideas, some of the things they have done for decades, are presented, duly watered down, as 'initiatives' – and, what is more curious, as Arts Council initiatives!

When that is noticed, the threadbare nature of the argument becomes clear enough. For this is an attempt, as pitiful in its way as is any attempt to make simple propaganda points about history, to present the 'consultations' as a part of a continuous Arts Council concern. A concern which stretches back through the mists of time to the mid-sixties, for it was then (we are led to believe) that mankind first began to notice that there could be a relationship between education and art. The Arts Council, bravely leading the way in radical thought, did what all fearless Britishers do in such circumstances. It took 'initiatives'.

Thus the long tradition of fostering creative writing in the young, the concern by men as different as Huxley and Lawrence for teaching and picking up the shy unfolding of new talent, dissolve into myth as we are confronted with not-to-be-consulted-about assertion that 'In 1969 the Arts Council set up the first Writers in Schools scheme'. Equally Professor Allen must have been mistaken when he wrote in 1949 of the 'growing number' of professional performances given by professional children's companies. No doubt all his subsequent work was a mirage too, for the initiative bird swoops again. 'The Theatre in Education movement began in 1966'. Just how inept such an over-simplified statement is can of course be simply proved by reading John Allen's report on Drama published by H.M.S.O., *also* in 1966, but we have already hinted that reading about other people's work is not something our authors do very readily. It is no surprise – even though one had *thought* most British people knew something of, or had been involved in, the vast amateur

191

movement in play-making, community music-making, amateur painting and community work in reclamation, restoration and beautifying of public places in this country – to learn that 'community arts . . . emerged' after Jenny Lee.

For by this time the political purposes of the document are clear enough. Actual social history, actual artistic history, are both ignored. A 'movement' or 'initiative' is only to be recognised as significant when the Arts Council was in on it. The purposes are clear enough – but can one imagine any other quango being so crass? Can one imagine the Schools Council discussing 'art' as if it only 'emerged' after Plowden? Or the Sports Council insisting that the first 'initiatives' to bring together soccer and the general public were taken after it had set up its own committees on the problem in the seventies? It is for that reason that I spoke of the *willed* ignorance of the authors; they must know better than this.

I said that it was also shallow. The best method of proving this would be for us to read it together, but in these brief remarks I can only take one typical example, the section headed 'Regional'. It begins with a curious hint of treachery in powerful places:

> 'It has not always been easy for the (Regional J.P.) Associations to translate their objectives into working schemes which do not infringe upon reported restrictions imposed by the Department of Edcucation and Science.'

Given the chance, these Regional thinkers would obviously sweep away the questions which, the report says, hang over much art teaching. So what are these 'reported' restrictions? Who has reported them – as the RAA's do not seem to (in fact) suffer from any additional restrictions over the educational practices they may follow than do the rest of us. They can set up as private schools and apply for DES recognition. Parents may, if they wish, send their children to study at the feet of the RAA officers. Anybody can, with or without DES approval, pass on any information they choose to anyone else in this country; RAA officers can equally prepare folk for examinations, hold public lectures, sit on school governing bodies, solicit the advice of trained teachers. In other words the RAA's suffer no more restrictions than do the rest of us. So perhaps they *want* to believe in them.

And what is this vivid desire to be involved in education which is being

so brutally repressed? The document goes on to give us a picture of its intensity and urgency:

> 'Lincolnshire and Humberside Arts Education Liaison Committee is now in its 15th year, whilst Greater London Arts Association established an Education Liason post in 1975.'

A headlong rush indeed. Wisely, the authors add a note of caution:

> 'Such enthusiasm is not shared by every RAA',

I don't as a matter of fact share it myself. I don't think that the two examples the text quotes can fairly be described either as showing 'enthusiasm'. I suspect that many RAA officers are wary of appointing people with fashionable titles like 'Education Liaison' officer, unless one can be quite certain with what liaison is taking place and to what purpose. To do otherwise is to move dangerously close to one of the twentieth century's tragi-comic bureaucratic nightmares – the frantic placing of high-sounding titles upon a pontificating coterie whose actual power is illusory.

So what are the enthusiastic RAA's enthusiastic *about*? The climax to the argument comes in one unforgettable sentence, a sentence which finally exposes the shallowness of the whole nature of the 'consultation', a sentence which so plainly is coined by an unhappy writer who has been asked to make something positive-sounding out of nothing that it deserves permanent inscription in some bureaucrats' handbook. It is this:

> *The need to pursue educational objectives is widely acknowledged.*

It is worth savouring:

> The need to pursue educational objectives is widely acknowledged.

Of *course* it is! The need to pursue educational objectives is recognised by every country, every society, every group, every primitive tribe and a proportion of the animal kingdom. The Klu Klux Klan, the Born Again Movement, Women's Institutes, Alcoholics Anonymous and Keith Joseph have in common that they recognise the need to pursue educational objectives. The problem is *which* objectives? And how do you pursue them? To say that the need to pursue educational objectives is widely recognised is to say nothing at all.

But it is, unfortunately, nothing which is at the heart of the document.

Appendix A

The authors do not know what education *is* - are they talking of a social organisation, a psychological process, a philosophy or a theology? They *seem* to think that they are talking about the state education system, but if that is so (and we use the homely phrase deliberately) they do not know what they are talking about. For the argument is carried on, here as elsewhere, at a conceptual level far lower than that which would be tolerated in, say, a decent B.Ed. study by an intending teacher. The attempt to distinguish between 'training' and 'education' is curious and, as any kind of material suitable for consultation, crass and inadequate. Other attempts to say something meaningful about such a central matter as the relation of artist to his audience – who is educating whom? – seem simply confused. For example, on page 9 is the stern admonition that a work of art must not be modified to make it accessible. On page 8 however we have just read the approved finding that:

> 'Contact with inquiring and interested members of the public has brought changes in direction; an artist in residence in a primary school, who had earlier produced large-scale formalist structures, began to shape smaller-scale representational work.'

A case, one would have thought, of modifying works to make them accessible. I repeat – who is supposed to be educating whom?

Perhaps you will allow therefore that this is a shallow and (deliberately) ignorant document. As such it would scarcely be worth attention, but I said that in one important respect it surprised me, and in that respect is is highly significant. That is, the document everywhere confuses education with marketing.

We need to pick our way carefully here. In the tradition of 'teaching about art' there are in Britain two strains. One, associated with a certain kind of public school teaching and with the kind of teaching one hears in the high church, is a kind of authoritative passing on of a defined high culture. Students are taught the meaning of the clues, and pass then to the higher realms, joining their fellows in the divine realms of the best, the *unquestioned* best. The second strain, which however clumsily and uncertainly is the strain which predominates in our schools, is the *critical tradition*. In this, art is constantly revalued; the student is taught critical awareness as he is taught to read a variety of clues; the best is not handed down to the student, but slowly, and often painfully, learned and assessed

by each student. We might put it crudely and call the first kind of teaching totalitarian, and the second democratic.

What we call totalitarianism in teaching about art is not always a dishonourable thing. It is sometimes honourable when the majority agree that certain things are the best in art, and where there is common consent that to teach about those things is leading citizens towards the good life. In this respect totalitarianism in education can be a right or left wing political tool. It can be used by the Catholic Church (who are in accord over their view of the best things) and by the Russian Communist Party (who are in similar accord). It becomes dishonourable when educators become totalitarian against the will of the majority; then it becomes a kind of marketing exercise, a desire to pass off a minority (political) view of what is the best contrary to the instincts, will, and even *critical reaction* of the majority.

And the notion of education which permeates these Arts Council pages is a totalitarian one. Everywhere the assumption is that if you teach people *about* certain kinds of art, they will then approve it, recognise its significance, and wish to be inward with it. There is little difference between what the Arts Council seems to mean by 'accessible' and what the Ministry of Art in the USSR will mean by it; those things supported by the state are to be aided by teaching (that is, marketing) by the state education system. Thus, when we read that there is a polytechnic course of lectures at which folk are to meet contemporary composers in dialogue (itself a perfectly reasonable idea; a proper development of a critical faculty about art) we learn that the aim is, bluntly, to 'increase the audiences for contemporary music concerts in the area', concerts supported, that is, by the Arts Council! It does not seem to occur to the authors that such a series may well – and properly – *diminish* attendances on the contemporary music network even further. In a democracy, low attendances are not always the result of ignorance. The arts may be perfectly accessible, but people *may choose to ignore some of them out of a proper critical discrimination.*

We hear much about the public indifference which greeted some great works at their first appearances. Upon that view is built a whole creed, of the artist *necessarily* attracting a cultured few, and of the enlightened state having to help in building the larger audience which the art 'naturally' should have. But such a view is a partial one. Many arts of quality have

attracted large audiences at once; many artists have, like Byron, awoken to find themselves famous. But infinitely more important than that is the fact that much minority art, which has been nursed until it finds a larger audience, is ultimately seen to be worthless. We have to share the certainty of the Arts Council that the sounds it promotes on its contemporary music network *are* the best, the most significant, the most worthy of our age before we can approve an educational effort which simply, and without question, aims to increase their audiences. Future ages might well see the greater value in other kinds of contemporary music that find audiences without benefit of state intervention, but are seen as the result of deliberate and careful choice in a democratic market. At the least we should aim for an open education which means that those attending the contemporary music network do so as a result of their own free critical judgements.

I do not want to be drawn into those complicated but important realms of argument about the way an arts 'public' is formed. However I should say that I am of course aware of the arguments (Mrs Leavis and others) that a kind of totalitarian education about the best in art is necessary to counter the relentless marketing of the worst. Sometimes, it may be. What I am objecting to is merely the unquestioned idea that the best, proper 'Art', is always Art subsidised by the Arts Council, and the worst is always that promoted in amateur work, by the media or by commercial means, or that which finds an immediate response from a 'market'. It simply will not do. Any concerned search for the best in, say, contemporary literature must include making accessible Catholic and Jewish literature, the picaresque tradition, the military tradition, the biographical tradition, romany poetry, workers' drama, Anglo-American writing. Kingsley Amis and Tom Sharpe, William Trevor and Barbara Pym, Clare Raynor and Pam Ayres, the comic tradition and the great tradition. We must not assume – as in the logic of this paper we are led to assume – that concerned cooperation between the Arts Council and *education* will lead to a sustained rush to read the novels of Miss Laski. If the Council wishes to believe this – and Miss Laski has announced that she is primarily concerned to increase the readership of the best writing, with rather more than a hint that she knows where the best writing is to be found – then it should perhaps retitle its 'consultative' document *'The Arts Council and marketing the subsidised'*.

NOT WAVING BUT DROWNING

A reasonably generous person can feel nothing but pity when glancing through the Art Council's 1986 manifesto, *Partnership; Making Arts Money work Harder.* At the end of its effective life the Council wears its years heavily. Its rhetoric is exhausted, its 'facts' the random chitterings of near dementia. It no longer claims to embody the cultural life of the nation, but totters heavily along, supported by its 'partners', with no sense of direction except that bequeathed to it by dimly-recalled monetarist principles and a fading belief in Americanised management. Recognising too late that its definition of 'the arts' was narrow and possessive, it now seems to accept that any kind of activity, however limp and however ill-regarded, as being worthwhile provided of course that it is subsidised, and subsidised by the state approved mix of Arts Council, RAA, local authority and industry. Festivals of comedy, designs in metro stations, woodland walkways, flogging pictures to tourists – all are now acceptable, approved not because of any inherent merit they may possess, but because of the fashionable bureaucratic structure which begets them. We are reminded of the ageing King Lear, dividing his kingdom and gasping to his tiny court, 'None does offend: none, I say, none'.

It is indeed the general sense of exhaustion which first strikes the reader; the reiterated phrases from past decades designed to make us think that this Arts Council is a natural offspring of literate parentage; old, empty and near-meaningless gobbets of cultural theology; tired slogans of midget exhortation:

> 'The arts and associated industries can lead the way in finding a new role for inner cities; they can play a vital role in sustaining rural life and values; they can give a means of expression to many disadvantaged communities and the unemployed.'

All truisms which are equally unexceptionable if one substitutes the word 'Sport' for 'the arts, or substitutes 'Yoga', 'Gardening', 'Bible Study', 'Campaigning for the Conservative Party' or any other kind of human activity which is more or less approved by a number of influential folk. So exhausted is the Council that it more or less admits that it can no longer tell 'the arts' apart from other activities. It is now only the bureaucracy – of 'funding', of 'assessment', of 'programming' and of 'marketing' the arts which interests it:

> 'The Council's regular detailed assessment of arts activities of all kinds throughout the country shows that one of the most common causes of under achievement is the absence of good marketing. . . The arts are not different. . .'

Yet one must insist that the arts, in the widest and most generous definition, *are* different. They are not products to be priced and 'developed' like chocolate bars, nor are they a service akin to a general vaccination programme. The arts exist in another realm, apart from the goods and services that answer other kinds of needs, and a proper arts marketing programme begins by acknowledging that difference. The arts are not competing, on the same level and within the same framework, with Mars Bars and launderettes, equal competitors for our time and money. They are emphatically *not*, in the Council's clumsy terms, 'competing with everybody else for the consumer's time, interest and money'. We are indeed in dire straits if the national quango which professes to knowledge and understanding of the nature of the arts, has come to believe that the reason people do not choose to attend the performances of the Contemporary Music Network is simply that the Mars Bar organisation has a better marketing strategy.

Its lack of interest in the arts is nowhere more apparent than in its perfunctory recital of its achievements. It does not claim that the arts themselves have prospered or that they have improved in quality. It makes instead two other kinds of claim – one probably true, and the other almost certainly false. First is the reasonable claim that bureaucratic and entrepreneurial tinkering with the arts has greatly increased – 'The last 40 years have seen a dramatic increase in activity and flowering of enterprise in the arts in Britain'. That may be conceded. However there follows a curiously worded claim about 'attendance and participation':

'There have been greater increases in attendance and participation than at any time the last century.'

This is, if it means what it seems to mean, the purest poppycock. The *increases* in attendances in the new industrial cities of the nineteenth century were of a scale, in orchestral music, in dance, in theatre, in gallery visits, in museum attendance, in opera incomparably greater than any within our own century. But in the last forty years attendances for most arts activities have in fact declined, and the few increases have not in most cases been as great as those in the inter-war years. But the sentence is full of weasel words. 'There have been . . . increases' it says darkly. There have been *some* of course in carefully defined areas. To which one can only add with equal courtesy, 'And there have been decreases too.' Fewer people attend the theatre than forty years ago. Fewer people read seriously. And to the dark, and unknowable assertion that there is more 'participation' we can only express mild surprise, given the much discussed collapse of work in the arts and humanities within our national educational curricula. Have the narrowing of extra-curricla work in school music and school drama, the closure of Art Colleges, the cutbacks in liberal education, the decline in arts work in adult education, the axeing of creative arts work in Higher Education, and the allied non-availability of workshops, studios and tutors led to *increased* participation throughout the land? Was Sir Keith Joseph after all a true friend of community art?

Whatever 'participation' may mean (and one is bound to suspect, given the pervasive tone of this document, that it means the managerial brouhaha which associates itself with art, rather than in creative activity i self) it is clear that the Council has lost interest in the processes and artefacts of creation, and saves its waning powers of discrimination and approval for the artists' marketability and for the organisational efforts which exploit that. The Arts are now held to be synonymous with 'the cultural industries':

'At the root of these new industries is the imagination of our artists and the sense of excitement which their work generates. But equally important has been the valuable support for their work and the commitment to developing the arts from an increasingly wide range of organisations. The support has been led by the local and national government, but increasingly also comes from business and

commerce, education authorities, other national agencies, development corporations and enterprise boards, local and community organisations, trusts and foundations.'

What on earth is being discussed here? What *new* industries? What industries within the arts have the increasing support of education authorities, at a time when the arts have been so savagely cut within education? What is *new* in publishing, in theatre management, in the record industry that has been newly *led* by local and national government? The paragraph can only refer to the new government-created subsidy structures which produce the examples given later in the book – examples of co-operation which have produced a few festivals and a few developments over the last couple of years – interesting and valuable of course, but, as justification for this 'new' excitement, a gnat's bite in comparison with the hundreds of well-established commercial or singly sponsored events which cannot be claimed as recent bureaucratic successes, and which, by and large, the public does not have to be heavily bribed to enter.

Events have forced the council to adopt its posture of uneasy co-operation with the local authorities, and that uneasiness squeaks at every join in the booklet's argument. It cannot quite relinquish its pretence, even with its infirmity upon it, that it is the wisdom and acumen of the council which has led the Philistine local authorities towards the light. Gateshead, which has six major works of sculpture in public places, is authoritatively congratulated upon this 'innovation'. 'A splendid first', announces the booklet's author. All this is part of the 'newness' of course. The vast range of public sculptures in London, in Manchester, Birmingham and Coventry, in Nottinghamshire's Rufford Park, in Leicestershire's Village college Campuses and in dozens of other cities, towns and countryside locations are all ignored – invalidated because of their unfashionable or outmoded sponsorship. (One is naturally chuffed that the good folk of Gateshead have six thoroughly-subsidised Big Jobs on their public places, but they are 'firsts' by virtue only of their mode of sponsorship, not their artistic merit).

Of course it would never do to say outright that local authorities have been commissioning and buying sculpture for public places for at least a hundred and fifty years. For that would be to surrender completely and

admit that local government has, through its development of recreational and creative facilities, its library and museum services, its licensing and running of public halls, of music seasons and festivals, of films, galas and carnivals been involved in arts provision much more deeply and significantly and for longer than the Arts Council. It is nevertheless embarrassing to read, at the end of the booklet, that '*some* local authorities have been supporting the arts for longer than the Arts council'. Perforce, *all* local authorities have. It is because the present government forced its arts quango into co-operation with the authorities that the Council was forced, with manifest reluctance, to acknowledge the fact.

At the heart of the booklet there is another curious section which gives the game away about it all. The new 'partnership', both with the Regional Arts Associations, and with the local authorities, is to be manipulated so that the Arts Council retains nevertheless its position of control – it is to act, it hopes, as a kind of clearing bank, and as a kind of central strategic planner. Former roles as head of the national power houses, as the fulcrum of arts education, as keeper of national standards, as shrine to British liberalism are all to be discounted beside its new role, as *The National Planning and Development Board* for the Arts, no less.

The dire announcement of this depressing ambition must be quoted in full, not merely because the nature and function of all of the arts is so standardised, falsified and distorted by such claptrap ('Arts facilities are now important corner stones in strategic planning and development and, in some cases, take account of the need for increased support for disadvantaged groups amnd ethnic minorities' – an unforgettably clumsy boast which will be seen below in its context). It must also be fully quoted because even reading it, and without any kind of analysis, the reader is conscious that behind the grandiose phrases there is a deadening vacuity; incomprehension about what is really being discussed and no notion about how such questions might properly be formulated and addressed:

'The aim of all those concerned with the arts is to improve the quality and quantity of both arts activities and audiences. As well as seeking new resources this means, in practical terms, a better utilisation of existing ones – and that means people as well as buildings and traditions. In addition to these aims, the Council is committed to redressing Britain's historical imbalance, both geo-

graphically and in terms of art form versus art form. The overview offered by the Council can, through careful planning and consultations, help to minimise distortions in the development of new facilities.

Local authorities have for some time been aware of their responsibilities in this area. Arts facilities are now important corner stones in strategic planning and development and, in some cases, take account of the need for increased support for disadvantaged groups and ethnic minorities. Reflecting these concerns, the Arts Council has set up a new Planning and Development Board that, as well as providing a national view of these issues, will further encourage management training programmes, educational work, joint use of buildings and research into key economic and social factors relating to the arts. It will also work with the RAAs on creating broader development plans.'

The whole is embarrassing enough for its general air of political bluster, and painful enough for its insistence that what is mysterious and intangible can be 'better utilised', planned for and redistributed according to some alien notion of equality or fairness. ('The report shows that there's been an under-utilisation of lute-players in Grantham, Chairman'). The plan is shot through with the belief that what is complicated and unknowable can be simply known, and that which cannot be created by national planning can be planned for. (We're anticipating a ten per cent increase in sonnet writing of grade A quality following our investment in the poetry market').

In one of Stephen Leacock's short stories the shareholders of a neighbourhood church get together to redefine and repackage God to meet contemporary market needs. The plan for a Planning and Development Board in the arts reminds one of it, of course. But Leacock was being humorous, and, as far as can be seen, the authors of this booklet are not. They apparently seriously believe that, sitting in London, utilising people, and seeing arts facilities as cornerstones in strategic planning and development, they are going to redress Britain's 'historical imbalance' in the arts. Are we to be forbidden writers with a Bloomsbury address for fifty years to give Wigan a chance to catch up? Are the bagpipes only to be played South of the Border? Are University Libraries to be made to

employ poets to make up for Hull's former privileges? Are percentages of painters, who came from the wrong locations, to be struck from the national record? And how is this committee going to redress the imbalance 'in terms of art form versus art form'? Are we to have a moratorium on opera while neglected art forms are permitted to catch up – can we expect a sponsored revival of the masque, ballroom dancing, ice spectaculars and all the other arts that find themselves on the lighter side of the balance?

Our reaction could well be that this new committee exhibits nothing but ignorance combined with overweening arrogance, in its self-appointed duty of giving a 'national view' on local authorities' work, and in its presumption that it can reorganise and minimise 'distortions'. Of course if it could do such a thing, it would have powers without precedent in history, for it would be able to forecast when great art was to appear, and which people would form its audience, and where they would all live. But the prevailing impression is more of anxiety than arrogance. And it is ultimately our pity which is excited, rather than our laughter or our scorn, for the beleaguered Council officers who are asked to work on a prospectus which is at once so hectoring and so vapid.

For at its heart this document, like all of the depressing monographs that have issued from the Council since the ascendancy of Sir William Rees Mogg, contains a contradiction in aims so large that only cant of such large portentousness and such little actual meaning can hope to distract our attention from it. This is it. *Partnership*, like its forbears, claims that the subsidised Arts world is succeeding in terms 'the go vernment understands'. That is, it uses the stilted language of Conservative 'conviction politics' to describe what it is doing, and to describe what it is going to do. That language – the language of 'the enterprise economy', 'new industries', 'competing in the market place' – has to be used of a realm which by tradition (and through successive governments' actions) is thought to be at its worthiest when it is *not* competing in the market place, but when it is presenting heavily subsidised work. The 'enterprise' the booklet praises is bureaucratic initiative in drawing the arts out of the market place, and making them more heavily dependent upon the combined sponsorship of arts councils, local authorities and surplus industrial profits. We feel uneasy at the application of such familiar political terms to the arts not only because

there is no sense in which such quantitative processes can be applied to the intangible nature of creation, but we are also uneasy because we sense that a clumsy linguistic trick seems to hide the fact that in spite of the buccaneering talk the subsidised arts are becoming more bureaucratised, less dependent upon the market place, and less exciting. One cannot imagine any other 'industry' being praised in the same terms, or 'enterprise' being elsewhere defined as skill in scrounging subsidy.

The final lesson from this, which may after all be the last word from the Arts Council before a new government reforms or abolishes it, is that, whatever else, the language of arts politics and arts management must be changed. From the 'needs' of the people to the 'enterprise' of arts bureaucrats, from client 'assessment' to regional 'development' it clouds our vision and blinds us, like Gloucester, to common sense:

> 'Get thee glass eyes:
> And, like a scurvy politician, seem
> To see the things thou dost not.'

APPENDIX C

FURTHER READING

The most thorough historical account of the British experience is in Minihan, *The Nationalisation of Culture* (Hamish Hamilton, 1977). Dr. Minihan however has comparatively little to say about our post-war problems, and a wider account of the post war period is given in Hewison, *In Anger; Culture in the Cold War 1945–60* (Weidenfeld and Nicolson, 1981). The nature of the Arts Council is acutely described by Hutchison, *The Politics of the Arts Council* (Sinclair Brown, 1982), and the milieu from which the Council sprang is trenchantly described – with detailed accounts of members' curious political affiliations and dedication to 'the higher sodomy' – in Deacon, *The Cambridge Apostles* (Farrar, Straus and Giroux, U.S. 1986). The nature of 'tourism' increasingly impinges upon government arts policies – 'poor scraps of humanity' Waugh called them, 'trapped and mangled in the machinery of uplift' – and the tourism business has been entertainingly described by Feifer, *Tourism in History* (Stein and Day, U.S. 1986).

The 'Arts Council system' is defended at length in a variety of publications, notably Baldry, *The Case for the Arts* (Secker and Warburg, 1981) and in a book I edited, *The State and the Arts* (Offord, 1981) in which a number of senior Arts Council officers explain their purposes. Two important papers elaborate the argument in a wider context, Chartrand, *Towards the International Evaluation of Arts Council Funding* (Canada Council, 1986) and an earlier paper, Harris, *Decision-Making in Government Programmes of Art Patronage* (Western Political Quarterly, June 1969). More critical of arts councils and their practices is Benfield, *The Democratic Muse* (Twentieth Century Fund, U.S., 1984) and an equally trenchant look at the political assumptions involved in government subvention to the arts in Walzer, *Radical Principles* (NY Basic Books U.S., 1980).

Descriptions of the market systems for the various arts in Britain are

scattered throughout many publications. The theatre business is described, amateurs and all, in my own *The Theatre Business* (Comedia 1985) and the same publishing house has provided the excellent series on other art forms which includes Field, *The Publishing Industry* (1985) and Hardy, *The Music Industry* (1985). Moody's *The Art Market* is published in 1986. The best account of the media is in Tunstall, *The Media in Britain* (Constable 1983) and the second half of Drogheda, *Double Harness* (Weidenfeld and Nicolson, 1978) contains as revealing an account of the low politics and high finance of the opera world as will be found anywhere. On a broader front it is impossible to make any kind of definitive selection from the hundreds of books of reminiscence which pour from the presses, but Pye, *Moguls; Inside the Business of Show Business* (Temple Smith, 1980) has revealing accounts of the work of Robert Stigwood, Jules Stein, David Merrick and Trevor Nunn, amongst others. Mills, *Bertram Mills Circus* (Ashgrove, 1963) gives a revealing account of the workings of a great circus and Chipperfield, *My Wild Life* (Macmillan, 1975) offers an account of the origins of Wild Life and Theme Parks. Hobson, *Crossroads: The Drama of a Soap Opera* (Methuen, 1982) has interesting things to say about the quality of an experience normally dismissed as being near-moronic, watching televised soap operas, and Lahr's *Automatic Vaudeville* (Heinemann, 1984) is full of insights into the nature of being famous in the world of entertainment.

There are signs of a much wider understanding of the 'art world' and its finances in several recent publications, of which the most stimulating is *The State of the Art or the Art of the State* (GLC, 1985).

INDEX

Index

Index

Index

210

Index

Index

214

215